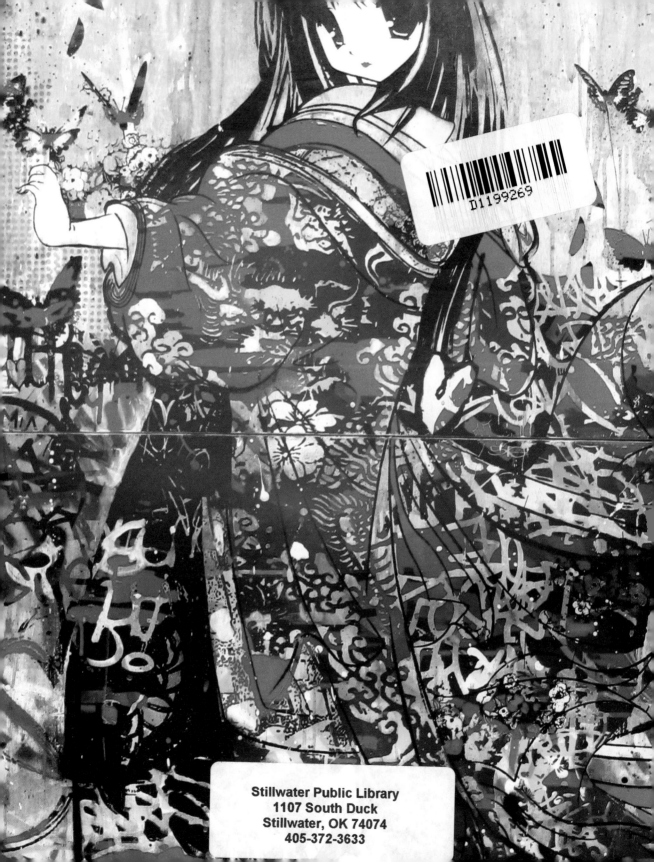

STREET KNOWLEDGE

KING ADZ

For Kaiya & Casius - My Inspiration...

First published in hardcover in the United States in 2011 by

The Overlook Press, Peter Mayer Publishers, Inc.
141 Wooster Street
New York, NY 10012
www.overlookpress.com

Published by arrangement with HarperCollins Publishers, Ltd

Cataloging-in-Publication Data is available from the Library of
Congress

Manufactured in China
ISBN 978-1-59020-477-1
FIRST EDITION
10 9 8 7 6 5 4 3 2 1

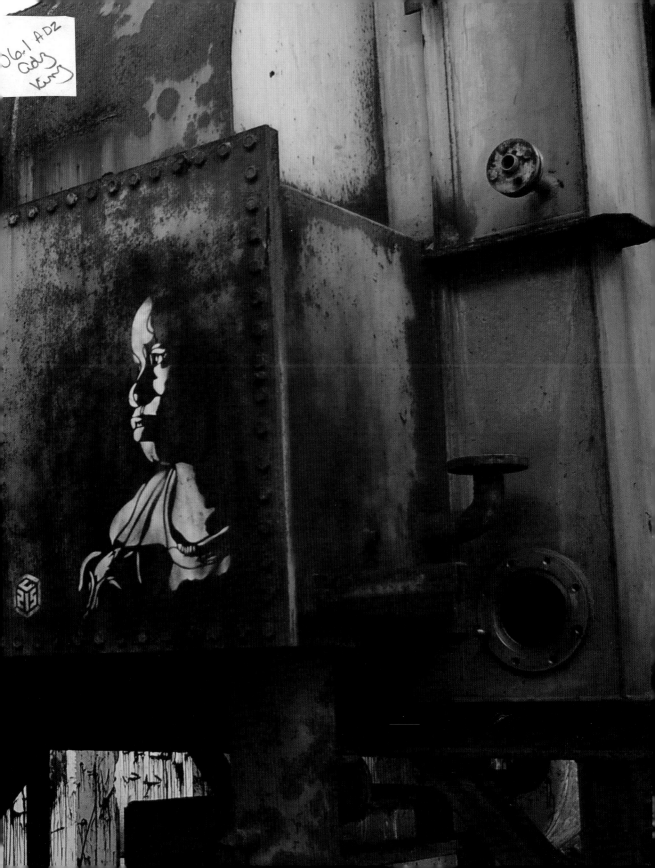

FOREWORD

One thing I can certainly guarantee anyone buying this book is that with the possible exception of those of you who have read King Adz's previous work, you'll wait a long time before you see anything quite like *Street Knowledge* again. You'll notice how lavish and vibrant both the text and illustrations are, and how comprehensive and off-the-wall the book is.

King Adz makes no distinction between so-called 'high' and 'low' culture, nor between the backgrounds of the diverse artists he includes in this work. Whether their point of exhibition happens to be in the corporate world – in terms of advertising campaigns or products produced by multinationals – or resolutely 'underground' – written on the walls and bridges of our urban environments – makes absolutely no difference to him. The only thing that matters is impact and visibility on the street. Adz defines street culture as 'an ever-evolving influence on daily life. It can't be held, but it can be seen, everywhere. It cannot be bought but it is often used to sell everything from video games to haute couture.

King Adz sees 'street' art purely in terms of its aesthetics and the impact it has on the people who experience it. So in *Street Knowledge* you'll see a variety of art originating from right across the globe, culture depicted not only by fêted individuals who have become world-famous stars and consequently treated very well by capitalism, but also by resolutely subterranean figures who are little known outside a small group of perhaps largely local cognoscenti (and in many cases that's exactly how they like it) – and just about everyone else in between.

Of course, the growth of the information highway and the continuing development of our cyberspace lives force us to consider the question of whether anything can truly be considered underground. As Adz says himself, 'it's 2010 and we're all down with the latest everything. Nothing is hidden; everything is instantly accessible.'

Art is created to be seen and enjoyed, debated and discussed. But while it can be accessed, it's becoming an increasing myth that the Internet necessarily throws everything that's good up into the light. For one thing, there's just far too much going on for most of us to be able to care or spend the time sorting out the wheat from the chaff. In a disposable culture, we experience things in different ways. As for music, a young kid in the seventies and eighties might typically have bought a single every week and an album every month. These items were cherished artifacts, played time and time again, whose artwork and sleeve notes were poured over. Their counterparts in 2010 can immerse themselves in tracks from the 1930s or music that has been made literally minutes ago. And there is so much more of it made now.

This is where someone like King Adz comes in; he travels the world, checking out everything and everyone he's heard of, been referred to, or stumbled across on the net. I personally rack up plenty of airmiles per annum, but I'm a positively stay-at-home, carpet-slippers individual compared to him. Look at the diversity of locations in this publication, he's been to them all – from my home town of Leith where we took a leisurely stroll down the Walk to the Docks on a sunny day, enjoying the banter of some of the more colourful locals, to the Cape Flats of South Africa and beyond to the backstreets of Tehran. Evidence of his globetrotting is apparent throughout the book; Adz in your town, hanging out, taking in the visuals and the pulse of life.

If I was trying to get in touch with someone who didn't want to be got in touch with, Adz would be the first person I'd go to, just in order to work out how to go about it. One of his great talents as an artist, compiler, networker and individual is his resolute refusal to see barriers where the rest of us have been conditioned into doing so.

Street Knowledge will turn you onto stuff that you would never ordinarily encounter in years of websurfing. I repeatedly found myself fascinated by stuff within its pages I'd hitherto had zero interest in, precisely because I had only had limited exposure. I tend to order books online these days. In some ways, this breaks my heart, because one of the great pleasures in my life used to be browsing in a bookstore, coming across something I didn't expect to see. That pleasure is all but gone now, as when we walk inside it's hard to escape the feeling we're being force fed increasingly dull, corporate fare by marketing people, pushing us into sterile consumerist boxes: art, literature, travel, cooking, crime, romance, thrillers, classics. It's therefore uplifting to come across something that intrinsically says, 'fuck all that nonsense'.

So have some Street Knowledge.

Irvine Welsh

BEGIN HERE...

The images, sounds and flavours of the street have always been paramount to me. Ever since the age of eleven when I left the safety of a laid-back hippy-bippy Rudolf Steiner school and signed on at the local comp, I've been down with all things street. Okay, so I had to deal with my first real taste of culture shock, but once I got to grips with the law of the jungle (or is that the law of the tumble?) and learned how to keep my head down at the same time as holding it high, it was a real eye-opener. I was hook, lined and sinkered. Soon, I became a Casual: Farrah slacks, Patrick trainers and Lacoste shirts were what went down, with my girlfriend (when I could get one) wearing ski-pants and an Ellesse jumper. I spent my time and money at the Haven Hotel Junior Disco each Sunday evening getting down to 'Dr Beat' and 'White Lines' (the Grandmaster Flash song – the drugs came later) and then I discovered Philip Salon's Mud Club in Charing Cross Road and the world was my lobster. I'd get a train into town every Friday and queue up with the rest of the kids, but I soon got to know Philip and my eyes were truly opened to the club world. The music went from pop to go-go to hip hop and then to Balearic beats, and it wasn't long before I went to the legendary Central Saint Martin's College of Art and Design and became one of the resident artists at the Brain Club, the most happening , creative club in London at the end of the eighties.

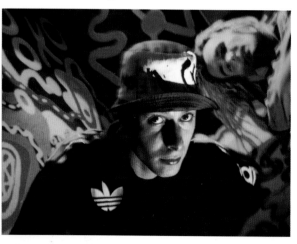

I am an urbanist. Okay, so I'm from the green suburbs of London but that is just the point. It's not about where you are from it's about what you are in to. They call it 'crate-digging' (a reference to record buyers going through crates of vinyl), as we are all about what we choose to take from the many influences and references that circle in the cultural ether like a 747 in the stack above LHR. And it's about what we choose to adopt as our own, to appropriate, just like the rise of the art of sampling (other people's records). Some people said that it wasn't music, but to me it was something that changed my life. DJ Shadow, DJ Cam, The KLF. Say no more. Most probably the same fuckers who said the Hip Hop was just a craze, that it would pass.

We are well into the twenty-first century and we're all down with the latest in everything. Nothing is hidden, everything is instantly accessible. Urban street culture has influenced everything you can touch, see, smell, watch, buy, wear, listen to, download, upload, TIVO, record and burn. The concept of this book is to document the influences on urban culture over the last 30 years and chart its progression from its origins to where it is today; to pay respect and give the biggest props to those people, places, social situations, music, films and images that have made a difference and helped shape the ever-changing look and feel of the movement. And to look to where it is going.

What is street culture? It is an unconscious creative collective (in the fields of art, food, music, fashion etc) that is borne from the streets of the urban environment. It has its own visual language: a multi-ethnic, multi-disciplined, multi-media, stream of consciousness that has a unique look and feel which cannot be faked. The audio/visual is god in street knowledge. As is frequently suggested, sound and image is (almost) everything, and it is an integral part of its DNA. This visual language is an ever-changing montage of retro and futuristic images. The cyclic nature of the culture means that looking back is just as important as looking forward. But to see the future you've got to know the past.

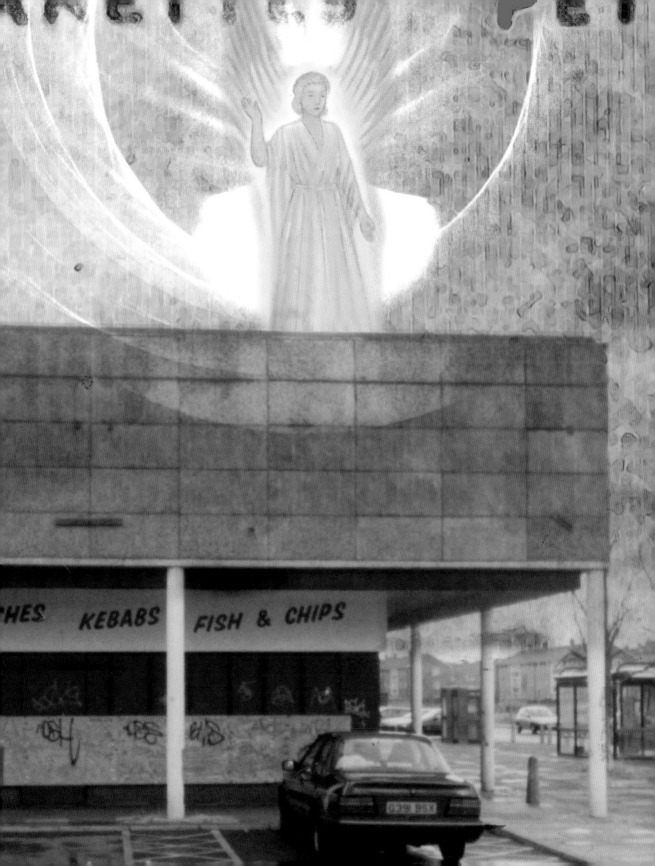

TOOLS OF THE TRADE

To create this book I used a Canon G10 Camera, a 24-inch iMac, a Sony HC9-HDV camcorder, a notebook and a pen. I flew around the world thrice times and had the honour of getting down with many of my heroes and a lot of seriously talented and seriously generous human beings.

The reason why I'm telling you this shit is that part of my M.O. is that knowledge should be shared and not hidden. There is no secret to what I do: I've just worked hard for years to get to this point. Okay, so you need to be able to write and have respect for your gut feelings when you see something good, and to be interested in street culture and the world and people around you. Like the man said, you have to work hard and be nice to people.

HOT SPOTS

One of the philosophies I want to spread with this book is to turn people on to new and unknown experiences, so at the end of each city entry there is a 'Hot Spots' list and at the back of the book you'll find a list of reference points, further reading or viewings to use as a starting point when planning your own adventure, on or off line. Once you're out there you will find out that these lists are just the tip of the iceberg and the real adventure is totally one of your own creation. This is the best kind of voyage: one you and no one else owns.

Please remember that this book is just my personal view of the world of street life and obviously I can't write about everyone who has ever had an effect on the culture, so there are going to be some people, events and happenings that I've not covered. I've tried to document the epic journey I have taken in the last 25 years of my life to present the past, present and future of street culture, looking at street art, music, fashion, film, design, the media, photography, craft, retail, street food, spots to hang out in the coolest cities, websites, events, sub-cultures and movements etc.

HOW TO USE THIS BOOK AS A TIME MACHINE

This book has been lovingly designed to read in two ways:

One – as a reference book, a kind of encyclopaedia of street culture. Dip in and out when you want to find some shit out.

Two – as a narrative journey through street culture. At the bottom of most pages (starting with this one – look down) there is a hyperlink to where to go next. This will take you on a journey through time to see how street culture has developed into the phenomenon it is today. There are also quick links in the text when a reference is made to a key figure or trend, these look like this (>pXX) and direct you to jump to page XX. They are detours from the main journey, but ultimately you will end up back on the trail straight after.

All massive hear me now! Hold tight!

Peace+Love **KING ADZ**

→ → → To start your journey, turn to p126

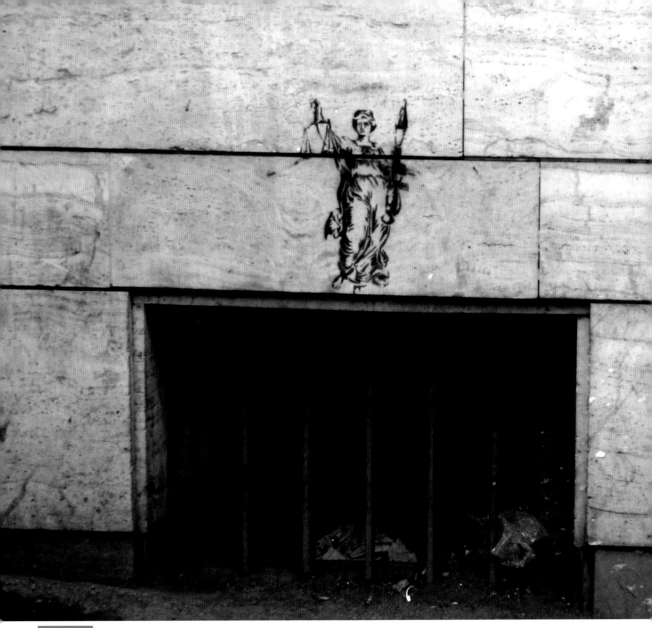

A1ONE

www.kolahstudio.com

When it comes to Iran, there's only one real street artist who is worth mentioning at the moment and that is A1one. He has been holding it down for many years on his own with no community support and is the most hardworking and dedicated street artist in Iran. In the west we know nothing about oppression and have been getting up (the process

of putting up illegal art in the street) for as long as A1one has been living under an oppressive, watchful regime, something truly remarkable indeed. People disappear for much less and in 2007 A1one staged the first-ever stencil art exhibition in Tehran. Which says a lot about how he operates – the fact that he was the only person to stick his neck out and put on an exhibition dedicated to an outlawed art form. I have been friends with A1one for some years now and have seen him develop an

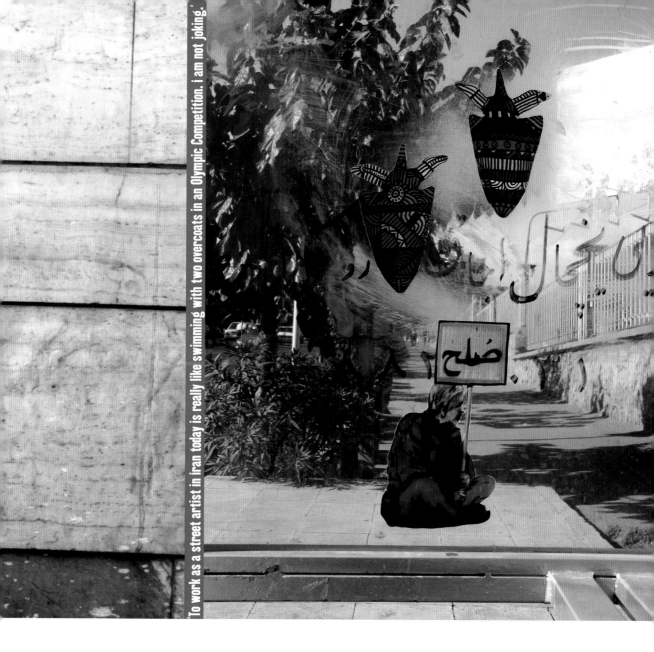

'To work as a street artist in iran today is really like swimming with two overcoats in an Olympic Competition. i am not joking.'

original style: he started out just using stencils and now has allowed his work to be influenced by folk art and contemporary painting. I asked him who his influences are.

'My work has been influenced by Van Gogh, Francis Bacon, Nietzsche, music, Blek le Rat, Logan Hicks, Jeff Soto…'

It is when I ask about his goals that I begin to underderstand about life in Iran.

'Goals? Me? I really enjoy painting and finding more things from the act of painting and forgetting my urban self. To live and feel that I am ALIVE. In my social life I am trying to learn what I need and give what I have when I'm painting. I have many goals for my future and life but when I am at the desk I feel like I have no goals.'

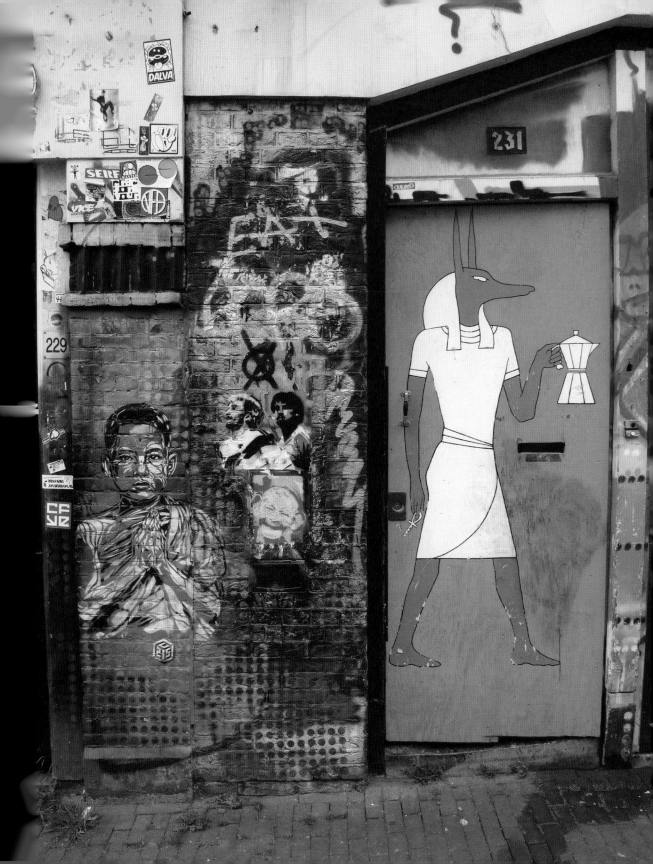

AMSTERDAM

This is the old pirate island where back inna day you could buy anything you wanted and anything went. It has changed a bit in the last 20 years but there is still something for everyone in the city of madness. I always liken it to an adult Disneyland: a place chock-full of adult rides (sex and drugs) and fantastic sights and parades (check out Queen's Day on 1 April for complete mayhem). The Dutch are a creative lot and Amsterdam is where the best of them congregate to get it on. They love their street art, stickers, good food, football, drinking, legal and illegal drugs, galleries, clubs and advertising. They aren't hung up about much and so this leads to a free-and-easy atmosphere.

But that said, Amsterdam is changing slowly from an open-air adult-orientated museum into a city of pure creativity. For a while, the city's inspirational talents were jumping ship in favour of Rotterdam, but that is now over. The tourists are still arriving in droves but they seem to be contained to one or two areas of the 'Dam, namely the red light district and the coffee shops. These tourist areas are in the east and the south central area of the city. Just a few hundred feet east of the Centraal Station you'll find the Warmoesstraat, the beginning of the red light and coffee shop area, in which to lose your mind. The sex and spliff aspect of the 'Dam has to be experienced before you can make up your mind about whether it's cool or not. I've spent many trips to the 'Dam getting wasted back inna day and stumbling around the red light district, but these days I'm straight and the place still rocks. Remember that all the guys selling drugs on the street are just trying to rip you off. Okay, the first thing you gotta know is that all hard drugs are illegal, but if you're determined to buy drugs then stick to the coffee shops. If you want something that isn't on the menu then ask the dealers in the coffee shop if they have any info. There is a heavy heritage of culture within the city and all aspects of creativity are respected and encouraged. There are some killer advertising agencies here now (>p104) and the fashion and arts industries are gathering momentum.

If you go off the tourist route slightly you will find the real Amsterdam – a clean, civilized place, almost the opposite to the red light district.

Around the Spui (a square slap-bang in the centre of the 'Dam) is the place to be for book lovers, as there's a ton of bookshops and a weekly book market on Fridays. There are some great places to eat and traditional style bars in which to spend the evening. Which is exactly where I was when I last hooked up with Michel van Rijn.

Amsterdam is home to my old pal Michel – one of the world's last true adventurers: art expert, stolen antiquities hunter, multi-millionaire playboy. He's a larger-than-life character with a heart of gold, and I'm truly happy to see him whenever I go to the 'Dam. We always mooch off to a pavement bar where Michel begins to tackle a long line of double bloody Marys without any visible effect. He then fills me in on his latest accomplishments, none of which I can speak about, let alone write about here. Let's just say that he's got his fingers in a lot of pies and one of the biggest and most complete collections of religious art in the world. A true bon viveur!

HOT SPOTS

<u>Best homemade fries in town:</u> Vleminckx, Voetboogstraat
<u>Wicked bookshop:</u> The American Book Centre, Spui 12
<u>Great 'hood:</u> De Pijp, take tram 16 or 24 or 25 to Albert Cyperstr then walk east
<u>Good Bar:</u> Café 't Spui-tje, Spuistraat 318 (old-school 'Dam bar)
<u>Great Hotel:</u> The Lloyd Hotel. Oostelijke

→Turn to p104

ASBESTOS

www.theartofasbestos.com

A few years ago I bumped into Asbestos while he was busy rubbing down one of his large-scale pieces of someone's hand on somebody else's wall in a suburb of Antwerp. I know his work but had never met the guy so I stopped to talk. It's at moments like this that you know you're gonna get on with someone and me and Asbestos click like a clockwork orange and that is it: Down for life, and so we hang out for a weekend doing the 'street-art shuffle' and generally getting down with some serious hang time and talk shop.

'My art is defined by the people I meet and interpreting them, it's about the human form and the environment that I live in' he says. 'I like to interact with the space that's around me and the streets are ripe with opportunities to express yourself. Whether it's a painting I've put up on a wall or a sticker on a lamppost, it all adds to the layers of dirt and personality of a city. My paintings are meant to become part of their environment and the longer they stay up, the more they blend in and integrate with the walls. Hopefully the odd passer-by will see the work and react to it. Positive or negative, any response is good for me – once work is out on the street it's fair game to be loved or criticized, I release all control of it once I put it out there.'

What I like about Asbestos' work is that his gallery pieces are all created on discarded material found in the streets, usually around where the show is taking place.

'All my work is done on found objects, be it wood, plasterboard, metal or anything else I notice in a skip at 3 am. These objects have a history and a personality to them that cannot be faked. They're a snapshot of the past and part of the fabric of the city which missed their chance of a quiet life in a landfill site.'

His art has evolved in a natural way. He has never jumped on any bandwagon or followed any trends in art whatsoever.

'In the last year my work has been inspired by the use of the triangle and deconstructionist shapes that I've seen in architectural structures. The triangle has now become a central element in my work that ties together the dirty, random, found aesthetic that I've always loved with a hard and structured form of the triangle. Thinking about the triangle, I've come to realize it's the coolest of all the shapes – circles and squares have nothing on it.'

The other side of Asbestos' art is his Lost Series of stickers and posters that advertise random missing objects that are lost but may not need to be found.

'This series has been a constant in my work over that last few years and provides me with a bizarrely fun outlet to interact with the public. I'm constantly getting amused and bemused mails from people who've spotted the stickers to tell me that they've found what's lost or that they hope I find one of my errant objects.'

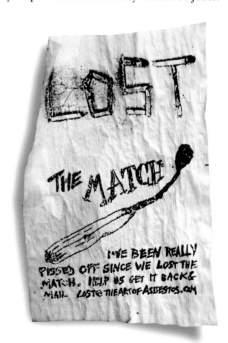

→ Turn to p.46

JONAS ÅKERLUND

www.raf.se

Jonas Åkerlund is one of the world's most visionary and consistently innovative film directors. He's created some of the greatest, most memorable music videos for the likes of The Prodigy, Madonna, Blink 182, The Smashing Pumpkins and Ali-G (respect!) and made the transition to the big screen seamlessly with his debut feature *Spun* – a film so dope that it made me want to start taking drugs again (after being totally clean for at least five years) when I last watched it! His Swedish sensibilities ensure that his work is always original, and bacon-sandwich-droppingly controversial. Way back when, Jonas happened to be working for a production company when he was presented with an opportunity to step up his game.

'I was working in other areas of production when Swedish TV went commercial. We were one of the last countries in the world to have commercial TV and when it happened every company wanted a commercial. So I just started shooting commercials. It was the most natural thing for me to do.'

He then began to make commercials in Europe and then gradually moved into music videos, which is where he found worldwide fame. He blew up with his brilliant and controversial 'Smack My Bitch Up' video, which is still the greatest music video – ever.

'I think being Swedish I have a different shock level than the rest of the world, so I honestly try and bend the rules. I know that you can't show certain things. With the Prodigy video, the most shocking thing was how big it became. This was before the Internet so everyone was passing around videotapes. Everyone saw it you know, Jay Leno made jokes about it on his show for five nights in a row… It was the first time that I made something that seemed to affect people…'

I kinda wonder if the music video is still relevant now as it was back inna day, when MTV ruled supremely. I ask Jonas if he still feels the same when he is making the videos today as he was back then.

'I still enjoy making music videos but the problem I have is that everyone is worried about the content. There used to be a time when the videos were creative and free from all red tape, the brief was 'just do something that we haven't seen before, something that sticks out that people talk about'. And today the brief is that it's gotta be 'Iconic'. Making music videos has recently become a bit more like doing a commercial, but with an inexperienced client. The thing with advertising agencies is that they know what they are talking about. They know their audience. With the music world they are all smart-asses who all think they know what they're talking about – but they really don't. Out of that inexperience comes great creativity, that's why I still love it!'

Back in 2002 when he made *Spun*, no one would even send Mickey Rourke a script, let alone cast him in a movie; he was seen as box-office poison by the fools who run the show, but Jonas ignored all this bullshit and cast him as 'The Cook' – one of Mickey's finest roles to date. I give him total respect for that action alone. Jonas has recently completed shooting a $25m horror film, *Horsemen*, and continues to create amazing music videos and commercials around the world.

Turn to p120

ADVERTISING

So I may be a bit biased (as I used to be an art director, hence the ADZ in my name) but advertising has had a massive influence on street culture and vice versa. In terms of audio/visual culture, adverts are not only massively influenced by street shit (usually they are always playing catch-up to what is really happening on the street), they also, once in a while, influence it. Okay, so right now the advertising industry is in a bit of a strange place as the Internet came along and changed everything. The web is a showcase of original ideas, created by everyone and anyone – it totally changed the way ad agencies worked, who were no longer an exclusive source of creative genius anymore.

Back inna day a full-scale ad campaign to launch a new product consisted of a couple of press ads, some outdoor and – the king of ads – a TV spot or two. Now all that has changed but some of advertising's most respected players – and my personal heroes (Tony Kaye, Oliviero Toscaniro) – have made their names in advertising before moving on to bigger and better things. Take for instance the legendary Dunlop – Tested For The Unexpected TV ad from 1993, an advert that totally changed the face of how TV ads were made and watched. The most amazing visuals (an S&M mask-clad man, a grand piano on wheels driving across a bridge, black ball bearings), cut to a Velvet Underground song, it blew the genre apart. It showed that elements of street culture (the ad was drenched in pure street style and attitude) could be harnessed and used in the mainstream media without having to use the obvious images of things like break dancing youths. This ad was light years ahead of the game, and in turn influenced music videos, film which in turn had a direct influence on street culture.

'The Dunlop TV ad was an incident where the stars all came together at the same point. I was working with a creative team from an ad agency Tom Carty and Walter Campbell – and they trusted me completely. I'd just come off making a terrible British Airways commercial which really went completely wrong, so I said to them, and their client – "If you want me to do this for you then you have to back off and let me do my thing otherwise I won't be able to give you what you really want." And they all did. Originally that script was "Open on a big frying pan with a car driving round the frying pan and it's got these tyres." That was what their idea was. And we completely changed it and got something out on TV that if it ran next week, it would be as radical as it was then.'

Tony Kaye

Advertising has now become an integral part of the street culture, as a lot of the new campaigns are what's called 'guerrilla' – stuff that actually happens in the street, events that people can interact with and not merely watch. Advertising has become harder and harder to spot within the urban environment. Brands are hosting events, exhibitions, star-maker competitions, websites, publishing magazines, all of which appear to be non-branded, but are actually just vehicles for an energy drink, sneakers, or a pair of jeans, often using imagery, techniques and other ideas lifted directly from the sub-culture of the street. Sony executed a campaign where they used street artists in Berlin to advertise their PSP, much to the scorn of the Berlin public who worked out what was going on (they were being sold to by a huge corporation) immediately as the 'street art' went up. It didn't matter how good the street art was, it was dismissed as it was just advertising.

But that said, advertising is part of the day-to-day whether we like it or not. There are direct lines of influence between street culture and advertising, but more recently it has been a one-way street with street culture (including its online presence) being absorbed, regurgitated and then spat out as advertising. This will change as society is always hungry for the 'new' and in the not-too-distant future it will be the turn of advertising to carry this torch.

→Turn to p288

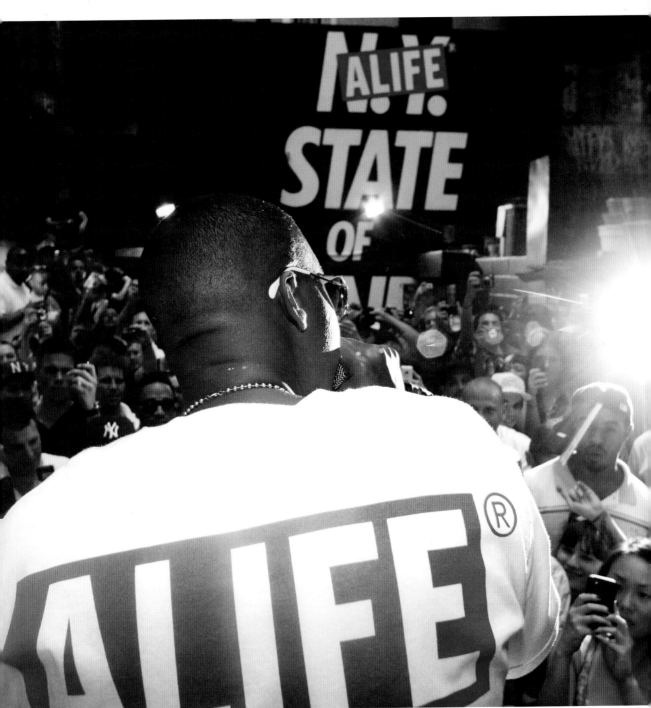

Hip hop legend Nas previews his album *Nigger* in Alife's backy

ALiFE

www.alifenyc.com

The purest attitude and motives go into the creation of their constantly amazing clothing range and other amazing products and projects. Alife is the strongest brand that's come out of the New York bombing movement. Alife started out as a creative space on Orchard Street in the Lower East Side. They chose this spot as 1) it was affordable and 2) it was an area that people from all the other boroughs of Manhattan would not be opposed to coming to. Coming out of bombing you have to think about this shit! I sat down with Rob Cristofaro the founder of Alife.

'I used to write graffiti and I decided to start this new thing – workshop, retail space – I guess it was a store but never had any experience doing any of that shit. Me and a few other dudes were like "we're gonna start something" as there wasn't anything going on. We started the plans in 1998 and by '99 we found the space and opened up shop in the Lower East Side, Orchard Street, which was basically at the time affordable rent as nobody was really down there. We didn't know what the hell we were doing and were just like "fuck it, let's just try this new jump-off and see where it goes."'

Once they opened the space, Alife became their new tag and their mission was to get the name out there in any way possible: stickers, T-shirts, magazines, the same shit as usual; self-promotion is all bombing really, with no budget. They don't pay for advertising and everything is hand done, independent street promotion. That's not to say that if they had a big budget to go do some serious marketing, they would be going large on billboards, as I'm sure they'd still retain that no-budget attitude.

'That's the graffiti way – it's like, "king, shit, fuck everybody else; fuck all crews, we're by ourselves, no respect for really anybody else out here," and that's our shit: We're gonna king New York. Alife was based on the street and before we opened our space we put the word out to the graffiti community – who were the only people we were in touch with – that we were opening a platform, a workshop, a creative space, and we wanted them to be involved. We had a meeting before we opened the store with 50–60 people. These were all the creative people before the shit became what it is. This was people like Espo, Reese, Kaws, the people that were graffiti writers but ready to take it to the next level and at the time there was no other venue for it.'

At this time there wasn't any commercial side to the graffiti movement, and Alife has been based on the art side of things from the beginning. Back then they didn't make clothing, they didn't do footwear – just a space for art, and after they had made enough noise from that, did they think about producing clothing and everything else that they do now.

'Everything that we've done has been a learning experience from having no experience of owning a business to running businesses and independently promoting all the shit that we do. And then having big corporations come and, like, mimic the shit that we're doing but with big fucking budgets. Once in a while there is some interesting shit that goes on out there, and the people that evolve and are not following any shit, any trend – that's the kind of people we like to involve ourselves with. Where I see us going is hopefully the money is going to get bigger and with the bigger budget do more powerful, widely seen things for the public. Using the clothing and the footwear to bring the money in to do the shit that we really like to do – the creative shit.'

Wherever Alife is going you can be sure of one thing: that Alife will continue to create and produce art clothing whatever, with a real connection to the streets from which it came – New York City streets, and that is the one place that is King of street culture.

Turn to p142

21

B

BANKSY

www.banksy.co.uk

Back in the 1980s when graffiti was just crossing over into the New York downtown art scene, somewhere in Bristol, some kid called Robin was going to school and having fun. Years later, mirroring the past (just like the old-school New York graffiti 'writers'), Banksy began his career as a graffiti writer and attempted to get up on every wall of the borough of Easton, where he was from. The Banksy juggernaut began rolling with his first ever exhibition, which was held in a block of council flats. He sold four canvases to the band Massive Attack. He then progressed to using stencils, as it was a lot quicker to apply and created a harder impact, something that has always been important for his work. A well hard impact! And the resulting attention to detail is one reason why Banksy is responsible for the popularity of street art right now. He is the undisputed leader of the movement and his work is by far the wittiest, most accessible of any artist of the last 50 years. This is because everyone gets it. He gets up somewhere and the resulting piece makes the front page of newspapers all over the world because the work is beautiful, topical, cheeky and extremely accessible.

Although Banksy hails from Bristol, his artistic home is the streets of London (and later LA, New York, New Orleans, Bamako and the West Bank) for it was here that he built up his name with his stunts such as installing his illegal 25-ton statue opposite the Law Courts, or stickering police cars with 'Legal Graffiti Zone' written on them. Shows from Shoreditch to Mayfair showcased his unique brand of street art. Banksy is undoubtedly responsible for the rise of the art movement, as he has taken graffiti out of the streets and into the hearts and minds of the public with his witty, spot-on pieces all over the world. No-one would be making a living off their street art if it wasn't for Banksy.

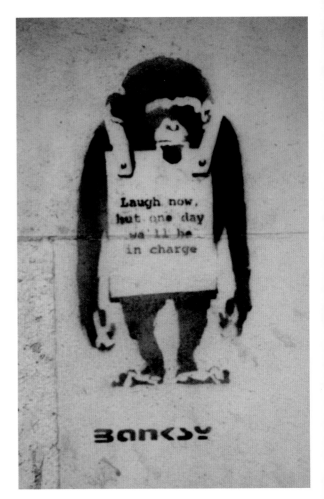

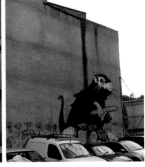

→ Turn to p28

KELSEY BROOKES

www.kelseybrookes.com

Kelsey is a contemporary painter whose work has been inadvertently influenced by the street. I first met Kelsey when he was working as a scientist in some lab in San Diego and had tracked him down as I wanted to show his killer work in '1percent', a free online PDF that I used to edit all about urban creativity. He was doing something completely different and fresh, and was a sweet, out-there guy. I then ran 'The 92024 Report' in which Kelsey would tell us about his life on the West Coast in Issue 3 but the column never really developed, as it was the last ever issue of the mag.

So eight years later he's blown up and is a full-time fully paid-up member of the global artistic community, and having exhibitions around the world. Couldn't have happened to a nicer guy.

'My work is about what I see when I close my eyes. It is about spirituality and the unknown. Others are calling it "Neo Shamanistica", I call it what I do when I'm not eating. It's evolved by means of random mutation and natural selection. In this case I am both the mutation and the selection, which really accelerates and distorts the evolutionary process.'

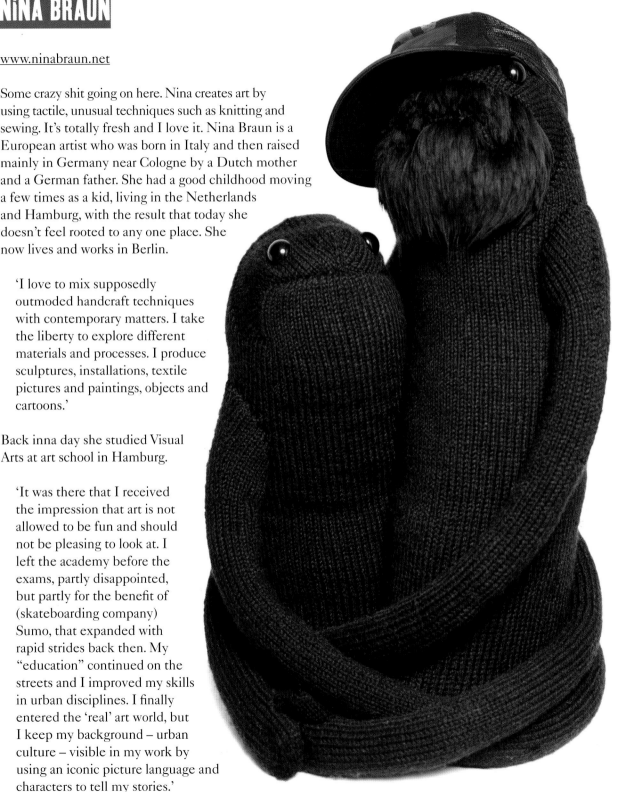

NINA BRAUN

www.ninabraun.net

Some crazy shit going on here. Nina creates art by using tactile, unusual techniques such as knitting and sewing. It's totally fresh and I love it. Nina Braun is a European artist who was born in Italy and then raised mainly in Germany near Cologne by a Dutch mother and a German father. She had a good childhood moving a few times as a kid, living in the Netherlands and Hamburg, with the result that today she doesn't feel rooted to any one place. She now lives and works in Berlin.

'I love to mix supposedly outmoded handcraft techniques with contemporary matters. I take the liberty to explore different materials and processes. I produce sculptures, installations, textile pictures and paintings, objects and cartoons.'

Back inna day she studied Visual Arts at art school in Hamburg.

'It was there that I received the impression that art is not allowed to be fun and should not be pleasing to look at. I left the academy before the exams, partly disappointed, but partly for the benefit of (skateboarding company) Sumo, that expanded with rapid strides back then. My "education" continued on the streets and I improved my skills in urban disciplines. I finally entered the 'real' art world, but I keep my background – urban culture – visible in my work by using an iconic picture language and characters to tell my stories.'

Berlin has been one the finest cities for the urban generation for the last ten years and will continue to do so for some time, as in the grand scheme of things Berlin is a total infant as it has only been one city since 1989. The streets are plastered with graffiti and street art (only recently outlawed) and the Kreuzberg, Friedrichshain, and Prenzlauer Berg areas are where it's at for street life. This is where the young and the restless hang and the great-quality, cheap places to eat, sleep and drink are in abundance.

Because of the number of youth in the city there is a lot of cheap entertainment on offer. There are too many clubs and venues even to think about listing and every genre of music is catered for. In the Kreuzberg and Friedrichshain neighbourhoods there are many small bars that open up and attract boho crowds that are seriously unique. This is the place where the doner kebab was invented. Forget what you know about the doner, in Berlin they are one of the most delicious things you can eat.

A short walk from the Ostkreuz station is a really great street called Sonntagsstrasse, which is a great place to spend an evening. A lot of students live in this area as it is cheap and not-yet developed. There are a few hostels and cheap hotels here and many bars and restaurants.

The Mitte area has been almost completely rebuilt since 1989 as this was where the wall ran its course with large parts mainly no-man's land between East and West Berlin, and a lot of the fashion industry and boutique hotels are situated here.

One thing that is interesting about Berlin is the courtyards behind the tall apartment buildings. There is a whole world waiting to be explored and most courtyards are accessible to the public. You can be on the most urban street and wander through the heavily graffiti'd arch, then step into another world: ponds, trees, timber yards, artists' studios, kindergartens, communal eating and living spaces, indie cinemas. There are some great independent festivals and events in and around the city, especially in the summer when the city comes alive. The Berliners love their independence and when the 02 stadium was built recently there was much protesting at the homogenization of their culture, with a lot of the city promising to boycott any concert there. Here here! I say. Fight the power and commercialization of culture.

There isn't much left of the wall except for the tourist area in the Potsdammer Platz and the West Side gallery along the river in Kreuzberg. The latter is the one to visit as a lot of the original wall art is still visible and this tells its own story of the wall.

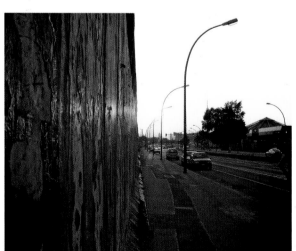

BERLIN ON LESS THAN 40 EUROS A DAY

Berlin is one of the cheapest western European cites. The figures below will change slightly with inflation, but this is what you can live off:

Dorm bed in decent hostel	€16
Continental Breakfast	€2
Lunch (doner/pizza)	€2.50
Supper (quality)	€7
Travel Card	€6.10
Drinks (ten bottles of beer/soda)	€5

→ Turn to p230

BROKEN FiNGAZ

www. brokenfingaz.com

I drive 90 km north of Tel Aviv to the city of Haifa. On the way I pass gas stations with giant dragons sat on the roof breathing neon fire onto the peeps filling up their cars and state-of-the-art shopping malls and entertainment complexes. There is nothing backwards about Israel, even out of the cities. I'm in Haifa to hang out with the Broken Fingaz, a multi-faceted, multi-talented, young and restless art and music crew who virtually run the street scene in Haifa single handedly. And after I marvel at their fucking cool shop in the mixed Massada area, they take me downtown to the Arab part of town for some killer hummus.

'We attempt to recreate our personal twisted world into our art. Most of the time what comes out is a lot of colors, organs, fat people and animals on acid. We started as part of the first generation of graffiti writers in Israel at the beginning of the decade. Five years ago we started a line of underground parties, and designed all the posters and flyers for the events. That was our first serious experience with graphic design, and slowly we started to design most of the flyers and posters for parties and shows in Tel Aviv. From there we evolved to other media such as T-shirts and plush dolls, screen prints, fine art and eventually opening our own gallery and shop, keeping it DIY at all times.'

Not only do they design the posters, they host the events in Haifa and then promote the shit outta whatever, as they believe in what they do. It's been a while since I've met such an enthusiastic and energized bunch of kids, and this is a breath of fresh air for street culture.

'Street culture means having an edge, style, being a part of your local community. It's about putting your shit outside, not only through the media and the web. The fact that street art gets so hyped these days just makes it possible for us to actually make a living from stuff we like doing anyhow.

'We grew up in Haifa City, a true old school town. It's like San Francisco of the Middle East, only without the hipsters and the gays, just the homeless and the old hippies. On one hand growing up in this gypsy town made it hard to be exposed to many things we liked in this culture; on the other hand, being a pioneer and playing on fresh ground made the game much more self motivating and gave us the opportunity to see the scene growing from zero to really cool and artistic.

'Our influences are, hash, music, weird people, growing up in a fucked-up militant country, hummus, skateboarding, porn, Haifa….'

→Turn to p286

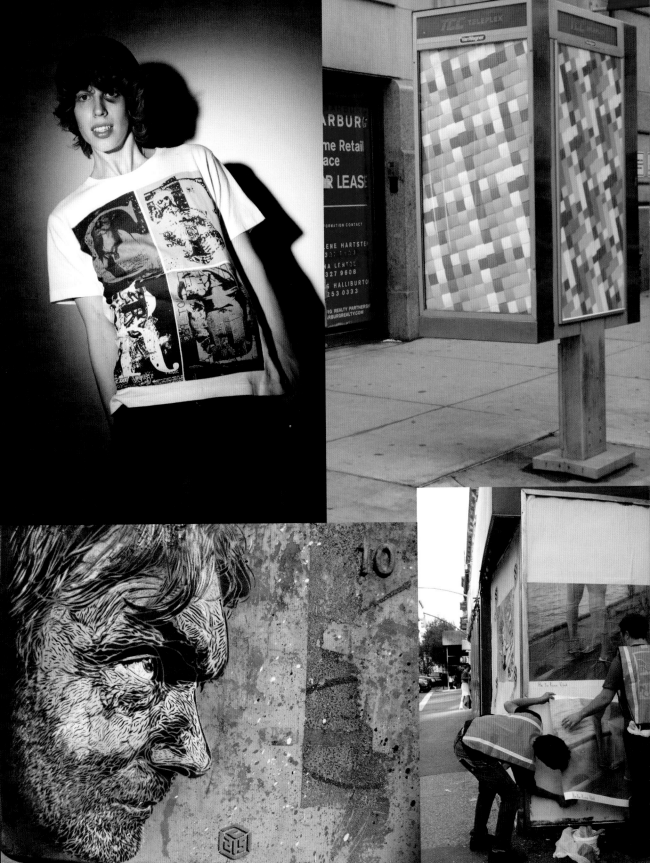

CENTRAL STATION

www.centralstationdesign.com

One of the creative driving forces coming out of Manchester (>p172) is the creative collective Central Station, comprised of Matt and Pat Carroll and Karen Jackson. The visual yin to the Happy Mondays audio yang, Central Station provided all the art, including record sleeves, stage sets, music videos, to the movement. And their art is fucking amazing. When I had to swiftly make a business card in South Africa I was so inspired by their Black Grape 'Carlos' cover (see right) that I used the same police photo-fit image with the words 'Graphical Terrorist' scrawled underneath. I sat down with Matt, Pat, and Karen in Manchester on a sunny day in 2009.

'We've been into making art since we were kids. There was eleven of us living in this tiny council house – it was chaos. Art became a way of entering our own world and space. We were influenced by all the shit that was around us, music, books, films, magazines and mad characters. A subliminal intake of the world, a subconscious collection of ideas. We were into things like drawing, type, and making marks – stuff that kids round our way were just not interested in.

'Our front room was full of our brother's massive record collection and we were fascinated by some of the sleeve art – it was amazing. We'd buy our own records and redesign the sleeves ourselves, or if we bought a single without a proper sleeve we'd make one. We'd spend hours copying images from Marvel comics. Drawing pictures and cartoons of pop stars and people off the telly.

'Our Dad introduced us to magazines and books that we would never have looked at. It opened up a world that had a massive effect on us. Some of the visual images we discovered at that time – like when we read about the air disaster with the rugby team in the Andes in 1972 – that fascinated us for 20 years. Reading about things like the Baader-Meinhof gang, terrorist movements, stuff like that had a big impact on us and influenced our work – eventually. Being a kid in the 70s and early 80s, you have to remember that it was a fucking grim time – but we always had dreams and aspirations beyond our means, we always thought outside of what you're supposed to. One of the most important things when you get older is to connect back to all those key moments. People forget that… A lot of people become adults and they fucking erase everythin' they think is no longer important. We've always believed that's the stuff you keep. When we set up Central Station our priority was to celebrate this idea. Growing up with the Mondays meant we shared the same mentality – we didn't give a shit.

'Factory records became an outlet for us all to infiltrate a commercial environment. Our art, images like Bummed and Carlos the Jackal were exhibited in high-street shop windows, people's homes, and posters were plastered around the country. We were part of an underground movement, using the establishment to communicate to a wider audience.'

→Turn to p486

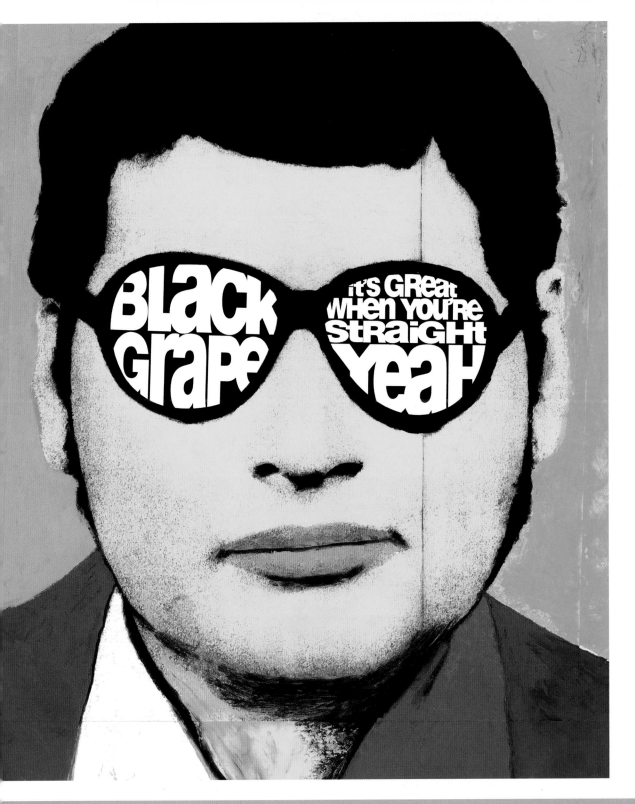

'We encouraged each other and the priority was having a good time as well.'

MARTHA COOPER

Martha Cooper is a living legend: one of the most influential documentary photographers of street culture and co-author of *Subway Art* – required reading for anyone into street culture. Martha has done all kinds of photography over the past 40 years in order to make a living. The bottom line is that she is an editorial photographer, meaning that she shoots photos for publication in newspapers, magazines, books and the web, so that people can find out about things.

'I prefer to call myself a "documentary photographer" rather than a photojournalist because to me journalism implies news and I don't like shooting news stories.'

I first met Martha in Berlin in 2007 when, one summer afternoon, her German publisher tried to get her to autograph 1500 copies of her latest book. I helped her out with the signing of 700 or so,

by keeping her supplied with a stream of open books to write on, and we bonded over the absurdity of the situation. She returned the favour and shot an interview for me in the rubble of a hip hop museum that was being built nearby.

'For me, the subject matter always overrides factors such as unusual light or dramatic angles. I really want to be able to see what's going on in my photos. I feel the camera is an excellent tool for capturing the world and I'm more interested in historic preservation than I am in art. That being said, I would also like my photos to be aesthetically pleasing so the challenge is to present straightforward documentation well framed and well lit. I've pretty much shot the same way my entire life. Over the years I've been more specialized in my choice of subject matter but my basic way of taking pictures has remained the same.'

→ Turn to p72

www.ctrlclothing.com

Coming straight outta Helskini, Finland, CTRL began its journey as a skateboarding company back in 1994, but in the last five years it has moved smoothly into the fashion world. The roots are still in skateboarding and street culture, but now the main focus is clothing, for both men and women.

'The biggest motivation for the gentle switch to the fashion world came from the fact that by owning a fashion label you get the most attention from the best looking girls, basically.'

And now they also get to decide what their friends should wear. All this leads to a lot of networking and travelling around the world; lots of tradeshows and secret drunken gatherings. CTRL is now sold in 33 countries around the world. But this is just the start! I hung out with Freeman, the designer/art director and asked him how his work has evolved.

'Graphic design-wise my work has gotten more mellow. It started as a vivid, colourful and disturbed mega blast and slowly got easier and easier. I'm trying to put more effort behind the design, meaning that in the beginning I was satisfied with something that just looked cool to me; now it has to mean something as well, conceptual thinking is key, I guess. And in general my way of working has changed a lot more into being a clothing designer more than a graphic designer – my way of working of combining those two, though, but compared to early days it was mostly just working with deckgraphics or T-shirt graphics, but now I have whole clothing lines to think about, cut, sew and everything.'

I was curious to know how Freeman saw fashion/streetwear influencing the urban landscape.

'Living in Helsinki, I can only say that the rise of fashion/streetwear brands has done a lot of good to the urban landscape, meaning that in general people dress better than before. It wasn't such a big thing, you see in Helsinki dressing up isn't obvious, especially if compared to our neighbouring country capital Stockholm, where dressing up and being aware of the latest trends has always been a huge thing. But on the other hand there the trend consciousness is on such a level that it almost looks like people are wearing uniforms, everybody looks the same. And I guess this is happening in many cities around the world. But in general it's not really the streetwear brands that dictate the way fashion is going, but the skaters and everything that is around skateboarding, and therefore skate brands are always on top of the pyramid.'

→Turn to p146

CULTURE JAMMiNG

www.publicadcampaign.com
www.areyougeneric.org

One of the most exciting and ingenious elements of
street culture is culture jamming. Culture jamming
is what people turn to when they have had enough
of the more popular forms of mainstream culture
– shopping, movies, the media, advertising. It is
a healthy reaction to the propaganda and bullshit
that is fed to us 24/7 through the media, and is
manifested in street action (hijacking advertising
or shop fronts), media action (using Internet and
traditional media to raise awareness) and events
I can't even categorize (using a giant projector to
beam out anti-consumer messages on to a building).
It could be a protest about how big business rides
over the lives of humans in the cause to make even
more money, or the way that a lot of advertising
billboards are actually illegal. On the road writing
this book, I spent time with two serious culture-
jammers, Okat from areyougeneric.org and
Jordan Seiler, who's the mastermind behind the
New York Street Advertising Takeover.

areyougeneric.org, the US-based website has been
'Giving brand-America the finger since 2001' and
links the protest with creativity. Areyougeneric is a
group of artists that seeks to protest, to question and
to disprove. Its nemeses are unethical corporations,
censorship, the biased media, hypocrisy, excessive
advertising and plain stupidity. Its heroes are art,
discussion, independent thought and creation.

'At first the site was nothing more than a place
for us to show off a culture jam or two (such as
stickering the front of certain fashion magazines
that are totally controlled by their advertisers)
that we pulled off. It has now evolved to be
much more than that. It's become a resource
library of street-art photos from all over the
world. It also houses our catalogue of clothing
and print art intended to critique and reclaim our
social and mental environments.

'Our shirts promote a concept, not a name (not
even our own), and are intended to provide an
alternative to big business and small thinking.
The shirts have no label, no logo, and are printed
on sweatshop-free tees. We've also shared all
our culture jams in the public domain and are
constantly supporting and encouraging others to
pursue their concepts in the public arena.'

As I helped Okat sticker up a shop that was being
converted into yet another Starbucks, I asked him
to define street culture.

'In the most simple terms, I define street
culture with the word "raw". The street is where
everything is born, where it lies before the
mainstream gets its hands on it and refines it to
something tolerable. Street culture embraces
the unfinished, the pure, the work that was
improvised without the intention of ever getting
noticed and that is why it so beautiful.'

The first of Jordan Seiler's seriously ambitious New York Street Advertising Takeovers (NYSAT) took place on 27 April 2009, when over 120 illegal billboards throughout the city of New York were white washed by dozens of volunteers and then turned into works of art. NYSAT was a reaction to the hundreds of illegal billboards that are not registered with the city. Even though these adverts are illegal, the violators are rarely, if ever, prosecuted by the City of New York, allowing the billboard companies to make some serious money by cluttering the outdoor space of NYC with some seriously shit adverts. Jordan tells me what it's all about.

'Outdoor advertising is the primary obstacle to open public communication. By commodifying public space, outdoor advertising has monopolized the surfaces that shape our shared environment. Private property laws protect the communications made by outdoor advertising while systematically preventing public use of that space. In an effort to illuminate these issues, I illegally reclaim outdoor advertising space for public ideas and visual forms. Through bold acts of civil disobedience I hope to air my grievances in the court of public opinion and witness our communities regain control of the spaces they occupy.'

How has your work evolved?

'Today I try to make work that not only uses outdoor advertising space but also announces itself as doing so. This means if I am making personal work, I use tactics that allow my work to stand out from inside the advertising frame. Things like giving physicality where one expects two-dimensional prints, being quiet when someone would expect images to be loud, breaking the frame, and always trying to create honest personal interactions that are so rare in commercial messages. As well the work has embraced a sense of activism and the organization of events has become a part of my art.'

 Turn to p18.

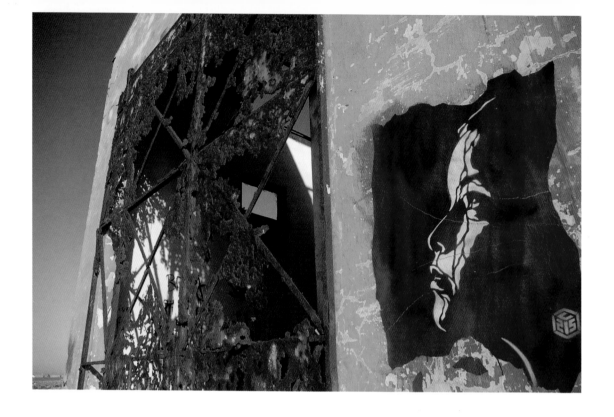
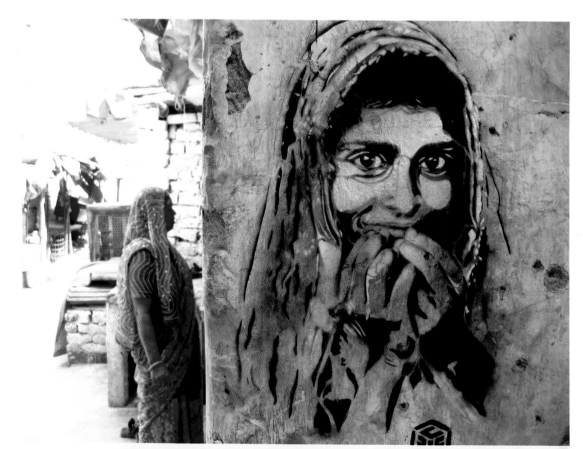

C215 grew up in the small city of Orléans in France, a very quiet place where he began creating his street art as a teenager.

'It was a balanced life I could not face, since I am a very unbalanced person who needs action. This city was too small. Paris is now too small. I sometimes feel this world is too small.'

His art has developed into some of the most amazing stencils around and can be seen in many cities around the world: Delhi, Sao Paulo, Istanbul, Brooklyn, LA, Dakar, Casablanca, London, Amsterdam, Rome, Barcelona, Athens, Warsaw, Berlin. 'I think my art is painting stencils in the streets. I could do other things, but what I am good at is stencilling the streets. I'm used to painting anywhere I am and I am travelling quite a lot. I try to place paintings in the streets, but almost without asking for any authorization. Trying to place the right stuff, at the right place, at the right moment.'

What does street culture mean to you?

'A lot of things, and not only hip hop culture. As a Frenchman, we think to the firemen dancing parties of the 20s, the Parisian terraces, the political posters, having fun between kids in parks, putting tags by night in the streets, being rebuked from night clubs, smoking a cigarette outside a club, smoking a joint in a small street. But more seriously I also think to homeless people, street kids and beggars, since those experience streets continually, with its violence, its indifference. These suffer from streets and cannot be avoided.'

What/who are your influences?

'Ernest Pignon-Ernest, the original pioneer of French street art, is certainly at the basis of most of my works. But older classics are big references for me: Dürer, Rubens, Delacroix, Ingres, Géricault, Courbet and many others, I am even influenced by French poets like Baudelaire, Apollinaire and Rimbaud.'

→Turn to p59

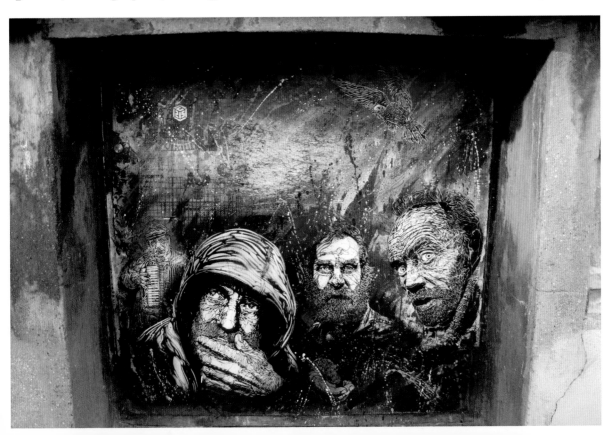

THE CITY LOVES YOU

www.thecitylovesyou.com

The City Loves You is a Mexican art and culture crew who get their messages about urban art, fashion, movies and events out there, through a web-based magazine. Operating out of Mexico City since 2006, TCLY was primarily created as a platform where artists from Mexico could show their work to the world, and ever since they have been invited to collaborate with a lot of different companies and represent a lot of artists in Mexico City. They also create events and parties based on the themes they usually talk about on their website and they are the best reference point for anyone who wants to find out what's really happening in

the lives of Mexican youth, from the street to art to nightlife to leisure life and beyond. I caught up with Cesar Ortega, founder and director of The City Loves You.

'We started TCLY as an urban artists' and fashion designers' community, the idea first was to give an account to all the emerging artists so they could show their work on a website. Obviously they were never able to update the blog so I started inviting friends who were fans of the scene and were interested in having this as a hobby, and since this was a good idea it grew a lot in the world and it started to be a job for everyone because it was considered as a one of a kind piece on the internet.'

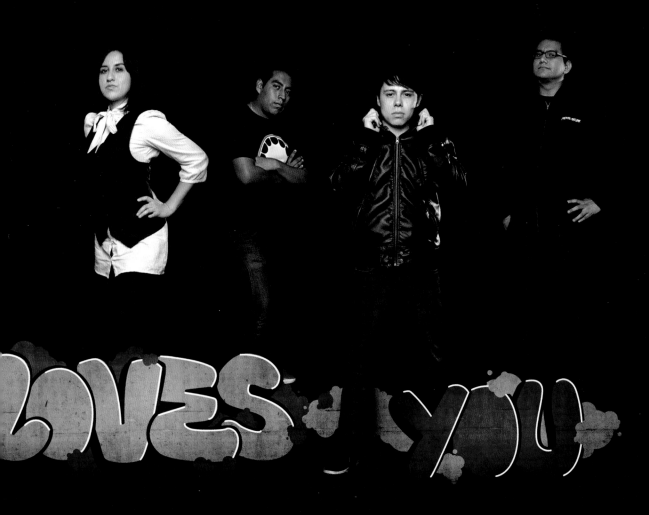

'I grew up in a barrio in the north of Mexico City called La Industrial, well known for being a half wild barrio and also because it's a very inspiring hood. Actually there are a lot of famous creators who also were raised there. Then I moved to another place which was more like a wealthy place full of Spanish people and Nuevos Ricos. I didn't quite like it but I started skateboarding there, and there was the place where the local skate shop called Time Skateshop made a park for us where I basically used to spend all the time skating with neighbors and friends from around.'

'The street is the perfect medium for us to communicate in different and simple ways, like the clothes you wear, the music you represent with it or the sport you practice, or any other way to express peacefully and impact the others to continue the process of freedom and love between each other on the planet. We have a lot of musical influences, we're really eclectic: we go from punk to hip hop and many genres more, it doesn't matter, but we've been also influenced a lot by all the people who started growing the scene in Mexico, the people who believed in the underground culture in all of its different forms.'

I love it: street culture Mexican style. This is what the culture is all about, taking something global and giving it a local twist! Big up The City Loves You!!

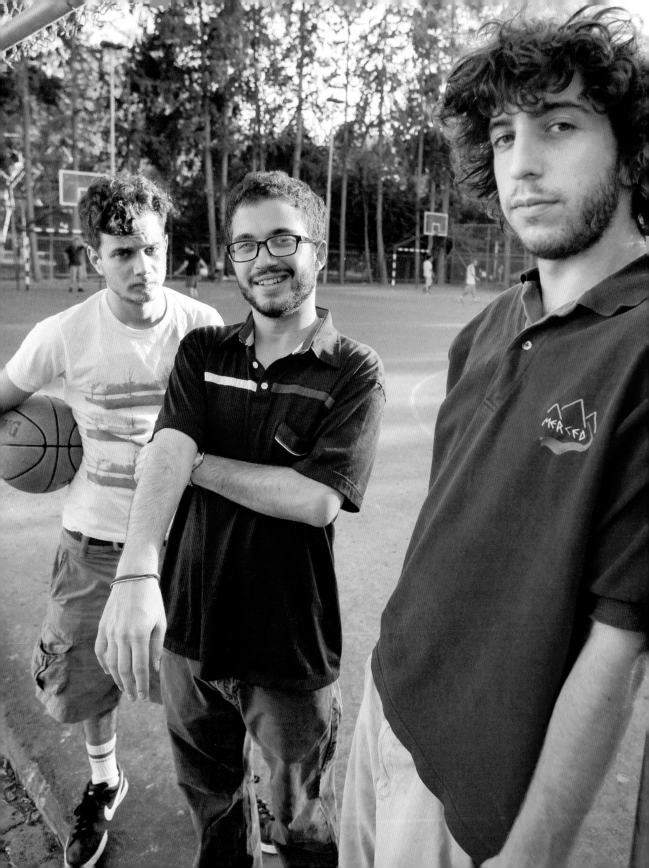

COHEN@MUSHON

www.myspace.com/cohenetmushon

First off, let's get this straight: Cohen@Mushon are three guys – two MCs and one DJ. The trio, Michael Cohen, Michael Moshonov and Itai Drai, are some of the most humble and likable guys I've ever met and when we spend some time together I discover the boys have an infectious sense of joy about them, a rare thing indeed in the rap game. They are like the Beastie Boys used to be when they were young and restless. Cohen@Mushon are from Tel Aviv. They rap in Hebrew and use old-school Israeli music samples mixed with the fattest beats. This may sound like something that won't cross-over, but I can assure you that their music has a global appeal. A serious global appeal.

'First of all everything started as a joke. We met when we were sixteen-years-old and we started to do this routine every Friday and record a song – it was like our hangout – it grew and grew and when Itai (our DJ) came to the event we really became a band. We stated having like bigger and better shows and we started connecting to the scene. We used to have shows for our high-school friends but after we hooked up with Itai we got more serious and then at one of those shows we met Ori Shochat who is like the fourth member of the group. He's a pioneering hip hop producer/DJ in Israel. He saw us and we started working on our album at his studio. That's when we got serious, we kinda picked the material and we said, okay, we're making a real album. Ori gave us a home to do everything and record for free and he really believed in the project and we were off on the journey.'

So Cohen makes the beats, then Cohen and Mushon write the lyrics together, and then Itai, AKA Walter, digs in his crates and finds some vintage Israeli sample to scratch in. The song that put them on the map contained a sample from an old-school Israeli track from the 70s, to which

Walter added something from an Israeli cartoon to bring out the humour. What is also interesting is that even though they rap in Hebrew, the music works overseas as the message is universal.

'We rap only in Hebrew because we feel that hip hop is all about your own language and talking on a personal level so that the only way to say something truthful is in your mother tongue. So it was only natural for us to sing in Hebrew even though most of the stuff we listen to is in English, but we wanted to make it our own. How it happened was very simple. Michael did the beats on Fruityloops (easy-to-use music software – and by the way we still work on it!) and he used to send me beats and I said to him, "You should be the MC also," and he said, "No, you should be the MC and I will be the producer." I said, "No, you have great things to say!" and so we started writing together. Our first concept for a song was "I have lost my physical fitness". It was about us being unable to run or do anything sports related. It was very important for us to put some humour in our music, because when we started out, Israeli hip hop really took itself seriously, and was very political, very heavy headed. We needed to add some of that humour we had from our heroes – Tribe Called Quest, De La Soul, The Beastie Boys – to bring back an element of fun to it. But that's not to say that we don't take it seriously. We don't do it as a joke. We take our fun seriously.'

→Turn to p196

JAMES DODD

www.james-dodd.com

Jimmy and I met by chance when we were both guest speakers at some insane street art fest in Belgium (>p82). It was a strange but interesting weekend and it was one of those meetings where it feels like you've known the person forever, which is what friendship is all about: eternity. Jimmy used to be one of the most prominent stencil artists in Australia until he gave it all up to go back to uni and study for his Masters of Visual Art. This was an astute move as now his work has all the influences of the street but with the heavy-weight conceptual backing of the art establishment.

What Jimmy does is travel the world collecting scrawls and graffiti (not the street art kind, but the underclass style – people writing band's names, expletives, insults, gangs etc). He shoots them on a digital camera, and then comes up with a concept to incorporate the image – like the time he built a facsimile of a Darwin bus shelter (which are renowned for being painted with very kitsch sunsets) and used exact copies of the collected scrawls to cover its surfaces. Thus underclass outsider art (ie art created by members of the underclasses out of frustration) becomes high art. I fucking love it.

'I've always been attracted to graffiti and to people who do things that they're not supposed to.'

Having spent years knee-deep in the Melbourne stencil scene, Jim knows better than most what he likes and, more importantly, what he doesn't:

'I've decided that most New York/train-oriented graf is very derivative. As a culture, it often doesn't support innovation and experimentation. But these are the primary things that I find exciting in all creative endeavours. That's why I find outsider graffiti so exciting, because it doesn't adhere to a set of rules and is often unpredictable.'

→Turn to p78

50

51

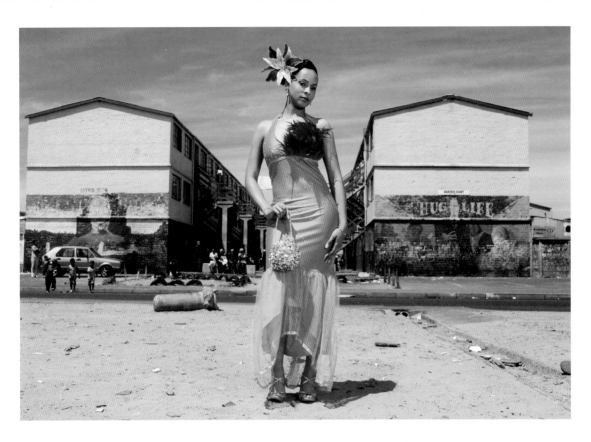

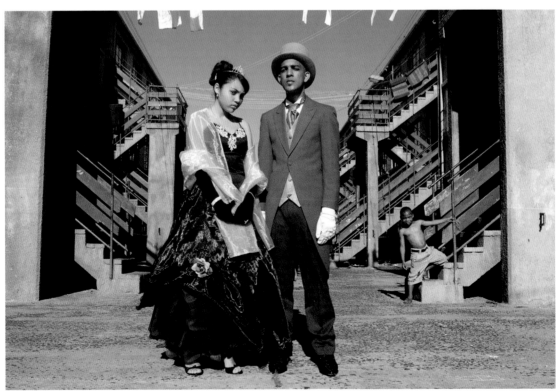

ARAMiNTA DE CLERMONT

Araminta has a great story about how she got into photography and subsequently how she shot two different sides to South African – more specifically, Cape Town – life. 'Prison gang tattoos and matric' dresses' for her first exhibition. (Matric' is short for Matriculation and is when you spend your last year at high school and graduate, like the US high school prom. Then you have a graduation party and this is when the dress comes in!) The moment I spotted her work I knew that she had something special and I had to get her in here. I'll let her tell you her story in her own words…

'I did an architecture course in England but what I really liked was shuffling around London looking at sites I was given. I really enjoyed that bit. And then I studied it at St Martins, which was quite an odd course as it hadn't really started as a course properly, it was just me and another girl. I had walked in off the street and said "Do you do a photography post-graduate?" and so they said, "No, but talk to the tutor who basically had to shoot all the fashion," and he was rather bored. So he made us a course, which was lovely. And what happened was by then I had a terrible drug habit and everything went a bit pear-shaped for years and then I came out to Cape Town for treatment and rehab. I just locked myself in the darkroom in London and used it as an excuse to do what I wanted and when I came out to South Africa I started shooting properly and also I found that I had all these ideas.

'It was because of the drug stuff that enabled me to meet the 28s and the 26s [prison gangs], really. When I came out here I had the most horrendous scars, almost disfiguring, on my face, but when I met the prison gangs, the first thing I thought was that the

tattoos were such a rich art form in their own right, and I found it so fascinating, and also interesting because of my own scars. Which were nothing compared to the branding that the gangsters get from their face tattoos. It was very healing for me to see this. I had empathy for them as I had made my face peculiar as well. But I had the best year and a half with them because they are like the most amazing men and their stories are incredible. The tattoo is a kind of way for a human being to express themself when they have had everything else taken away.

'I actually was going to do the matric' photos across the board, all the people, but I became really interested in the Cape Flats (a notorious area of Cape Town, (> p270)) where the kids there have the best dresses, the most imagination for the one night they can style on. It was quite grinding to shoot the gangsters and I was quite happy to shoot something fun. The girls were full of self-expression and really into making a statement. They all think about the dress they are gonna wear for about five years and the parents spend every penny on it and it's all focused on the one moment when they step out of their blockhouse in Mannenburg and the whole neighbourhood turns and looks at you and they all go wild. Just unbelievable…'

→ Turn to p40

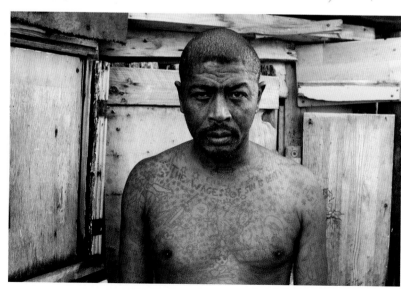

DJ CULTURE

For me, I first really understood the power of the DJ when I was in a small club (Snoopy's) in S'arenal, Majorca, in 1986. For some reason I was stood near the DJ booth and I watched him cue up a record. He began to play 'Last Night A DJ Saved My Life', not at the beginning but at the end of a 12" mix, and as this was pumping out he quickly cued up a different version of the same record then dropped that in, and with that one swift move he had created a live remix. What the fuck did he just do? I was hooked.

If you went back to 1970 in New York, the year dot for DJing, you'd find it all began with a man called David Mancuso. He started holding private parties at his loft apartment in New York that year at 647 Broadway. The first party was called Love Saves The Day. These invitation-only parties became so

weekly basis at 74 and then 99 Prince Street from 1975–1984. The Loft was inspired by Harlem rent parties of the '20s and '30s and if you were a member and had no money, David ran an IOU system so you could pay the following week. It was all about being able to be with your friends, dancing and having a good time. It was a true social experiment where all walks of life got down next to each other. This is why it was important. And then there was the sound system. David designed his own unique sound system which was his secret weapon. It wasn't about volume, it was about quality.

The Paradise Garage opened in NYC in 1976 at 84 Kings Street, the home of legendary DJ Larry Levan. Originally a parking garage, hence the name, it was largely inspired by the loft parties: no food, alcohol or beverages were on sale, and it was

You had to be a member to get in. As word spread, people would queue round the block each Friday night, hoping to be able to get in with a member, almost prostituting themselves in order to gain entry. Now that's a club. This was the birthplace of 'Garage Music'.

'The club was down some dingy backstreet by the docks. From the outside it was not what I was expecting. Nothing could have prepared me for what I was about to witness inside the club. The place was rammed. The clientele were almost all black, all male and very gay. The club was made up of numerous rooms; it was impossible to get any idea of how big the place actually was as it was so chock-full and difficult to get around. This was like no nightclub that I had ever been in before. The unseen sound system was pumping

like before. Mainly they were stripped-back extended mixes of shuddering electro tracks with soul divas' voices on top; they almost made the Giorgio Moroder records I knew sound like kids' stuff. Track after track, all seamlessly segueing into each other. Never a drop in the energy level. This was something else altogether. It was literally an ocean away from cheesy Euro disco or the soul-boy sounds that dance clubs would have been playing in the UK… On leaving the place I noticed that it was called "The Paradise Garage".'

Bill Drummond ex-KLF

Over the sea in Europe, in 1976, a club called Amnesia opened on the Balearic island of Ibiza. DJ Alfredo Fiorito took over as resident DJ Amnesia in 1984 and changed the face of DJing. Turn to p122

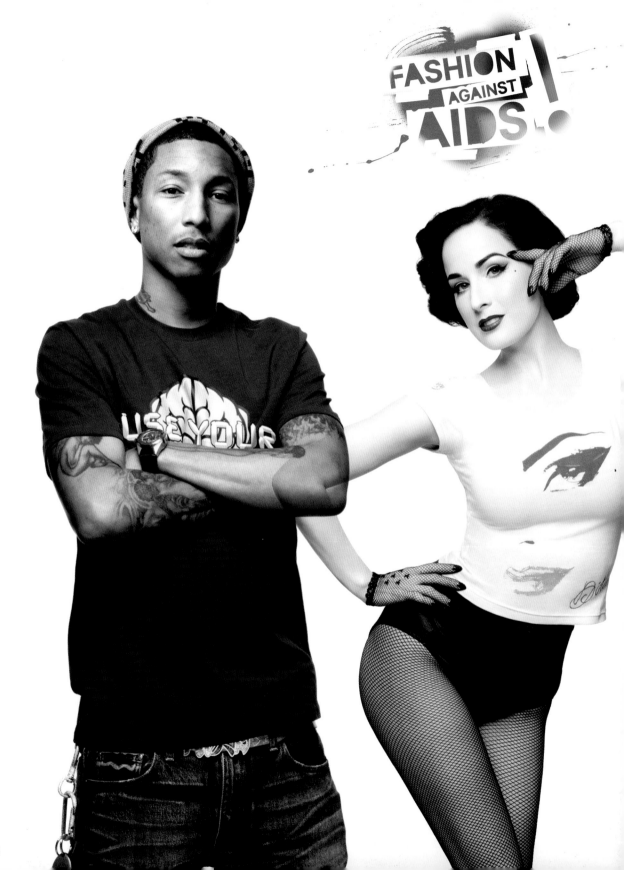

DESIGNERS AGAINST AIDS

www.designersagainstaids.com

Designers Against Aids came to life in 2004 after long-time fashion journalist, Ninette Murk, and a photographer and music journalist, Javier Barcala, joined forces. Their idea was to build different campaigns that would utilize their serious network of friends (artists, fashion designers, musicians, celebrities) to create different messages of HIV/ AIDS awareness using their talent and vehicles of expression. Starting from fashion collections, they've also organized conferences, been involved in music festivals, created video-clips, photographs and moreover, two worldwide campaigns with giant retailer H&M that reached more than 30 countries. DAA have worked with Estelle, Katy Perry, Yoko Ono, Cyndi Lauper, N.E.R.D., Moby, Tokio Hotel, Robyn and Dangerous Muse.

DAA is now training students to start campaigns in regions with dramatic rates of infections (such as China, India, Russia, Ukraine, East Asia and South Africa) through courses at their International HIV/ AIDS Awareness Education Center in Antwerp. They're also looking into possible collaborations with sports celebrities, because they have the power to connect with the youth as much as musicians do and are very great role models.

'Our goal was always to create messages that would keep the youth interested in AIDS awareness and wouldn't make them look somewhere else or lose interest.'

Javier Barcala

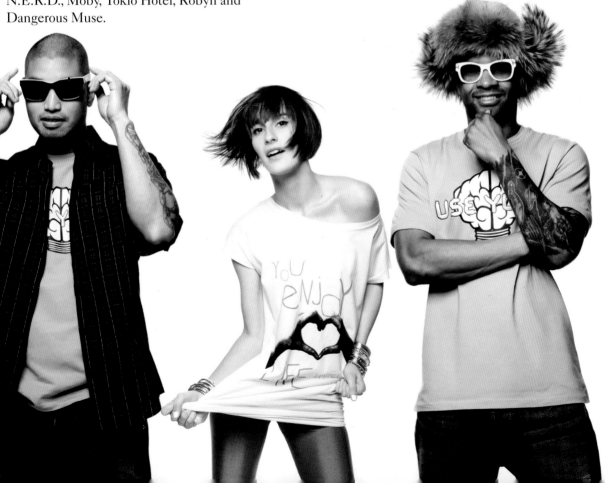

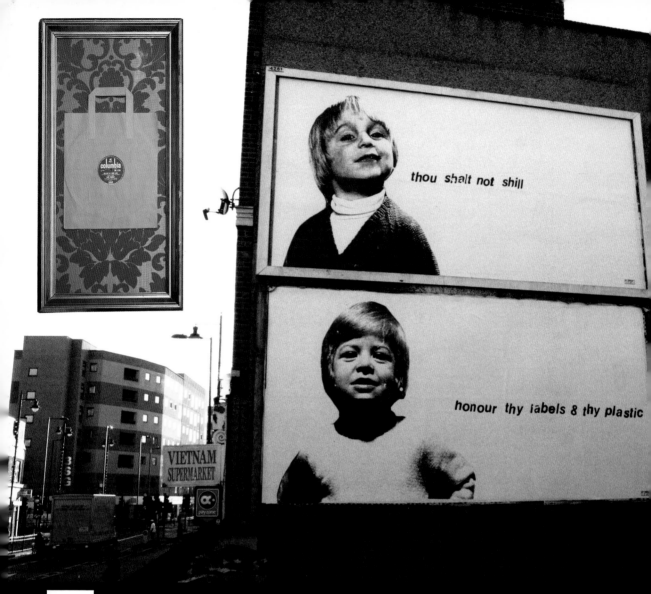

On the billboards:

thou shalt not shill

honour thy labels & thy plastic

DR D.

www.drd.nu

dr.d is a street artist who specializes in billboard hijacking, which is one of my favourite mediums. Billboards are there to be fucked with (> Culture Jamming p40) and the good doctor does just that. dr.d's work is a take on life:

'It'll either be funny or political, I think the most effective political stuff will have an element of humour that makes it work better.'

He started off just cutting bits from one billboard to stick on another, which was generally just funny or stupid, but...

'After a while you find that it's really limiting as to what you'll end up with, as all you can work with is what the advertisers throw you. Now as well as being technically different (ie I'll use stencils over posters and even do small scale collage that I then print up billboard size), I suppose my work now has more of a point politically or socially.'

I was introduced to Dot's work when I was cruising the streets of LA (>p156) and 'Day & Night' (the tune he wrote & produced fwith Kid Cudi) was on heavy rotation on every urban radio station. I tracked him down and we hooked up at his brand new studio in Brooklyn.

'I've been doing music pretty much my whole life. I went to music school from seven to like fifteen and from then till now I've been playing the piano. When I first got to college my roommate did electro/techno music and he gave me my first beat program to make beats on, called Fruityloops – a cracked version. That's when I first started making beats. I just kept making beats and working with anyone who wanted to work with me, as I was just starting. My A&R first worked with Cudi when he first came to New York and he linked us and we made music for two years straight and then the song just took off.

'I've been influenced by artists from Lily Allen to Rick Ross. I was influenced in the beginning by the Neptunes, Timbaland, Swizz Beatz – the staples: the blueprint as everyone wants to attain that kind of success. All these producers influenced me to do my own thing. You have to jump from one genre to another. A lot of people make the mistake of staying in one lane.'

→Turn to p192

E

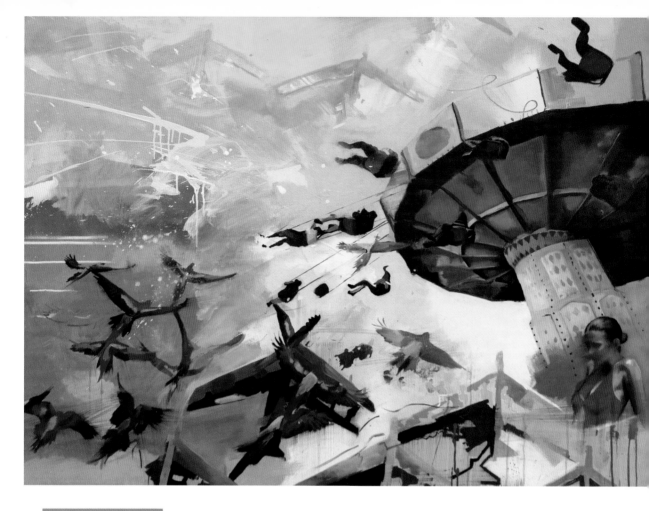

CHLOE EARLY

www.chloeearly.com

Chloe's work will stop you in your tracks and make you look closer. This is what it's all about. Her work is simply amazing and unites street influences with fine art sensibilities to create something unique. She grew up in Cork, Ireland, just outside the city.

'It was beautiful in a mossy, green moist kind of way. We had a lot of space, we climbed trees, nature was close. The city was big enough to have great gigs, bars, clubs, and discovering all that as a teenager seemed like an Aladdin's Cave

of new delights. I think with painting there is always two strands to the work. Painting is an all-encompassing absorbing task, the process becomes the reward.

'I think a lot about colour, mark making, movement, composition, form; these are the bricks out of which a painting is built. For the viewer the first thing they often relate to is the imagery. Previously, landscape was my primary subject but my emphasis has now switched to the figure. Oil painting and the figure seem to belong to each other and I take a lot of pleasure

in painting flesh. But mostly my paintings are about the combinations of imagery I use, unexpected pairings and trying to create a narrative and then drown it out again in paint. It's a tug of war.

'When I go to Italy I love seeing extended families walking together in the evenings, talking to the neighbours. I'm sure it's got a lot to do with the weather but also sadly I think here in the UK the streets are becoming homogenized as the same chains dominate high streets up and down the country, and even from borough to borough in London, it's all starting to look

the same. Perhaps, though, the same things I despair of are one of the reasons why street art and skateboarding have taken off so much in the west, as some kind of territorial way of reclaiming ownership and leaving a mark or belonging to our surroundings.

'When I think of street culture I think of other countries. Where I live in London there is large African and Turkish communities, the Turks stand outside their barbers, bakeries and flower shops talking late into the night.'

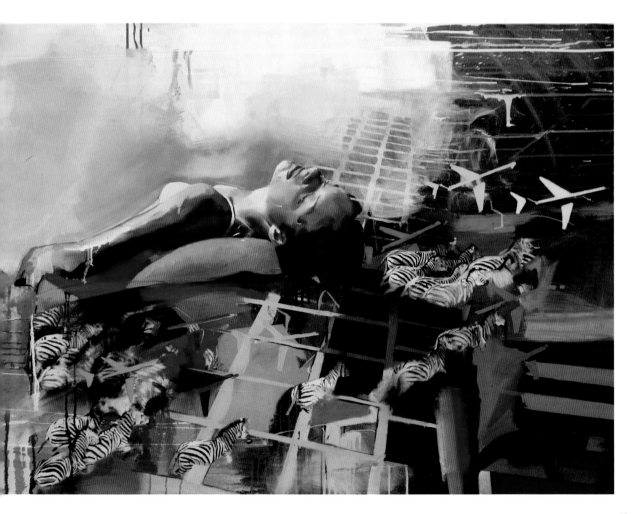

EELUS

http://eelus.com

Eelus is a killer artist who was born in Wigan and has always been fascinated by the darker, weirder side of life. He creates his art on and off the streets, using stencils, spray paint and by hand.

'Ever since I can remember these are the themes that I've worked with just because that's what's always in my head. Even when I was very young I remember we'd have to draw some kind of dinosaur scene at school, but my dinosaurs would be being ridden around by other-worldly monsters, hunting and eating people. There would be utter carnage on the paper, the kind of shit you see being drawn by disturbed kids in horror films. Then when I was about ten I found a pirate video in the house that my mum had borrowed from someone at work, *The Exorcist* and *The Texas Chainsaw Massacre*, back to back. So there I was, sat crosslegged on the floor in the dark at around 2 am with headphones on and watched both films one after the other. And so began my love of the dark.'

He moved to London where his amazing work caught the eye of everyone who likes art. He does his own thing and this sets him apart.

'Like I said earlier, I haven't grown up being part of a graffiti crew and I've only ever stepped on a skateboard once in my life, the fucking thing nearly killed me. I know a lot of artists/writers have a chip on their shoulder about other artists who haven't grown up "on the street", but fuck that. I'm not trying to prove anything to anybody but myself and I'm certainly not apologetic for never running around a train yard at 4 am with a skateboard under one arm. To me, street culture is about people and the environment they call home. It's everything from the yoot on the back of the bus with their shit music pumping from their mobile phones to the Turkish ladies making bread in their shop windows down the Kingsland Road.

'There is no right and wrong with street culture, there's just people of all walks of life living every day the only way they know how, in the clothes they choose to wear, listening to the music they like, doing the things they like to do. I've recently moved to Hastings and the street culture there is similar to that of east London, where I've just moved from. There's quite a young and alternative crowd wearing interesting gear and sweet tattoos, I love it. On the other hand there's weathered old fishermen with little dogs everywhere drinking by themselves in the quiet local pubs; both are equally as fascinating to me and that to me is street culture.'

His work has steadily evolved into something special.

'When I first started I used to make small stencils of weird scratchy characters that filled my sketchbooks. From there I practised more and more and got my head around the stencilling process then along came my Shat-at piece which is what really drop-kicked me into the scene properly. From there I did a series of *Star Wars* themed pieces, a trilogy to go with the original films. These went down well and I was lucky enough to work with Pictures On Walls in making the images into screen prints and get them out to people who wanted them.'

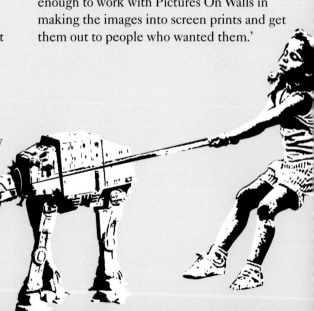

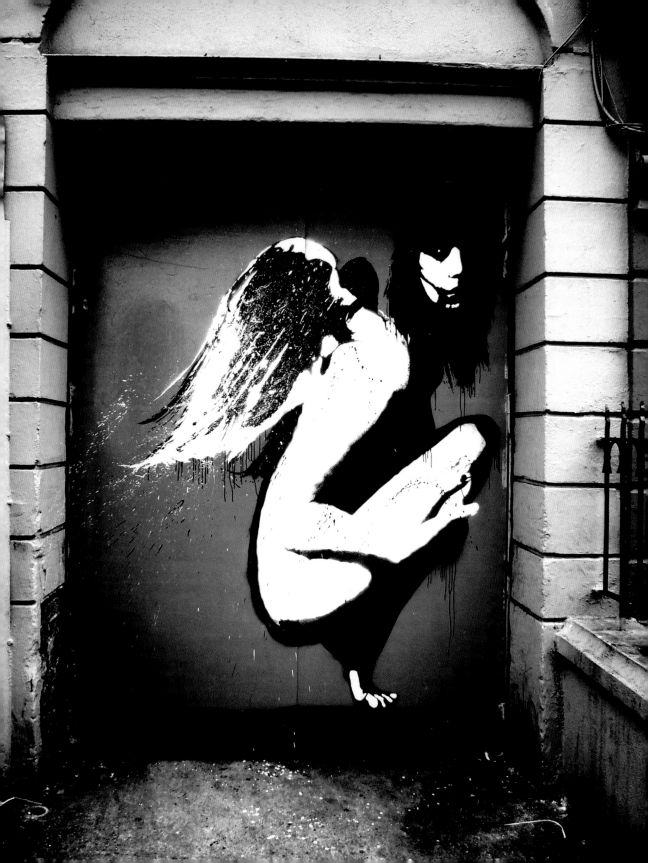

RON ENGLiSH

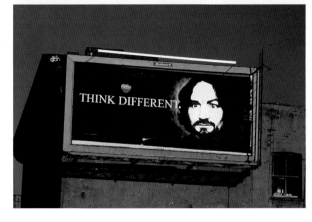

www.popaganda.com

Ron is America's most prolific street/pop artist working today, expressing himself through his amazing work both on and off the streets. In 1981 he blew up through his billboard take-overs, subvertising in Dallas, Texas, which, quite rightly, took pot-shots at global brands and their heavy use of advertising. He chose billboards because 'everyone sees them'. He is one of the founding members of the Culture Jamming movement (>p40) and he questions the ethics of companies such as Apple, McDonald's, Camel tobacco and Disney through clever re-interpretation of adverts. Back inna day he hand painted the subverts and then pasted them up on billboards; today he uses a large-format printer. But the message is still as sharp and the art as spot-on as it ever was.

He was caught liberating billboards in 1984 and would have served some serious jail time, but Ron managed to convince the billboard owners that it was just art, and escaped with a fine of $100 for each defaced billboard. During the 2008 US Presidential Election, he craftily combined the features of Abraham Lincoln and Barack Obama for 'Abraham Obama', which was a massively popular image and the star of the film *Abraham Obama*.

<u>I asked him to define what his art is all about.</u>
'It's a subconscious REM state; a relationship to post modern culture.'

<u>How has your art evolved?</u>
'I'm not sure it is evolving but it's always changing.'

<u>Where did you grow up? What was it like?</u>
'Illinois. Lots of factories, cornfields and boxcars. Not a lot of art.'

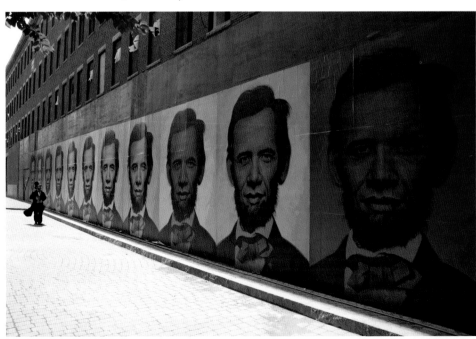

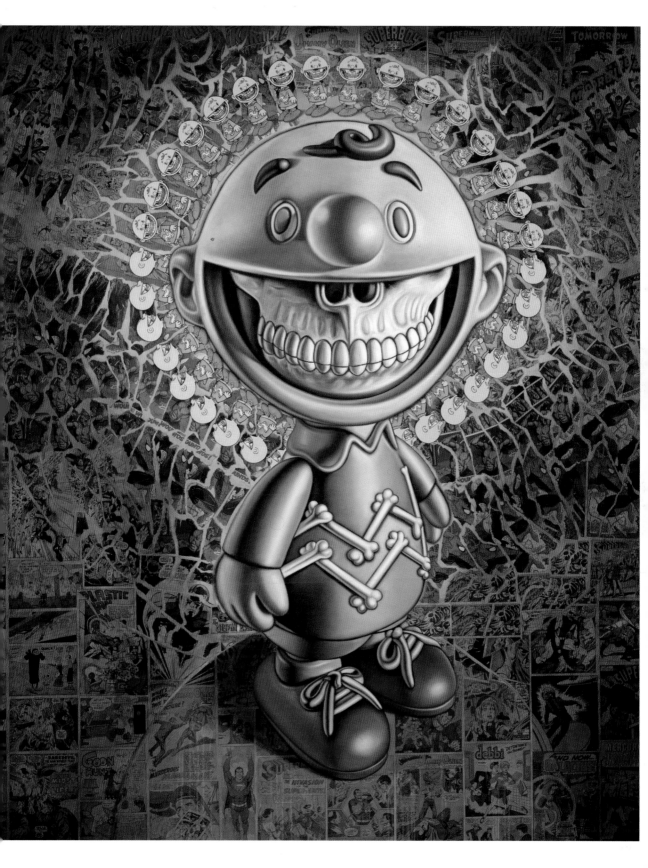

ENDTRODUCING: THE ART OF THE SAMPLE

I first discovered the art of the sample when my mate taped me the album *Tenants of the Lattice-Work* by a band called Mainframe, a synth duo connected to the two geeks who had developed one of the first samplers called a Greengate DS3. The album really blew me away and the DS3 was later used by the KLF a few years later (>p142) on *1987 (What the Fuck Is Going On?)*. But due to manufacturing problems the DS3 never really sold many and went the way of the dodo.

After the golden years of hip hop defined modern music production as using other people's music, the art of the sample was pushed forwards by the creation of the MPC60 by Roger Lin for Akai. Originally designed as a drum machine, producers and DJs discovered that if you installed the maximum RAM (1.5MB) it could be used to play and loop samples on top of the drum sounds, and a whole track could be created. The urban producer, most often working out of home studios or bedrooms, universally adopted this piece of affordable kit and the tunes went worldwide. The machine was developed and the classic was the MPC2000.

Here is my all-time top 5 albums that defined the art of the sample:

THE BEASTIE BOYS – PAUL'S BOUTIQUE (1989)

The Beasties stumbled onto an instrumental mixtape by the DJ/producers The Dust Brothers after moving to LA in 1988, and they knew where they had to take their sophomore album. One hundred and five samples (most never cleared) utilizing a whole lot of funk, rock, country and almost every other musical genre, to create one of the finest and most progressive hip hop albums ever.

MASSIVE ATTACK – BLUE LINES (1992)

Coming out of the Wild Bunch, a legendary Bristol sound system comprising of members DJ Milo, Willy Wee, Nelly Hooper, Tricky, Mushroom, Daddy G and 3D. Mushroom, Daddy G and 3D branched off to work as Massive Attack and hooked up with producer Cameron McVey and Neneh Cherry, who helped them to record their first LP, *Blue Lines*, which defined the sound of Bristol and was the beginning of trip hop.

DJ CAM – UNDERGROUND VIBES (1994)

In Paris DJ Cam was working away in his home studio with partner Smooth 1, sampling jazz and films scores to create a genre of beats referred to as 'abstract hip hop.' He dropped *Underground Vibes* and changed the game.

'I started buying records when I was seven-years-old,' he says now. 'My parents were shocked 'cos I was really young and I'd say, "Yeah, I really want to buy some records". I was a music addict since I was very, very young, and when everybody else was learning piano, trumpet, drums, I'd say, "I want to be a DJ" because scratching was fresh and new. I started to DJ around fifteen, professionally at eighteen when I started to organize parties and then I got some ideas: I wanted to make some music so I buy my first sampler (an Akai S950) and start making beats.'

DJ Shadow in his studio, photograph by Raph Rashid

DJ SHADOW – ENDTRODUCiNG (1996)

A defining record in musical history. This took the art of the sample and the whole idea of how music is created and sent it off in a totally new direction. Listening to this record and the works of Shadow was a totally life-changing experience for me. I cannot convey to you how important this man is.

'This is my little nirvana. Being a DJ, I take the art of [crate] digging (spending hours looking through the racks of vinyl in a record shop) seriously, and this is a place I've been going for eleven years. It's an incredible archive of music culture, and there's the promise in these stacks of finding something that you're going to use.'

THE AVALANCHES – SiNCE i LEFT YOU (2000)

A classic album created from nearly 4000 samples. Coming straight outta Melbourne, the Avalanches came through with a completely different approach and sound, and that was what made them. An album you could dance to from start to finish, or just light up and immerse yourself in without lifting a finger; it worked both ways and I still nod out to it today!

→ Turn to p154

F

JOHN FEKNER

www.johnfekner.com

John Fekner is a total street art pioneer. He grew up in Sunnyside, next to Long Island City, a ten-minute train ride to Manhattan. His first outdoor work was in 1968 when he painted the words 'Itchycoo Park' in large white letters across the front of an empty brick park house in a Queens playground. 'It was huge and everybody saw it from the streets. I painted it on the top of the building the way I did Last Hope years later in the Bronx.'

In the sixties, there was very little graffiti; the only things on walls at that time were gang names, lovers' names, hearts and daggers, top hats, skeletons. Everything was crude at its best, like the writing on a toilet wall or bus stop.

'In 1976 I returned to working outdoors, using cardboard, stencils and spray paint around New York. In 1978, I organized the Detective Show in the same park with about thirty artists including Gordon Matta-Clark, Don Leicht and others.

'In 1979 I was invited to Sweden and did stencils and had two books published. The size of my stencils kept getting bigger. Growing. I sprayed "Wheels Over Indian Trails" at the entrance to the Queens Midtown Tunnel approach to NYC. It stayed there for eleven years. Nobody ever touched or graffitied over it which was pretty amazing.'

→ Turn to p212

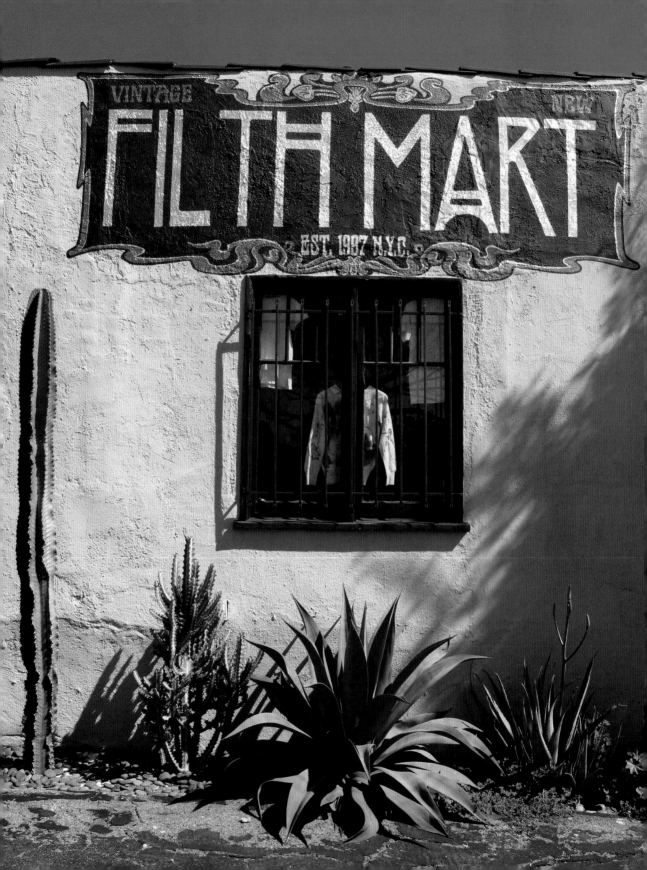

FiLTH MART

www.filthmart.net
1038 N Fairfax Ave, West Hollywood, LA

One summer I became friends with a guy called Blue who ran a stall of vintage clothing at the Orchard Street Sunday market, in the Lower East Side of Manhattan. It turned out that Blue had a small retail space in a shop called Filth Mart on 13th Street in between Avenues A and B. I spent a blissful summer hanging out with Mike (the owner of Filth Mart) and Blue. It was a fantastic time sitting around in the sun smoking chronic and letting the world drift past (and sometimes into the shop). Filth Mart sells the best, classically unique and authentic vintage clothing on the planet. I caught up with Mike in LA.

'We opened Filth Mart simply to create a style. Vintage stores, prior to our opening, typically offered cheap options for existing "fashion" or costumes. Filth Mart is a homage to the counter culture, and the many styles that stem from those movements. The shop has become more select and focused on the rarity and design of specific pieces, which has led to more styling and wardrobe design.'

Filth Mart was open in New York from 1997 to 2005, then it moved to LA.

'We moved to the west coast to catch some of the famous sunshine, "air out", if you will. New York, at the time we left, seemed to be losing some of that independent spirit… the ability to live with minimal hassle and find one's way, survive and look good doing it, was just becoming less worth it. All the little mom and pop shops were turning into the third and fourth Starbucks in a three-block radius. So we moved to the land of franchises. I love California, but definitely miss that town.'

'My influences? Art, music, books, various intoxicants...and ass!'

FAMIGILA BAGLIONE

FB is a collective of artists from São Paulo, Brazil, comprising of: Herbert Baglione, Walter 'Tinho' Nomura, Flavio Samelo, Felipe 'Flip' Yung, Alexandre 'Sesper' Cruz and Thais Beltrame. They work on and off the streets of the world.

Herbert Baglione: 'I grew up in a neighborhood on the east side of São Paulo, considered the poorest and most violent of the city. I've always been around crimes and some type of violence, and at the same time street soccer and kites. I've always been more of an observer than participant. I believe somehow I was developing my critical side, from what I'd lived but didn't feel part of anymore. In the last years I have been traveling to different countries and observed more rather than talking. '

Walter 'Tinho' Nomura: 'My work is about living in big cities, their social lives and their personal struggles. My work had evolved in different ways through the years, from old school graffiti to site specific installations and performances going into the cities and inside art galleries and art institutions.'

Flavio Samelo: 'I want to bring back the Brazilian concrete art using the modern cosmopolitan view of the streets. I spent more than twelve years shooting photos of skateboarding on the streets of Brazil, our culture and our reality. In 2004 I decided to put my photos into another application. As I always drew and heard a lot about painting and brushes from my graffiti artist friends, it was quite natural that I discovered a new way to use my photos.'

Felipe 'Flip' Yung: 'My work is about feelings, turned into natural shapes creating a metaphor for the symbiotic relationship between human feelings and nature. I've been studying botanics, camouflage, patterns and fetish, and all this mixed together with my art skills becomes my work. Street culture is a culture based on street knowledge. Every place has got their own, since they have streets all over the cities. The most important is that they're all based on respect.'

Alexandre 'Sesper' Cruz: 'I'm very influenced by skate stuff – hardcore crews like early 80s stuff from places like DC, NY, UK. I like symbols a lot and mix all that crap.'

Thais Beltrame: 'My work is about conjuring up memories and feelings from childhood, and bringing forth images from dreams and the unconscious. I'd like to think I'm always telling stories through these drawings, and that I always work from the inside out. I used to draw ever since I was a small child and have always felt comfortable with black and white – and negative spaces. I don't see much of a difference between what I used to do when I was little and right now, since I've always worked from imagination.'

→Turn to p16

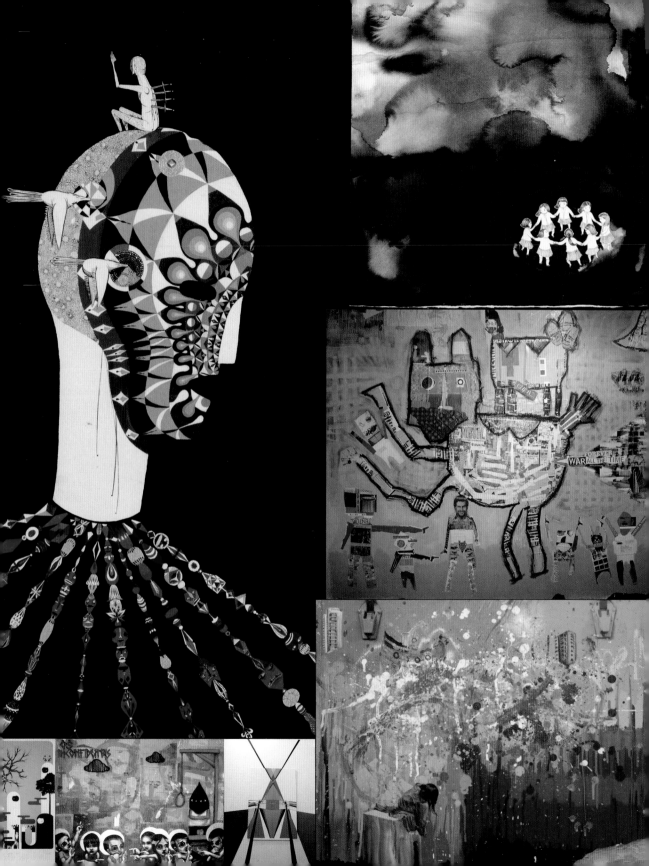

I'm from film stock! My family are old-school cinema. My grandad won an Oscar back inna day, my uncle is a Hollywood director, and my dad, Bella Granny and two aunts are all film editors, so the film industry is a major influence on me. I have worked as a director, producer and editor on over 30 short films, commercials, music videos and documentaries, so the films I'm talking about here are not only films about street culture, but films that have had an influence on my work as well as street culture. Outside of the actual making of films, cinema today has some great stuff happening, such as the Secret Cinema events hosted in disused railway tunnels and other film-specific locations.

AMERICAN HISTORY X (TONY KAYE, 1998)

One of the greatest films of all time that examines the difficult subject of racism in America, specifically Los Angeles in the 1990s. Created by legendary English director Tony Kaye (>p138) who had to fight his own battles with the Hollywood system when he was making the film.

STYLE WARS (HENRY CHALFANT, TONY SILVER, 1982)

Originally made for PSB (Public Service Broadcast) TV in 1982, Style Wars has become the definitive film about hip hop (graffiti, breaking, DJing and MCing) as it captured a historic time of pure creation in 1980s New York. It is still revered today, especially since *Style Wars 2* was released with deleted footage (Dr Revolt in the house!) and hours of footage of bombed trains.

PUBLIC DISCOURSE (BRAD DOWNEY, QUENELL JONES, TIM HANSBERRY, 2003)

The only recent film worth watching about street art – a great journey through the NY underground at the beginning of the twenty-first century. One of the film's directors – Brad Downey – went on to become one of the most prolific and original street artists (>p48).

BIGGIE & TUPAC (NICK BROOMFIELD 2002)

Documentaries just don't get any better than this. Mr Broomfield gets down with the hip hop community to solve the mysteries of who killed rap superstars the Notorious B.I.G. (>p100) and his former friend and rival Tupac Shakur. An amazing journey through the urban American landscape and the well-murky world of hip hop, and, yes, he comes up with an answer!

DEKALOG (KRYSZTOF KIESLOWSKI, 1989)

The greatest TV series ever produced. This is an understatement. This is the only time TV has had an influence on anything, and the series came out of Poland. Basically it is the ten commandments set in a 1980s housing estate in a country on the cusp of change: the end of Communism, and the beginning of a new life for the inhabitants, for better or for worse.

GOMORRAH (MATTEO GARRONE, 2008)

The best film to come out of Italy since Fellini stopped dropping bombs. An amazing film about the Camorra that fools you into thinking that it's a documentary.

ZOO YORK MIXTAPE (RB/OCULAR, 1997)

The only skate/hip hop mixtape worth watching. This VHS is the best look at the East Coast skating and rap scene in the 1990s and has had the fuck copied outta it ever since. The freshest NYC street skating mixed with exclusive freestyles from rappers such as Fat Joe, The Wu, Buster Rhymes, all before they were big names. The zenith is Harold Hunter (RIP) ripping the shit outta NY streets backed by a killer Method Man and Ghostface Killah track. Check the pager messages!

→ Turn to p14

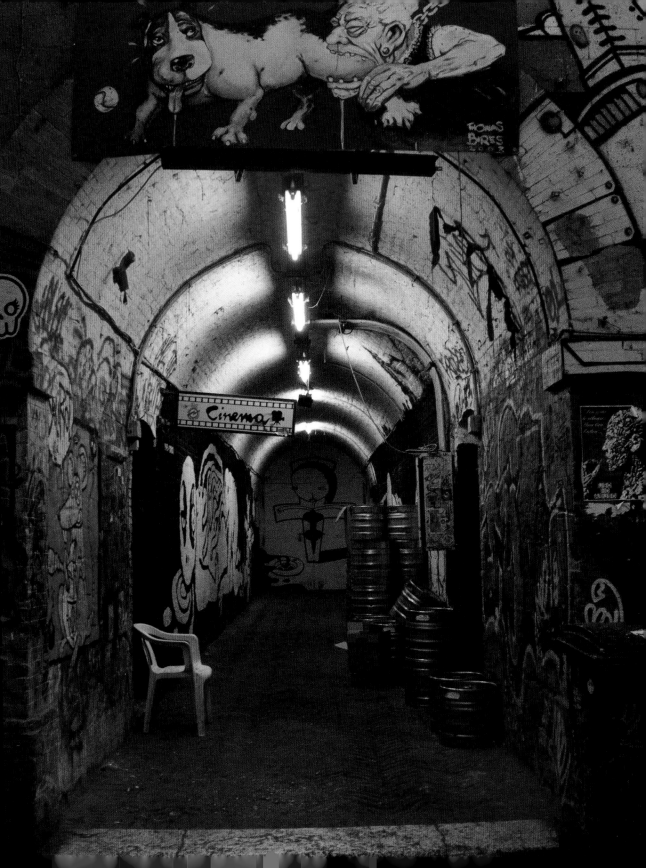

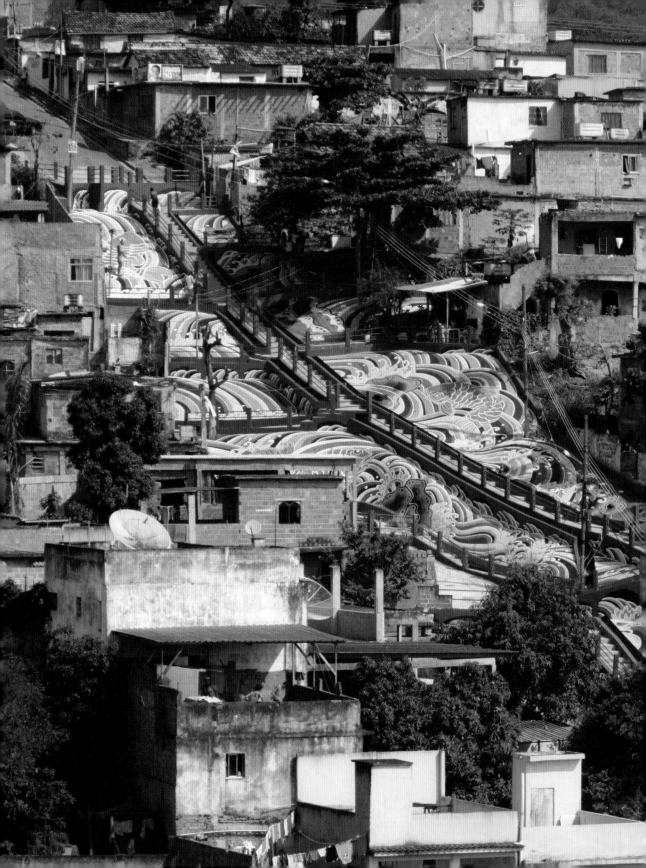

The Favela Painting Project is the labour of love of two guys from Holland, Dre Urhahn and Jeroen Koolhaas (Haas & Haan). The project came about while they were shooting a documentary in the slums of São Paulo and Rio.

'We felt we were "taking" something and thought about what we could actually "leave behind". The idea was simple: as everybody outside is always talking shit about the slum-clad hills, what if you would just put something really simple and beautiful on them. You'd take away that little initial start of the whole cycle of social exclusion and maybe could help spark a fresh thought about the situation of these parts of the city.'

They took that idea home to Holland and began speaking to people about the project and the enthusiasm it had sparked. They talked the talk and soon bought tickets back to Rio to start looking for a place to paint.

'We felt that the favelas were misrepresented, misunderstood and neglected as legitimate parts of the city. Of course, there are many problems of the city. Of course, there are many problems in the favela, such as education, healthcare and the ongoing war between the drug gangs and the police. We feel that at the same time there is so much talent, creativity and ambition present in these areas. We came up with favela painting as a plan to help improve the reputation of these areas and their people.'

The first painting was meant to be a kind of sketch or test, rather than a life-changing piece of art. The 150m² painting depicting a kid playing with a kite – the favela dwellers' favourite pastime – got huge respect from both inside and outside the slum and even made it into the pages of the *Guardian*. This was the indication that Haas & Haan were on the right track.

'We have completed two large paintings in Vila Cruzeiro. During that time we started making T-shirts with "Vila Cruzeiro pela Paz" [Vila Cruzeiro for Peace]. These shirts became really popular and we realized that through the massive media coverage we received we were actually doing a sort of marketing or advertising for people from the favela who are misunderstood by the rest of the city and the media.'

→ Turn to p76

FESTIVALS

Undoubtedly one of the biggest social events of the last twenty-five years has to be the festival. Music, art, film, whatever: a weekend of smoking, drinking, imbibing whatever, chasing the opposite (or same) sex in between (or during) watching and listening to your favourite band, DJ, musician, director or artist doing his or her thing. It's a great idea to take a venue (out of season holiday camps are good, as are places on the Med.) and then fill it with like-minded people and bring the most diverse, original talent you can book.

With regards to music festivals, I'm not talking about your usual, boring dinosaur events which I wouldn't be seen dead at, but the interesting and vibrant smaller 'boutique' festivals such as All Tomorrow's Parties or Standon Calling in the UK, or some of the European festivals such as Roskilde in Denmark or Exit Festival, Serbia, which are all really good examples of how to put on a festival.

There are many Street Art festivals such as Names Fest in Prague, FAME in Grottaglie, Italy, and Nuart in Stavanger Norway. There are tons of smaller, more underground events but these are the ones worth checking, as they always pull in the best names in art.

The FAME festival is great because it encourages the artists to work in disciplines in which they might not usually work. Like ceramics. It is legendary for the food prepared by Gilda, the mum of Angelo who runs the festival. The Names Fest in the Czech Republic has come from nowhere and is developing into one of the most interesting festivals in Europe. MC Honza is the man behind the festival.

'I had the idea for Names Fest for a couple of years on my mind, but the right time came last year. I always wanted to invite all the people who I respect to my town and let them leave their marks here. Names was very lucky. When we set up the team, we had just space and enthusiasm. In one year we realized what we were dreaming about in the beginning. The idea of a festival is cool for the artists. You can meet some old friends from other parts of the world. It is also interesting for the public. But maybe it is just one epoch. The artists are getting older and maybe need more attention for themselves. So maybe it is more interesting to do focused exhibitions, but let's say 80 per cent of Names was legal.'

HOT SPOTS

www.atpfestival.com
www.famefestival.it
http://namesfest.net
www.nuart.no
www.roskilde-festival.dk
www.exitfest.org
www.coachella.com
www.thegardenfestival.eu

→Turn to p312

'G' is one of the great original talents to come out of Paris. He creates trompe-l'oeil (street scenes-within-street-scenes) on the streets of Paris to great effect. His work is very French and fresh as fuck. All the work shown here is 100 per cent illegal.

'My nickname for my illegal activities in the streets is the letter G. First I was a photographer and I found a way to show my work in the streets through a large-scale technical print, very huge like pasting one photo on a billboard – which was the first thing I did seven years ago. And then it opened a sort of underground way to show a photo in the street with a very low-tech tool: a printer used by architects to make plans.

'I'm trying to illustrate my meaning; the way I think about the society and the life and how all the things are going wrong. I'm trying to illustrate it with my eye – taking photographs – and after with playing with the reality by pasting some black and white posters in streets. It's a bit like an underground advertising campaign to show people that we could have an underground and an alternative way of life with respect and love for mother earth and other humans, and not with money and the success as our only goals.'

KATE GiBB

kategibb.blogspot.com

Kate is an artist who expresses herself through silkscreen printing and creates some amazing art as a result.

'I'm not sure my work is about one thing in particular, but it has evolved from my continual exploration of the silkscreen technique. And still does. My background in printed textiles gave me an inherent love of colour and pattern which provides the basis for my work.'

She has created cover art for The Chemical Brothers, Simian, Bob Marley, Suede, My Computer and The Magic Numbers and it seems natural that music brings out the best in her art. This is something that I am always interested in: how one art form stimulates another. It's inspirational and influential.

'My influences continually vary, but I hope become broader as I get older. Things I may stumble across or see on my way to my studio, people, places all inspire me. I like to explore

museums and galleries, mooch around shops and markets, and I attempt to read random papers and magazines. Walking my dog, Ruby, provides plenty of time to mentally explore new ideas, giving them a test run as such. Currently I'd like to produce and see my work move into three dimensions. I'm growing tired of flat pieces of paper. Recently I've become a little obsessed with pottery. Having attempted my own at a local class, I think this may be limited to merely buying it!'

Collaboration is really important and even though she has worked with some killer names, there is always someone else out there who would be good to work with.

'So many people spring to mind… some are deceased so could be problematic! There are lots of cool new illustrators and designers I'm fond of: My name is Melvin, Kim Hiorthoy, Non-Format, Rick Myers, Garrick Palmer to name a few.'

GRAFFITI RESEARCH LAB

www.graffitiresearchlab.com

There are people who do graffiti (tagging, bombing and painting using a spray can, for no other reason than getting your name out there), peeps that create street art (creating art on the streets using stencils, paste-ups, painting by hand and using a spray can), and then there is the Graffiti Research Lab. The GRL was founded by Evan Roth and James Powderly when they both worked at Eyebeam Open Lab, a cross between an art residency and an research lab. The GRL mission statement:

> The Graffiti Research Lab is dedicated to outfitting graffiti writers, pranksters, artists and protestors with open source tools for urban communication.

The GRL has become the primary instigator of an international art movement, from writing on skyscrapers with lasers, ripping holes in the advertising industry with homemade tools, getting in trouble with the Department of Homeland Security and simply making activism fun again. The GRL promote free speech in public, open sources in pop culture, the hacker spirit in graffiti and the idea of not asking for permission in general. This is what it's all about, in the words of James.

> 'We were interested in technology in public spaces and seeing people interact. We passed around links of our work to each other and I saw some of Evan's Graffiti Analysis Project and I was struck by the fact that they were documentations and through the use of cool music and video work had some life afterwards on the Internet. I had made some videos and they weren't really working out and people weren't looking at them; when I saw his I was like "Oh, you just have to have a hip hop track!"'

They have taken graffiti to another level with the development of the laser tag, a piece of technology

that allows the user to project – broadcast – their graffiti onto the sides of buildings large scale and in your face massive.

> 'We kept coming back to spray paint as a technology that is extremely empowering, and with things like [LED] Throwies and Laser Tag people can actually do this and communicate on a scale that is larger than what they had before. Not just people who are writing big letters on trains with spray cans but also protestors and activists who are doing things in public and this hacktivist culture that we had seen growing, who were combining technology and public space with agendas: they were hacking urban spaces to talk about whatever was important to them. 9/11 forced everyone to start thinking differently about their city.'

After the advertising industry began to adopt all the rules of graffiti artists (using every available piece of public space to sell their products) it became a war and the GRL were like, let's take a side in this war:

> 'Instead of working with advertisers like so many graffiti crews do, if we all worked against those advertisers we could probably diminish our chances of getting in trouble 'cos people do give a fuck if you write on an ad, but also we could really do something to cut down on that one crew that is really all-city now which is the fucking advertisers – guerrilla and legal – and it's a shame that in the city that birthed graffiti, this is who's up the most.'

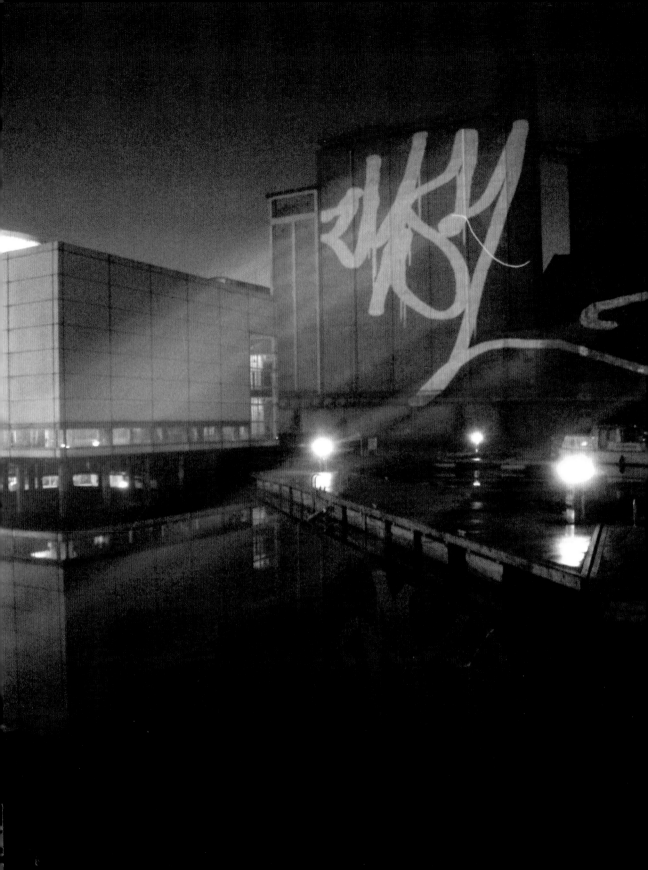

It all began as a joke. During World War II, someone from the United States Air Force drew faces on bombs that were going to be dropped on the enemy. Then a soldier from the US Army drew the same face on walls across the UK accompanied by the words 'Kilroy was here'. Back across the pond twenty or so years later, a guy called Cornbread in Philly tagged the Jackson 5 jet, a police car and an elephant (both replicated later by Banksy). This inspired some live-wire New Yorker messenger called Julio to write his name and Street (204) number all over the city (all-city) which in turn prompted Taki 183 to get up and do the same. Then hip hop happened (>p100) and the NYC art world was momentarily hypnotised by the freshness of graffiti when many galleries (such as the Fun Gallery) of NYC held shows of work by the old school masters such as Futura 2000, Seen, Quik, Dr Revolt and Zephyr.

Note: The fundamental difference between graffiti and street art is that graffiti was/is primarily about getting your name up in as many places as possible, and that street art is about creating art in the streets.

'Futura was a great motivator, and along with Zephyr, Bill Rock and Ali, found a store front on Amsterdam Avenue. They called it the Soul Artists Club and every Monday night we'd bring in the work we'd created during the week. Many of us had jobs or were in university, and come Monday night, Basquiat, Haring, Kenny Scharf, Patty Astor from the Fun Gallery, Stephan Einst from the south Bronx, would be there. So after a year the workshop had a shit load of work, things were happening.

Futura started putting our work in nightclubs like The Peppermint Lounge, and then he did a really cool show with Fred [Fab 5 Freddy] at the Mudd Club. What was really cool is that when you'd go to these type of shows and hang out with guys like the Clash, Wendy O. Williams from the Plasmatics, Afrika Bambaataa, The B-52s, Talking Heads, New York becomes a very small town and so you go to the pub and your art is on the wall and you turn around and these guys are your audience.' Quik

Even though it blew up in the downtown NYC scene, graffiti never really was accepted by the art world, and by 1985 it had slipped back into the undercurrent of the sub-culture. This could have been because the roots of the art form had stayed in the underground and stayed true. The bottom line was that most graffiti on canvases just didn't work, as something is indelibly lost when you take the art out of the street or off the train and put it on something a lot smaller and then show it in a totally different environment. During the late 1980s graffiti and street art split from each other, the former 'keeping it real' and the other becoming one of the fastest and most popular art movements ever, before imploding in the year 2008, under a shower of money and – worst of all – hype.

Rewinding a bit, a defining point, perhaps the year dot of the street art movement, is a moment in 1963

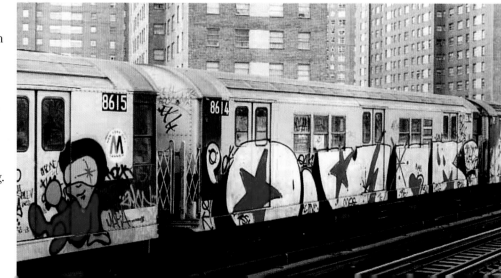

on the streets of Paris (not America as you may imagine). One of the first artists to use a spray can as a brush and a city wall as a canvas was Gerard Zlotykamien, a Polish Jew who fled to France to escape the Nazis during the World War II. He began to paint Les 'Ephémères – the same painting over and over again of a figure and its reaction to the Holocaust. He still paints the same image today, and refuses to have anything to do with the street art movement.

'Actually, to make graffiti in the urban space at this time in the beginning of the 60s was a way to say things while it was forbidden to say something,' he says. 'People realize the message of the artist when it's too late. When cars are burning and when the youths are fighting in the streets with the police. It is only then that the people get what the artist was saying all along, and that the artist had seen it all coming.'

One person who was heavily influenced by both Zlotykamien and graffiti in the 1970s was a man called Blek Le Rat, who spent several years marinating the idea of how to take the NYC wildstyle graff and flip it into something else: something fresh, something decidedly European. Blek had witnessed a lot of political stencil art after World War II and it was from combining these memories with what he had seen in NYC in the 70s, and taking inspiration from the silkscreen and charcoal drawings of Ernest Pignon-Ernest (a true street art pioneer), that street stencil art was born. Blek began stenciling rats around the streets of Paris in 1981 and progressed to full-size human figures and then classical sculptures, remixed into

stencils and then applied to the walls of the modern city, paying homage to the street poster work of Pignon-Ernest.

Urban art, street art, graffiti (often used incorrectly) – whatever name you know it by – is the most exciting, fresh and modern art movement there is right now. It is a great antidote to the often inaccessible modern art of the 1990s (Tracey Emin, Damien Hurst, the Chapman Brothers et al) just like Pop Art was a reaction to the macho bullshit of abstract expressionism before it. Revolutionary, fresh as you like, and for the masses. Street art is just that, art of the street that anyone can check out and appreciate, without any need for any translation from an art historian spouting doublespeak about the true meaning of the piece.

The street art movement is mutating into what is now referred to as 'Urban Contemporary Art' and artists who have begun life on the street are now using their experiences on the street to influence a more refined, conceptual art off the streets in galleries. For me this is the ultimate way forward for street art. One example of this is Bianca Elsenbaumer and Fabio Franz who work under the banner of Brave New Alps. I met Fabio through his great street artwork and when we last spoke and discovered that he was studying at the Royal College of Art, I knew he was doing the right thing. Taking what he has learned through working in the street and applying that to fine art methods and techniques can only produce something new, something progressive, and that is what all art is about.

→Turn to p208

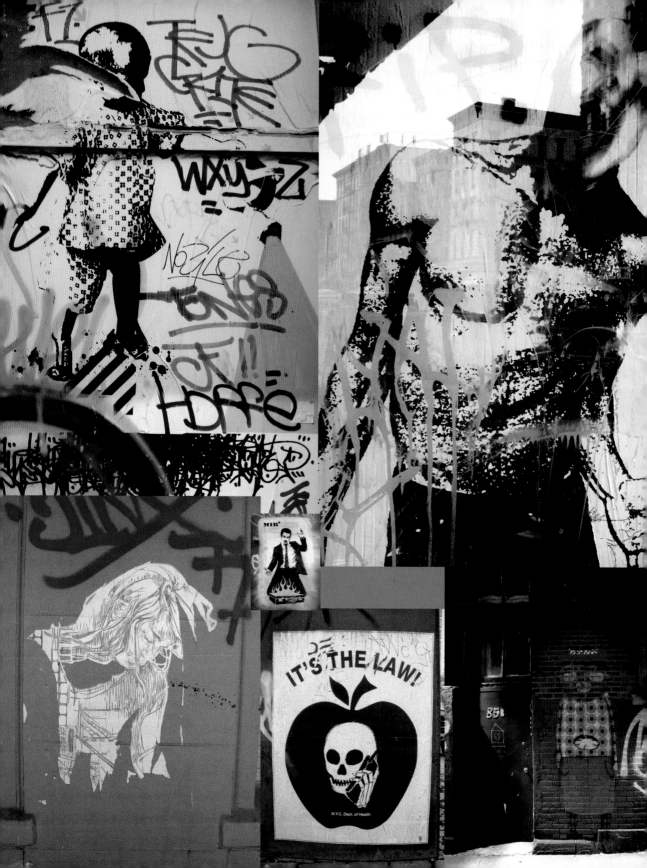

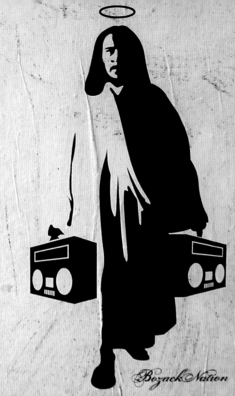

These are some of my favourite photos I've taken of graff/street art in the last ten years of travelling the world.

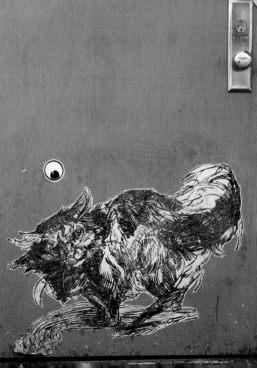

RiCHARD GiLLiGAN

www.richgilligan.com

Richard is one of Ireland's most prolific skate and street culture photographers. He grew up in pre Celtic-Tiger era Dublin, which was a totally different place than it is now – and being a skater he really stood out like a sore thumb. He initially picked up a camera in order to shoot skate photos of his friends, and by trial and error taught himself the technicalities of photography. It was after he had got to grips with the craft that he understood that the moments in between the action (the actual skating) were as fascinating to him as the action itself.

'I finally felt like I was in control of the photos I wanted to create in my head. I also began to realize that I was as interested in the moments in between skating as much as the actual action shots that I had initially set out to capture. It was around this time that I really discovered documentary photography by people like Robert Frank, Lee Friedlander and Eugene Richards. Something clicked in my head and for the first time in my life I knew that this was something I really, really wanted to do so I decided to move to Wales and do the degree course in Documentary Photography in Newport, which turned out to be three of the most inspiring/ gruelling years of my life. Street culture to me means making use of whatever you have around you, be that the architecture of a city centre for skateboarding or finding interesting ways to shoot photographs in an urban environment.'

HiP HOP

The only way to really understand where hip hop came from is if you travel back in time to West Africa, floating through Mali, the Gambia, Guinea, Western Sahara and Senegal, to get down with the griots (also known as jeli, jail, guewel, or gawlo) – travelling praise-singers, story tellers (the old school newsreaders) and poets who wandered the continent entertaining and informing its people of what's going on. Then because of slavery, things changed, and by the 1960s after many, many, years in the ether, this oral heritage eventually filtered through to the minds of African-American spoken-word poets and musicians Gill-Scott Heron and The Lost Poets. These pioneers were the first to record word and beat together and release it on a record, honouring the griot tradition by using it as a voice for the civil- and black-rights movement in the USA.

These sounds made a fertile bed from which the seeds of hip hop music began to grow. Move next to the Bronx in the early 1970s, when DJ Kool Herc (whose first sound system consisted of two random turntables and a guitar amp) and his sister began to hold back-to-school parties in the recreation room at 1520 Sedgwick Avenue. Growing up in Jamaica, Herc (Clive Campbell, to his mother) witnessed the dancehall sound systems and the toasting of DJs, and imported this knowledge when he moved to the Bronx. As these parties grew in popularity and size, Herc noticed that certain sections of records would re-energize a flagging crowd. He bought duplicate copies of these records and began to play these sections back-to-back to elongate the break and keep the crowd rocking. This became known as 'the Merry-Go-Round' using such records as, *Give It Up or Turnit A Loose* by James Brown, *Bongo Rock* and *Apache* by The Incredible Bongo Band, *Shaft in Africa* by Johnny Pate, and *Scorpio* by Dennis Coffey. Soon Herc was throwing block parties in nearby Cedar Park, with his spar Coke La Rock rocking the mike in true JA sound-system style. The hip hop DJ and MC combination was born.

One person who could've been standing next to you in the ever-growing crowd at these parties is Grandmaster Flash, who watched, learned and waited until the 1980s when he blew up with his single *The Adventures of Grandmaster Flash on the Wheels of Steel*, which defined a new style in DJ technique, using three turntables and sampling Chic, Blondie and Queen records to define turntablism. This paved the way for the second wave of hip hop in 1983 with the release of the eponymous album by Run DMC, Public Enemy's *It Takes A Nation of Millions To Hold Us Back*, Eric B and Rakim's *Paid In Full*, and NWA's *Straight Outta Compton*. This was the Golden Age of hip hop.

The Beastie Boys then ran with the ball across the country to LA and recorded *Paul's Boutique* with the Dust Brothers, which redefined hip hop and opened the game up for acts like De La Soul, A Tribe Called Quest and the Jungle Brothers. By 1991 you might be stood at Main Source's Live at the Barbeque concert when a young kid called Nas bounces onto the stage and absolutely kills it with his MC style. It takes a while but when he drops his debut album *Illmatic* in 1994, it's immediately compared to the effect that Rakim had on rap style. Nas is connected to Mobb Deep, whose album *The Infamous* is a classic and still being sampled today. Around this time, somewhere in the Bedford-Stuyvesant section of Brooklyn, Christopher Wallace was practising his flow, while street hustling and selling crack. His first mixtape (>p166), made under the name Biggie Smalls, was soon written about in the Unsigned hype column in *Source* magazine which lead to Sean 'Puffy' Combs signing him as The Notorious B.I.G. Puffy made him give up the crime and soon he recorded the legendary album *Ready to Die*, possibly the greatest rap album ever recorded. You then jump on the red-eye flight to LA to witness the west coast blowing up with (ex-NWA) Dr Dre's *The Chronic*, then bounce back to Staten Island, birthplace of the Wu-Tang Clan, who released their second album *Wu-Tang Forever* in 1997, which is where your journey ends.

Turn to p180

'High Life, Low Life and Nothing in Between'

MR. HARTNETT

www.paulhartnett.com

From London's New Romantics, Goths and fashionistas to Tokyo's Harakjuku Kids, New York's electro scene and the new rock world exploding in Paris, photographer Paul Hartnett's impressive archive of photographic work is characterized by a poetic appreciation of imperfection, personality and eccentricity. Over the last four decades Hartnett has painstakingly documented midnight's children and their club culture on a global basis for international publications. He has one of the most amazing and complete collections reflecting street and club culture in the world, with a particular focus on individuals who work a strong look. His photographic portraits are a remarkable and fragile social document, a record of the inventive and excessive sides of youth. Hartnett's compulsion to document the extremes of youth culture has always revolved around the themes of consumption, decadence and conspicuous sexuality played out against an urban backdrop. I got down with him in his hometown of Haworth, Yorkshire.

'After close to thirty-five years of magazine and newspaper features, exhibitions, on-line stuff and interviews within the fashion industry and beyond, to get from photographing with a Kodak Instamatic to having work in the V&A took quite a while, because street and club culture wasn't ever seen as anything that would reach any form of value, importance, beyond the flick of a style magazine or music paper page when I first started. Such snapshots are now seen as social and design reference points, seen as art. The world's changed so much, when I started there weren't people going out photographing as people now do with their telephonic toys, because film was expensive and to make a contact sheet was expensive and to make prints was expensive and there weren't style magazines around, it was Sunday supplements, teen and young women's magazines, inky music papers only. Soon after I started, *i-D* strutted into existence as a self-important, sneerily superior A4.

Then came the eighties style wave of *Ritz*, *Blitz*, and the often-forgotten *New Styles New Sounds*, but there were very few outlets for photographs of people working a look on the dance floor or out on the street.'

'Because I was eighteen I wasn't seen as a threat or seen as someone who was going to be taking manipulative or exploitative photographs for some dodgy photo agency to sell a quick piece about the punk explosion. When Steve Strange and all the Queer Punks got together and formed the New Romantics, I was one of them and I knew how to photograph them. The girls wanted to be photographed in a glamorous and campy manner, kind of Angie Bowie, kind of Roxy Music, but didn't want to be photographed in an overtly sexualized way that'd end them up in tabloids. The guys, all suffering from Bowie fallout, wanted to be shot in a way that was stylish, artsy, old school Berlin.'

Despite having worked within the constraints of a street and club situation, Hartnett's thousands of unique images are razor-sharp, composed almost clinically. He has always made it a priority to get in close to a subject, documenting the essential details with care.

'There's a seductive and self-destructive undertow to the playgrounds that we call clubland. The mirrored disco ball has a warping effect that reflects an inability for so many to make the transition from fantasy into reality, from the dreamlike state of childhood and early teens into adulthood. Clubland makes clowns of us all. It's generally held that all things teenage started in the late forties, but I'm unearthing remarkable kid Casanovas from the 1850s. Via eBay and fairs, I've dug up Wild West cowboys looking absolutely phenomenal, so heavy duty, dangerous and delinquent a genuine slum "punk" spirit to them, pubescent prodigies.'

→Turn to p148

HABBEKRATS

www.habbekrats.nl

Habbekrats are the future of advertising. Coming out of Amsterdam, they create original communication, and they know how to speak to the youth, unlike many of the world's advertising agencies. This is why they will be still here in the future. Habbekrats was founded in 2004 by Victor Ponten and Jim Taihuttu while they were still at college. By 2006 Habbekrats became an official company with bigger projects and more and more 'official' clients and partners for whom they do very unofficial work, most of the time.

'The origin of the word Habbekrats lies in the Jewish diamond industry. It's Yiddish for a diamond of half a karat ('ein halbes Karat' = Habbekrats). So at Habbekrats, we apply the craft of crafting diamonds to media. In our philosophy, it doesn't take much to create powerful ideas. Just a mind or two. We try not to forget that, now our projects grow bigger and bigger.'

What attracted me to Habbekrats is that a lot of their work just doesn't look like advertising. It's totally out there and a lot of it takes place in the street, and once you understand what the fuck is really going on you can perhaps make a connection to a brand or whatever (like with their MTV work) but the magic for me is the space of time when you're not sure exactly what you're experiencing, not exactly sure what is going on, be it in front of you in the street, online, on TV or in a magazine or newspaper.

This is the real deal. Habbekrats have worked with the most diverse range of clients, from experimental hip hop producers to *Het Parool*, a Dutch newspaper. All creativity has its roots in the street:

'Street culture to us is not an aesthetic. It's not about using a spray can, a stencil or whatever. Street culture is about independence, about telling stories you think should be heard and creating your own means to do that. So as a state of mind, it means a lot to us because our philosophy is rooted in it.'

Habbekrats are influenced by everything and anything and it is this total openness that makes the ideas work. They use film/video, print and ambient or guerrilla media with a style that cannot be faked.

'Big things, such as art and science, love and hate. And small things, like our neighbour who runs a small grocery store in a mosque, a sunset or a particular photograph by one of our favourite photographers.'

They look forward to working with the finest people of our generation. With their philosophy of beginning with a simple idea that can develop into something else, I'm sure they will be working with whoever they want.

Turn to p116

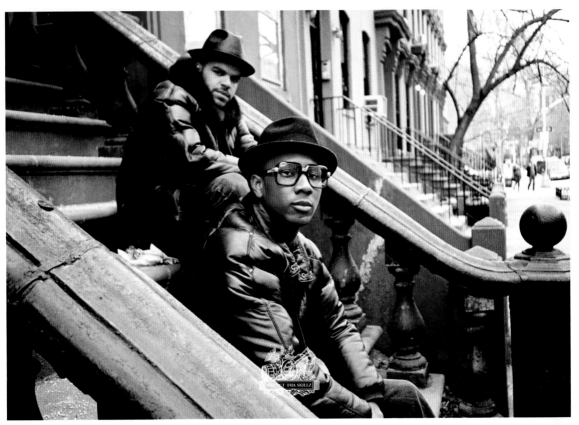

HUSH

www.studio-hush.com

Hush is the poster boy for contemporary urban art. There is no one out there to touch his eclectic manga-pop influenced art that has been borne out of the street art scene of the early 2000s. I have been on the road with him for the past few years, documenting his rise to fame, travelling from London to Belgium to LA to Amsterdam to New York to Newcastle, where he still lives, creating his art using stencils, screen prints, spray paint, Photoshop and a lot of street smart attitude in his studio.

'I spent my youth on the streets of Newcastle, and I was going clubbing big style in those days. A lot of my mates where organizing raves and illegal parties and so I got into designing the flyers, which is great work as it was very experimental and I brought a lot of my graff and street influence into it. The haze cleared after a few years and I found myself out in Hong Kong, working as an illustrator for toy companies and design agencies. This was when I started making art again and drew a lot of influences from my surroundings. Manga is huge over there and part of everyday culture. I was hugely influenced by this and the typography and graff writers out there. I got involved with underground pop-up shows and would share and post art to artists all over the world, it was a great scene.'

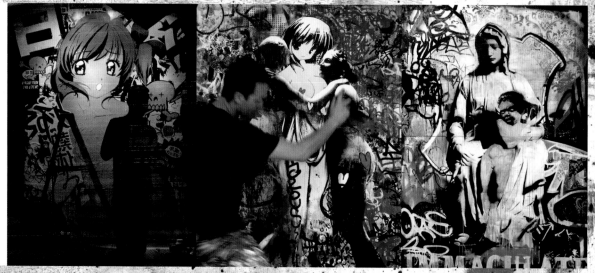

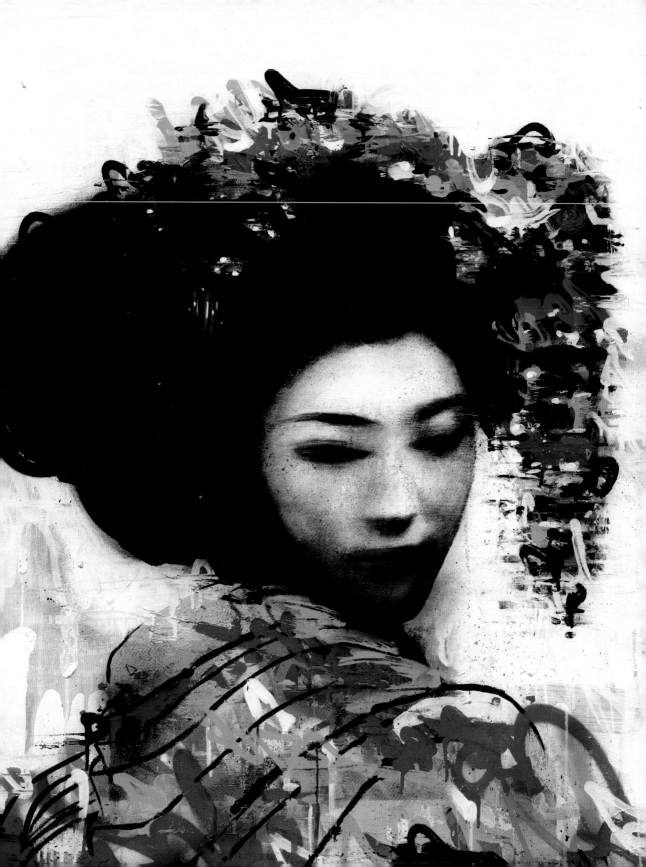

HOUSE OF DiEHL

www.houseofdiehl.com

The House of Diehl creates and produces interactive fashion events the like of which you will have never seen, as well as creating custom fashion items straight outta their home town of New York City. The brainchild of Mary Jo and Roman, a very cool (but nice with it, which is rare thing indeed) couple who run HoD from the heart. I applaud this kind of shit. I love their Style-Wars style battling events that has audience participation as a vital ingredient. The Style Wars shows are totally unique live events inspired by MC battling and haute couture. Eight fashion designers have to create fashion live on stage, for a panel of judges who vote the best ideas through to the next round, until there is one winner. Simple as that and a great night to be part of. This not only keeps it fresh as fuck, but is the total opposite to the exclusivity and snobbery of mainstream haute couture fashion, and ensures that their output of shows and the like are the coolest, freshest ideas fashion-wise. They began putting on small events in 2001 and today they take their show around the world on sell-out tours. I swung by their TriBeCa loft one balmy NY afternoon in June.

'Fashion is sex; fashion is rock 'n' roll. Everyone's been doing it ever since whenever: people have been customizing their clothes, tearing shit apart, making something better, working at thrift stores, but the idea of making it a competition, making it a sport, making it entertainment, making it a show, started with HoD. We've been doing this since 2001 when there was no Project Runway, no shit like that. It was definitely our big FUCK YOU to the fashion world. I mean everyone is literally in fashion but no one is in it. The fashion world see something like a billboard or graffiti, then they take a picture of it, a graphic artist does a rendering of it on a computer and then sells it back to you for five-times the price. That's not fashion, that's just cynical. Whether it's Victor and Rolf or K-Mart. In fashion we don't have the ability to get great ideas out there. Like for me I wanted to have this platform: you have this great idea and we're gonna put it out there for you. And that was really important for me. There is no family member of mine in fashion. I just had to come up with insane ideas and write about it, and make it interesting. That's how people started learning about House of Diehl.'

And this is why word is spreading about what they are doing with the Style Wars events that they have been hosting around the world for the past few years.

'Style battling is a process, not a product. The whole thing is getting people involved, that's what you have to do, so think about that: how do you get people involved in this process, make them feel good, make them feel edified and make it feel relevant. Fashion isn't relevant unless it's about the people. We made a denim jacket for a muscle car and drove it through the streets of New York and had everyone tag it. And then we took the fabric and then made it into a piece – so literally everyone designs it. The project was called Autograph. That's how you make something that's graffiti and then make something that you can see in a magazine and know you had a hand in the making of it.'

→Turn to p80

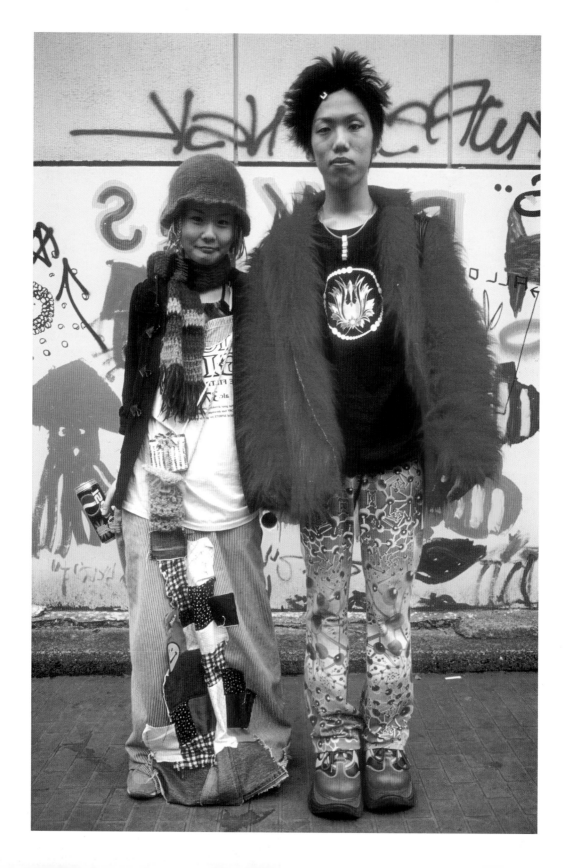

HARAJUKU STYLE/JAPAN

Harajuku is the area around Harajuku station in Tokyo, where every Sunday, the (mainly female) youth hang out on the Jingu Bashi (bridge) dressed in their own street style (often referred to simply as Harajuku or Fruits) which can break down into several tribes – namely Kawaii, Gothic Lolita, Visual Kei, Decora, Cosplay, Punk and Nu-Rave – to let the day slip by chilling and chatting to each other. Overall there is not one single fashion element, but more of a mish-mash of all styles. Often worn at once… This sub-culture dates from the early 80s, when the styling was bubblegum rock 'n' roll. The basic approach is 'Burokko', a term which translates as 'fake children' which is hugely influenced by the syrupy style of manga and Hello Kitty.

Paul Hartnett explains: 'Forget the old idea of some distant misty land of cherry trees and kimonos, a walk around Harajuku's Laforet department store on a Sunday afternoon is a culture shock that I would only recommend once your jetlag has subsided. Really. The outlets within Laforet – ranging from Hysteric Glamour and Girl's Murmur to Ozone Community – are mainly geared to the short-term possessive needs of teens with cash to burn. Tokyo's Harajuku and Shibuya areas go completely Mickey Mouse on Sundays. Whole gangs of teenaged girls and cute boys congregate on the railway bridge by the main entrance of the Meiji Shrine. On Sundays they like to dress UP! The long-term effects of one style cycle after another are everywhere to be seen, from punk to goth and hip hop to rave. There, a boy of maybe eighteen, sporting multiple beaded bracelets, feather necklaces and a stetson, totally throwing a conservative Burberry mackintosh with a cowboys and Indians touch. And there, a row of eyebrow piercings attached to the peak of a baseball cap, a dog collar around the neck of an adolescent, handcuffs hanging seductively from pinstriped trousers that have rubber dolls faces crudely sewn over the knees. Kind of demented, kind of "kawaii" (cute).'

The area is a shopping district that includes haute couture and mainstream designer labels like Louis Vuitton, Gucci and Prada, as well as home-grown Harajuku designers and cheap, accessible shops and stalls selling to the kids. Most of the week the place is full of business suits and shoppers, but on Sunday all that changes. The back streets such as Ura-Hara is where you'll find the Bape and Undercover shops. They have their own style, often referred to as 'Ura-Hara', of a predominately male population rocking a harder hip hop, graffiti, and skater look. Ura-Hara is the yin to Harajuku's yang and is considered properly underground. One possible reason why this youth phenomenon happened is that each Sunday from the early 1980s until 1998 the main street was declared traffic free and after a few kids got together the momentum picked up and moved to the bridge when the traffic returned after 1998.

→Turn to p138

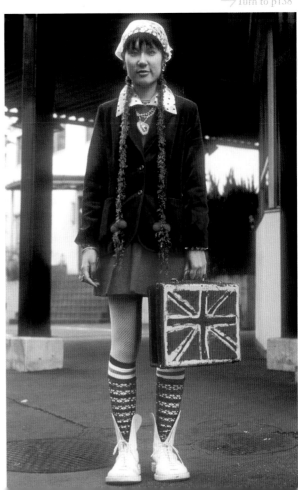

111

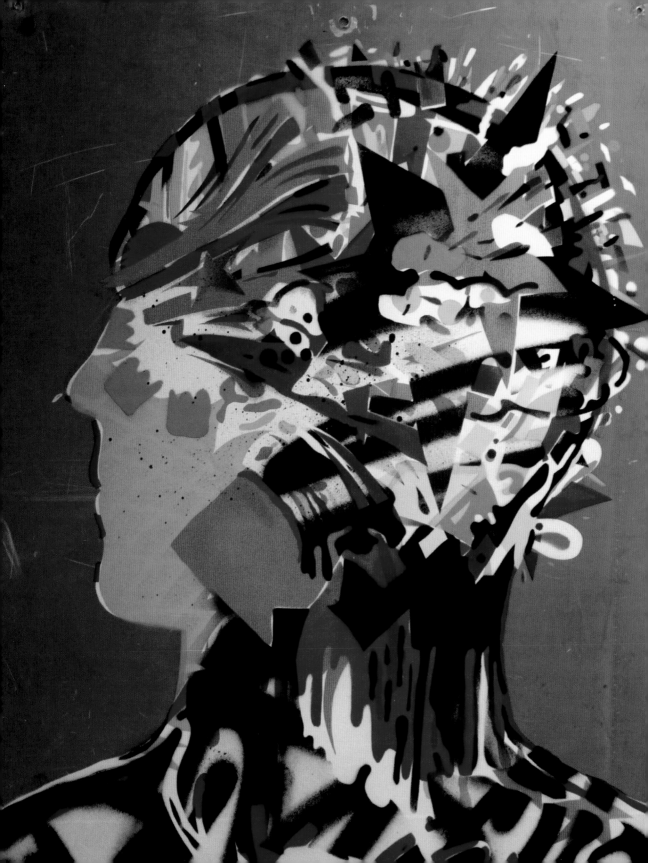

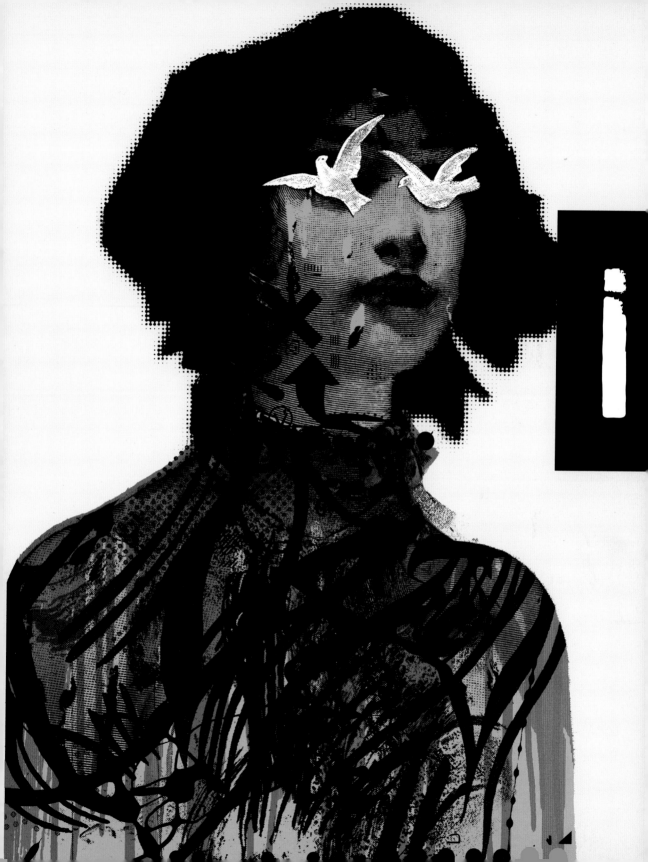

PAUL iNSECT

www.paulinsect.com
www.picturesonwalls.com
www.lazinc.com

Paul has emerged from the urban art scene as one
of the most original graphic artist of our times.
He has exhibited his work on the street and in
galleries around the world from London and San
Francisco to New York and Palestine. His very
graphic images are thought provoking and atypical.
His work confronts love, sex and death in a modern
world with a cutting satirical edge. He is a prolific
and exciting artist in our modern world.

I ask him what his work is about:
'Wanting to create strong and lasting image.'

How has your work evolved over the years?
'It's got darker. Actually, my work has always been
dark and surreal.'

Where did you grow up?
'In my mind… it was great.'

His influences are:
'Anything and everything, the streets are an
inspirational place, and who knows what you may
find around the next corner.'

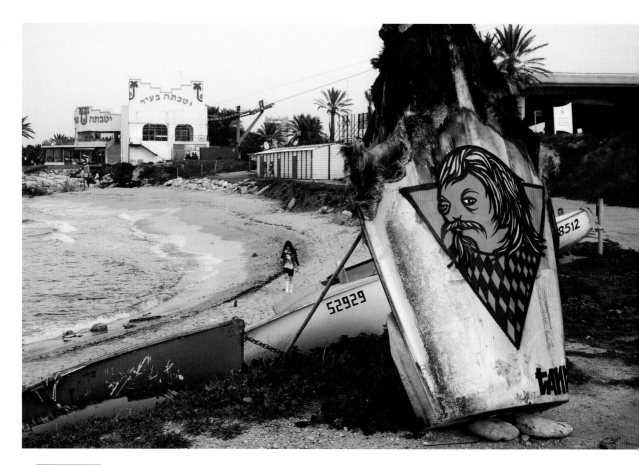

iSRAEL

Fresh culture, movements and creativity are always born out of conflict and struggle and the creative scene in Israel is a great example of this. It's exactly what happened in Africa and America back inna day, which resulted in hip hop, skate and street culture. Everything great that is coming out of the place is a reaction (direct or indirect) to the last 60 years of upheaval.

Tel Aviv is the party capital of the world (believe) and it has the freshest, most unspoiled street culture scene. The street art scene currently holds little monetary value – no marketing opportunities or street art dealers hovering on the periphery, eyeing up gaps in the market. Chances are that this could all change – the very fact that you're reading this, proves that. But for now it's just chock-full of fresh talent and virgin visions. Okay, so Israel has a

bit of negative spin right now (rightly so), but remember this is about the love, the talent, the people, not the bulllshit politics… The one thing you need to know about Tel Aviv is that geographically it may be in Israel, but it's a fucking oasis of cool street shit in a mad ol' country. Tel Aviv is not like the rest of Israel: it has its own state of mind. Forget what you know, read, watch or hear – none of this applies. Anything goes…

Tel Aviv by day is what I imagine Beirut must have been like before it fell in 1975. Coffee kiosks everywhere, people chilling and chatting in groups in the sun in the wide central reservations, plenty of youths sporting dreads and skaters galore. Sub-cultures are important round these parts – which is a seriously good indicator of the psyche of the place. The one thing there isn't is any sign of trouble. Day and night there are people walking

the streets and this tells me something. It's one of the most laidback places I've ever been (the polar opposite to LA!) and it has a real bohemian sense. The only reminder that I'm in Israel are the occasional soldiers strolling nonchalantly about packing some serious firepower – toasters galore, as they say in Brooklyn. Obviously I don't take any photos of this, as people are a little 'camera shy'.

My first night in Tel Aviv is spent uptown, in a bar that would be too cool for Berlin. A DJ is rocking the non-existent Sunday night crowd and we hook up with local DJ Walter Einstein Frog and a couple of promoters. Tel Aviv, it seems, is a small place. The boys spark up the chronic and the smoke begins to rise. No one in the place bats an eyelid. I get a grip on how the club scene is run (totally hands-on). Walter has a party on Friday and I'm on the list. On the way back to our ride we pass a kid sat on the kerb with his laptop, jacking someone's WiFi, like it's the most normal thing in the world to be doing on a Sunday night.

'Welcome to Tel Aviv,' my mate Pilpeled (>p196) tells me as we pass by.

After seriously abusing the cappuccino machine, I go out and mooch around Tel Aviv. There's tons of street art and graff which is a great indication of how cool a place really is. After this I go for a kosher burger (like a fucking half-pounder in a loaf of bread) and then I spend the day exploring the different parts of Tel Aviv proper. Pilpeled takes me to all the shops and galleries that he knows will hit the spot. The weather is killer and it's only winter. White dreads are everywhere and we pass a hairdresser that only deals with the locking up of dreadlocks. The white dread has moved from South Africa to here. He takes me to eat a sabich, which is a first (of many) as it tastes like nothing else. 'Each place has its own twist, adds its own secret ingredients,' Pil tells me after I've scoffed the lot. We then stroll to a coffee shop which is a total throwback to Goa. Geezers sit around playing chess under the palms in the courtyard and there is a bookshelf in the corner; people roll joints, while

young couples canoodle, oblivious to anything except each other. I shoot some film of this serene scene taking place a block away from one of the busiest streets in the city. Everyone is happy as Larry, everything existing in harmony. Only in Tel Aviv…

I stave off mid-trip fatigue from being out and about every day and night with my ever-growing crew of Israeli vandals and club-killers by chowing down on some killer lamuchan (a cross between a pizza and a kebab). This is where it begins to work for me – seeking out the fresh and the free, the unknown but obscenely talented. Most of whom can't really get a break as the industry is often so full of wankers who shouldn't be there, who when someone with real talent comes along they are seen as a threat. A threat who could blow the cover of the bullshitters and ass-kissers. This is something that I experienced back in the days when I worked as an advertising art director. Sometimes talent is not seen as something to celebrate, to promote and nurture.

HOT SPOTS

Best lahmajun in town: Torek Lahmajun, 77 Nahalat Binyamin

Best sabich in town: Sabich Charnihovski, Charnihovski St.

Wicked Shop: Urbanix 45 Shenkin Street www.urbanix.co.il

Great 'hood: Florentin. Near downtown, this area is laidback, dirty and small. Full of great independent bars and places to eat.

Good Bar: Shesek Bar, Lilienblum Street. Each night a different DJ spins music (all genres covered) and a fierce alternative spirit. A must.

Great Club: The Block, 35 David Hachmi Street and Barzilay Club, 13 Harechev Street

→Turn to p34

INTERIOR/EXTERIOR

www.framemag.com
www.mark-magazine.com
www.znak-life.com
www.ivanahelsinki.com

Zaha Hadid designing a pair of trainers is the indicator of how urban culture is now omnipresent. The street is now influencing how buildings look inside and that is in turn having an effect on how they look from the street. What goes around comes around. I love having a browse through *World of Interiors* but it's not really cutting edge, it's the kind of magazine that people who don't understand street culture like to read. So I hooked up with three of the raddest peeps in the interior/exterior game: Robert Thiemann, editor in chief of the two coolest magazines about interior/exterior design – *Frame* and *Mark*; Inese Zivere from ZNAK, a design agency that has changed the face of wallpaper and taken it to a completely different level; and Paola Ivana Suhonen, a Helsinki born designer and artist who mixes fashion and interiors.

I swing by Robert's Amsterdam office and ask him how interior/exterior design developed in the last 20 years, since the birth of hip hop?

'I think that the exact boundary between interior and exterior is slowly disappearing. I think what you see on the streets increasingly happens indoors, in many ways – by getting graffiti artists to do their thing on walls and doors, and by bringing the asphalt and cars inside. That is the very thing that is happening, but also the exact opposite is happening. If you go to a trade fair you see a lot of manufacturers of outdoor furniture produce exactly the same sets of furniture that you'd expect to find indoors – a sofa, armchair, coffee table – but for use in gardens and terraces. So what happens outside is used indoors and what's used indoors is used outside. So the borders between outside and inside are simply disappearing. Gardens and marketplaces are being treated as interiors.'

AFTER ALL IT WAS A GREAT BIG WORLD

WITH LOTS OF PLACES TO RUN TO

WELL SHE WAS AN AMERICAN GIRL

ZNAK have taken plain old wallpaper and made it great again. Not only do they commission some great work from a serious range of different Baltic contemporary artists, they stepped up with their Tear Off wallpaper range, where it's not just about what is covering the wall, but what is behind it. I got down in Riga, Latvia with Inese and let her tell me what is up in interiors!

'Because of the increasing trend towards interdisciplinary work, the interior design details will not only be discovered by designers and artists but also by other professions, from computer engineers to micro-technicians. This will lead to materials which can be updated daily with new designs reflecting your mood or being used as storage medium or even reminding you where you have left your other slipper. Frugality in design has been displaced by ornamentation. An interdisciplinary work trend has led to a re-association of the contemporary arts such as painting conceptual art and design. The ornaments of the twenty-first century are leaving the path of decoration and becoming means of artistic expression.'

To then get another angle, I chat to Paola Ivana Suhonen to get her take on how street culture has influenced interior/exterior design.

'I think street culture has nowdays one of the leading roles in all the design era influences – whether it is interiors or exteriors – fashion, graphic design or furniture. Ever since the word "street culture" came up and was established, it's been contemporary. There are three different paths to walk, that the others follow – streetwalkers, rock'n'roll guys and art-rebels.'

Turn to p150

'Afro… Afro… Afro Dizzi Act.' The hook of the song 'Afro Dizzi Act' by Cry Cisco hits my ears and fills my body with a rush of energy as I'm absolutely off my tits on an MDMA capsule that I'd gotten hold of by having a whip-round upon arrival at the rave (Biology II, Elstree, 10 June 1989). This was the defining and one true moment of my raving days. I was by no means a hardcore raver but I knew something was happening and paid careful attention to the effect that Balearic/house/rave culture had on the music and club culture of the world. My moment of pure ecstasy was dancing to the above tune in a tent full of other ravers who I'd never met before, all in similar states of intoxication. The tune changed ('Voodoo Ray', 'Strings of Life') the drugs wore off, the sun came up and I'd never felt so good after a night out. It never got any better because I never went back there again. I knew that it would only cheapen my memories if I tried to return. But I knew that it was a signal that something was coming over the horizon and as I've already said, times were a changing, thank fuck, and one of the elements that forced a change was the rise of dance music.

The birthplace of rave culture (Balearic beats, acid house, call it what you will) was the original open-air club in Ibiza called Amnesia. The DJ was Alfredo Fiorito and the time was the summer of 1987. Danny Rampling was the pioneering DJ who spearheaded the Balearic/rave/house charge on the UK, and then the world, after he went out to Ibiza for Paul Oakenfold's birthday with Nicky Holloway and Johnny Walker in 1987. He had read about a club called Amnesia in *The Face* magazine and had the idea of going to Ibiza to check the place out. It became one long party for a week, right from the time they touched down.

'It was the second night that everything changed. Everything changed. We became completely intoxicated on E and a whole new world opened up as the music that was played in Amnesia was very different to anything we'd experienced in the past… In an open air club… It was heavenly hearing the flair of DJ Alfredo who was creating such a soundscape with music and how he mixed – he was very very quick, chopping records in and out, mixing two copies, playing all sorts of music. And that blew my mind. It was like, "FUCK! I wanna play music like that." Alfredo would start the night off with funk pop indie rock: everything, any sort of music and as the night progressed, at about 3 am throbbing house music started, and I'd heard a couple of house tracks but not played like that. And that was it. A complete revelation. Up until then it had all been very linear, one sound in the past and this was totally eclectic: a raw soundscape. Alfredo was painting a picture with music. If he was an artist he would be a surrealist. His musical flair was immense. I'd never heard any DJ in the world play like that.'

Danny Rampling

Danny went on to open Shoom, Nicky Holloway opened Trip and Paul Oakenfold Pyramid and Land of Oz, both of which I was a regular at. These clubs began a revolution in both the club and music industry, and they were completely changed by 1990. Before the summer of love in 1989, the music industry was ruled by factory pop (like Kylie and Jason) and the club scene was dominated by the high street nightmares called Ritzy and Cinderella's, which played the aforementioned pop-shite. Not only did rave culture free up the music, it completely changed the fashion. Out went the 501s and blazers with badges, and in came the flowing ponchos, ultra-bright T-shirts and Kickers and Wallabee shoes. I remember seeing one girl wearing what looked like an oversized purple baby-grow, sucking on a dummy, eyes pinned and gurning like a good 'un. It was all about the music meeting with the drugs and people feeling free about being there. It was also a direct response to the bleakness of Thatcher's Britain, and it was no freak accident that the Conservatives – who were in power at the time – outlawed raves with the creation of the legendary Repetitive Beats law.

→Turn to

Dancing round the pool as the sun comes up, Amnesia II, Ibiza, 1989. Photograph by David Swindells/PYMCA

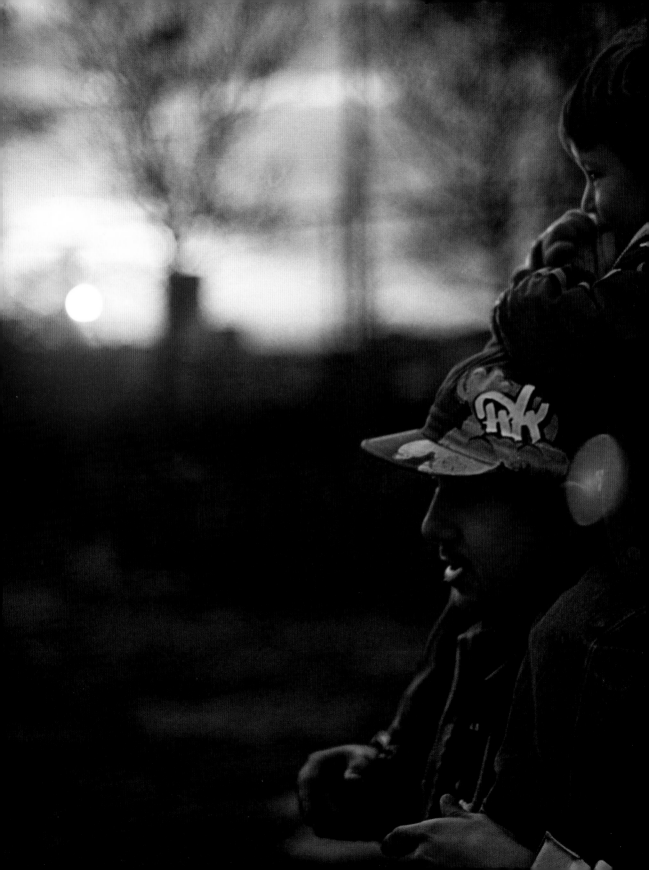

Culturally, this is the starting point for this book. Okay, so there's a bit of nipping about back and forth through time – but as I had to decide on a year dot this is where we begin.

1957: Stood in a hot dusty Kingston back yard somewhere not too far from Luke Lane and Charles Street, Cecil 'Bustamente' Campbell, AKA Prince Buster, is working away building his sound system. When the day is done and his graft finished, he christens it *The Voice of the People*. His philosophy behind the project is that the sound system should be used as a radio station for the people, broadcasting at the dancehalls and open-air dances, playing music made by the people for the people from ghetto to countryside; the wicked sounds that the national radio stations won't touch. The sound systems are where the ghetto people come to enjoy themselves – whether it was on the lawn in front of Forrester's Hall in downtown Kingston or in the many small towns that dot the countryside, like Nine Mile in St Ann's, birthplace of Jamaica's most famous son, Bob Marley.

> 'Reggae music is a people music. Reggae is news, the news of your own self, your own history; it's about things that they wouldn't teach you at school.' Bob Marley

A sound system is basically a huge stack of speakers, a serious amp, a turntable and a mic. You'd dress up smart and after paying a small admission fee, you'd nice-up the party until you needed to eat some food from the surrounding stalls selling jerk chicken and pork, rice and peas, and fried fish, and then quench your thirst with a Red Stripe, Heineken or Guinness. And then you might smoke some collie herb (marijuana), just to get you back into the mood. This was the dance, a social event that became the platform for Jamaican music to mutate from ska to downbeat to rocksteady to roots to reggae to dub from year dot to the 1970s. The first superstar of the sound system was Count Machuki, both DJ and MC,

followed by Clement 'Coxsone' Dodd and Duke Reid. What made a sound system was the music it played. This led the system superstars to begin to record their own dub plate 'specials' of popular tunes – the first ever remix. Prince Buster had his studio, Coxsone started Studio One, and Duke Reid founded Treasure Isle, all producing ska and rocksteady songs, all wanting to create the best dub plate for their sound system.

'Do the Reggay' by the Maytals was the first time the name appeared in print, but before then Lee 'Scratch' Perry (>p200) had released the tune 'People Funny Boy' in 1968 as a diss to his former employer Coxsone and upped-sticks and returned to his village in Kendal where – in the parish church – Lee discovered the energy and spiritual vibration of the songs being sung there. This was the birth of reggae.

The first reggae superstar was Desmond Decker, with his tune 'Israelites' killing it worldwide and pushing the music forwards. Paving the way for the Wailers and their leader, Bob Marley, and then a steady stream of stars such as Eek-a-Mouse, Yellowman, Clint Eastwood and General Saint, Gregory Isaacs, Dennis Brown, Ini Kamoze, Burning Spear and the UK's own Aswad and Steel Pulse.

My introduction to reggae was by way of David Rodigan's Roots Rockers radio show on a Saturday night in the late 70s and early 80s. I'd lie in bed and listen to the show on a shitty transistor radio, the music totally removing me from my suburban location. Reggae changed my life.

FURTHER LiSTENiNG:
Bob Marley and the Wailers – *Survival, Uprising*
Gregory Isaacs – *Night Nurse*
Ini Kamoze – *Ini Kamoze*
Barrington Levi – *Poor Man Style*
Steel Pulse – *Handsworth Revolution*
Greensleeves Sampler Vol.1
Lee 'Scratch' Perry – *Anything he's done*

→Turn to p 92

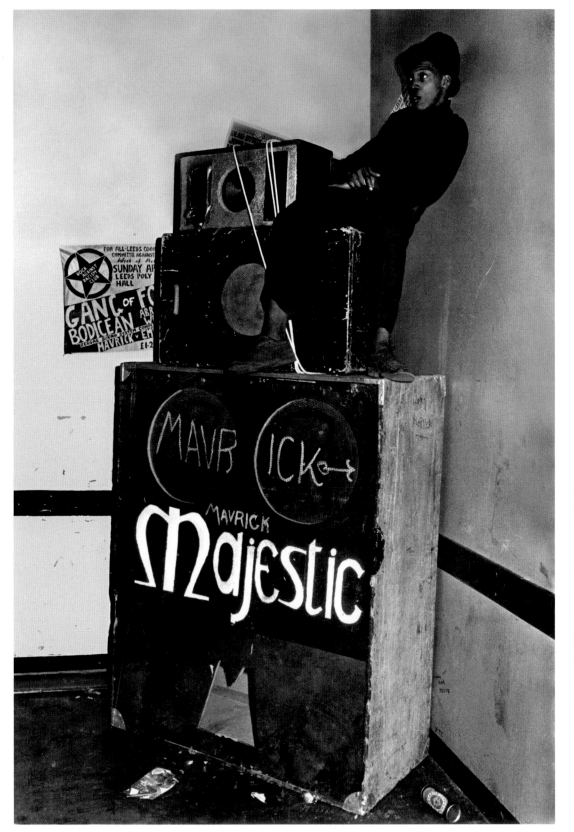

Maverick Reggae sound system, Leeds, UK, 1977. Photograph by Syd Shelton/PYMCA

TAMA JANOWiTZ

13 August 1988. That was the day I really discovered New York. That was the day I bought *Slaves of New York* by Tama Janowitz, one of the most killer books about New York and the 1980s downtown scene, and I've been reading her ever since. If I could write like anyone person in the world, I would choose Tama. Her writing is street smart and yet still light-hearted: almost a gritty comedy with a cultural significance. I was so honoured to get down with her and ask what it was like to walk the streets in New York in the 1980s.

'In the 80s, New York was still a real city. By that I mean there were distinctive neighbourhoods and there were still "working" neighbourhoods. In the meat market (where I lived, briefly, in the north-west Village – in what had been a former meat locker) the trucks came in every a.m. open-topped and filled with meat – all kinds of carcasses, offal – and they took it in to the different buildings that were sub zero and hung up the meat to be cut and took the meat on the hooks to hang out on the streets. The transvestite prostitutes worked the streets late at night – their main clientele was men coming in just for this purpose, from New Jersey. On pleasant evenings (though sometimes when it was not so pleasant!) after work these transvestites and transexuals slept across from where I lived, out of doors on a metal ramp and brought their radio and carried on all night. There were big rats and the streets were greasy with fat and blood and you could see a pigeon pecking at raw meat and the beak covered with blood. One day someone jumped off a building. The police came and chalked an outline of the body but could not be bothered, apparently, to move it for a whole day. And even then they left the shoes on the sidewalk as, perhaps, a reminder…

'The same with the East Village, back then it was major Latino and drug addicts and people living in these tenement walk-ups and if you lived there and came home late there might be an addict passed out in the entryway or big blood stains everywhere. And on the streets homeless people and drug addicts slept in the Tompkins Square Park which was filthy and everywhere in the cold they built big fires out of scraps and rags and paper and wood in these huge oil cans - it was an eerie sight. There were strange little bars and clubs but these were shabby and tucked in out-of-the-way places and you had to be kind of in the know to go to them. I could go on. How much has changed! Now of course it's all fancy art galleries and droves of people walking up and down between, say, 21st and 29th and 9th, 10th, 11th Avenues.

'Robert Mapplethorpe's [a legendary photographer] last party before his death, how AIDS changed the city. The myriad of people I did know or met who died. What happened after 9/11 and watching the Trade Centres come down from the Brooklyn view and thinking back to a party a friend had held for me at the top of the towers, in the restaurant there. My father was visiting me from the farm country of Massachusetts and he came to the party, where a baroness who was also a dominatrix attempted to pick up my Dad.

'In any event I have never considered myself to be cool, hip, in the know or anything else. I have too many people who sneer at me, who would sneer at me, who have always sneered at me. What I am is an observer and I have been fortunate to have had the continuing opportunity to have seen all kinds of things, amazing things, and experiences (taking the Goodyear blimp over New York City) and never quite fitting in anywhere. So I am lucky in that sense. Because if you don't fit in and if you are not a part of a certain scene or group or locale – then in a sense it is the same wherever you go: you are the outsider, more or less, and can look at things like a foreign visitor.'

→ Turn to p.240

JEREMYVILLE

www.jeremyville.com

Jeremyville is a prolific artist, product designer and author. He grew up in Wonderland Avenue, Tamarama, a sleepy beachside suburb of Sydney, right near Bondi Beach. He played with lots of Lego as a kid, and built and customized model aeroplanes which were his first 'custom toys', at the age of eight. His customized Darth Vader helmet was recently exhibited at the Andy Warhol Museum in Pittsburg.

He self-produced his first mass 3D inflatable toy in 1995, and wrote the first book in the world on designer toys called *Vinyl Will Kill* in 2003. He has also written and produced his second book, *Jeremyville Sessions*, and has recently worked on several toy projects with Kidrobot, and has a Jeremyville shoe out through Converse. In addition to exhibiting at the Andy Warhol Museum in Pittsburg, his work has been shown at Colette in Paris, the Madre Museum Napoli, the 798 Arts District in Beijing and Giant Robot in New York and San Francisco. He now splits his time between his New York and Sydney studios. He describes his work in the following way:

'A cross between many subcultures – graff, toys, sneakers, skate, surf, music, Pop Art. I'll try any medium that I feel like working with, and I produce a lot of my own products, as well as products with other companies, like Converse, Upper Playground, Rossignol snowboards, wallpaper for Domestic in Paris, skatedecks for Arts Projekt by Andy Howell, 2K T-shirts, toys with Kidrobot, books for IdN publishers in Hong Kong, Jeremyville jeans with Anti Sweden Jeans in Norway. It all falls under the Jeremyville aesthetic, which is not a traditional brand, but more a project-based concept. We work in the fields of apparel, fine art, publishing, licensing, animation, commissioned projects and product design.'

I'm really into multi-disciplined talent and Jeremy is certainly that. I asked him how his work had evolved.

'I began tagging on the streets, then public murals and drawing daily at the biggest newspaper in Sydney, the *Sydney Morning Herald*. Then I started customizing skate decks and surfboards, and had my first solo art shows. I wrote the first book in the world on designer toys, called *Vinyl Will Kill* in 2003. I then got more into toy culture, and Converse released a Jeremyville Chuck Taylor shoe in 2008. Still at the heart of my work is the basic need to create public art for the people, and to meet as many supporters of my work as possible. I love that connection with an audience.'

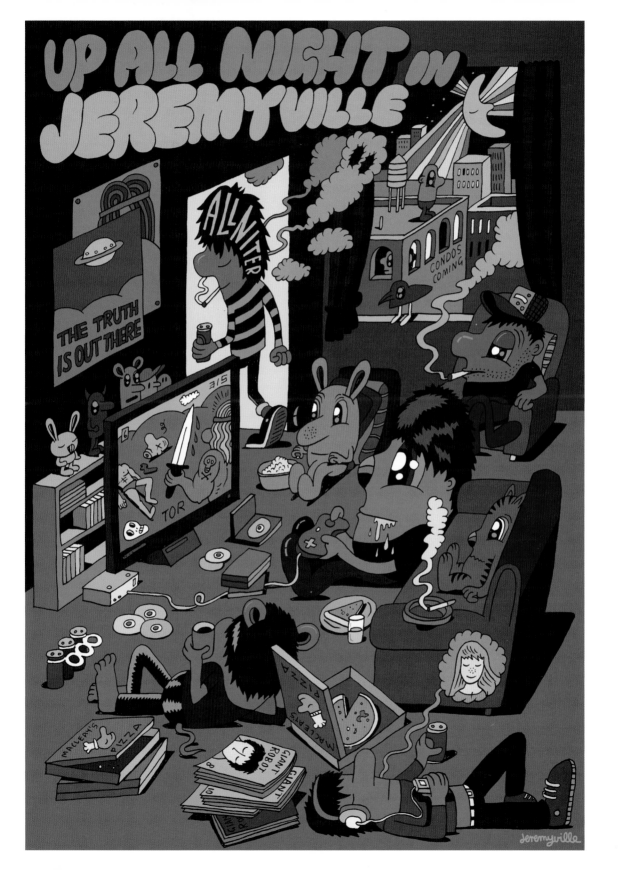

MR JAGO

www.mrjago.com

Mr Jago has taken the street and mutated it into something else in art. And he is also one the nicest people you'll ever meet, which is a right bonus… I sat on a busy Manchester street during a festival where Mr Jago was busy painting a large wall with one of his pieces.

'Abstraction is more an element these days. It's obviously based around a figure, even though they are camouflaged into the background nowdays. I don't really know how to explain it. There are obviously a lot of influences: classical artwork, the street, natural shapes, clouds, that sorta thing. It started off as something you could perhaps call "urban" initially because that was how it was then, but once you've got bored of

putting an outline down, colour becomes more important. It then turns into painting, but it's definitely not urban.

'I started out working with Will Barras [one of the original Scrawl Collective members]. Now we've gone in separate directions, but we started out drawing and then taking it into a Mac and then cutting it up on Photoshop, and then some-body asked us to do it live and we had to learn how to do it. So it was that way round. Me and Will went to Japan in 2001 and then we had to work it out, trying to replicate something on a wall from a drawing. It didn't really seem to matter how it turned out and so there was room for happy accidents. We just laid down some shapes and saw whatever (a dog wearing a top hat) and played along with wherever it took us.'

K

KNOW HOPE

Know Hope is one of the next generation of contemporary artists. Born in Huntington Beach, California, but raised in Tel Aviv, Israel, his art has a unique flavour that is part urban, part folk, part craft but all good. His work is a documentation and artistic snap-shot of the times, built upon a collection of minor incidents. Recently, his work has followed the storyline of an un-named character, with juxtaposed situations that are constantly happening around the character, which can be seen as direct portrayals of real-life happenings and a sign of the times.

In the beginning, his work was heavily text-based and consisted of a paragraph of sentences with an image, not necessarily describing or illustrating the text, but creating some sort of juxtaposition. He started using the character, an artistic everyman, about two years ago, and when he first drew it, it looked completely different, and slowly it took shape into what it is today. As the visual aesthetic developed, so did the storyline, the concept.

'Since my work is based on observations, fragments and minor moments, it is those things that compose my work, as it is those things that are most relevant to me. The current state of the world is messy and clumsy. Well, I don't think there ever was a time when it wasn't like that. The minor moments compose the larger issues. I deal a lot with the ideas of temporality and the ephemeral aspect of everything around us, including ourselves. From the timely conversations to the supposedly timeless gestures, it is all a fraction in some general ever-changing continuum. One of my main attempts is to create that momentary contact, that minor conversation. A small particle in that same large continuum. To create a future memory, the creation itself in real time. A proof that a moment did exist.'

'What really appealed to me about using the character on a regular basis was the realization that I could create a tool, not only to make up and form those same juxtapositions mentioned above, but allow the viewer to conduct a long-term relationship with it, and naturally, after time pick up on all the small nuances and gestures. Similar to the process made in the transition from a stranger to a lover, or even vice-versa. By attempting to break things down into the most common denominator in order to allow the most accessible conversation to take place, I see my character as an everyman. He is in all of us, you are him – or more importantly, we are him. But if I could hope for an evolution, I would hope that the world made up of the re-occurring imagery and symbolism is more consolidated and comprehensible.'

→Turn to p242

It seems like an age ago when I was sat in the waterfront cinema in Cape Town waiting for the lights to dim, really excited about the film I was about to watch. This hasn't really happened much since (I was excited to see *Gomorrah*, but not a lot else). The film back then was *American History X*. Fast forward eleven years and I'm getting down with the guy who made the film on an ordinary Saturday afternoon.

Film legend, commercials genius and personal hero, for the last 20 years Kaye has been one of the greatest film directors England has ever produced. He creates cornerstone films (such as *American History X* and *Lake of Fire*) and always delivers the goods. Forget all you've ever heard about him: he is a gentleman of the highest order and one of cinema's true pioneers.

I asked him what the words 'street culture' meant. 'Street culture is a generation of voices that are trying to express themselves and be heard, but they haven't yet found a proper audience within the mainstream. So they go outside into the world and onto the street and they shout – either with their voice or paint a picture on a wall or they stand on a corner with a guitar or some form of musical instrument and play a song or they do an open mic or whatever and they go through a number of hours, day, weeks, years and ply their craft and try to get their expression out into the world. And there is often a generic style of things that occur like that, and then there will be people who throw a net over that and say that's the street culture of 1984.'

Have you seen it change?
'Change may be six letters but it's a very big word and if you take a collective like film: has film changed over the years? Well, really, sound is honestly the biggest change that's happened to film, and that happened nearly 100 years ago.

Now has anything as big as that changed in film? Probably not! So it depends on what you're saying has changed. Has music changed? Has art really changed? Well, it went through a number of technical changes but painting is still the T-shirt of the art world, as it's the easiest thing for a gallery or dealer to sell. Can an artist get by if they don't produce a canvas with some sort of image of something applied to it in some way? So I dunno, have things changed? I think the big change will happen when we all realize that we're all connected with each other and we're all one soul, and things are not really gonna change until that happens. When people realize that then there will be a significant change.'

How did you become a commercials director?'
'I started out as a painter and took some of my paintings and tried to sell them and couldn't. I thought that there might be something that I could do in the day that would be a little bit closer to what I really wanted to do and I became a commercial artist and worked in a studio – this was before computers. You made up the artwork by hand, and then I kinda got quite interested in what design was and what art direction was and there seemed to be a good side of it and a bad side of it. So I kinda went from there. As I found out more about it I realized that film was the most appealing thing to me of all. And so I thought I'd make a bee-line for that and I eventually got a job as an art director at an advertising agency called Collett Dickenson & Pearce for three years. Then Frank Lowe was starting a new agency called Lowe Howard-Spink and took half a dozen people with him and I was one of them. It was a fantastic thing – I still think this – the best agencies now are tremendously exciting places to be. But you've gotta be careful if you're trying to get a message out or say something on a bigger canvas, as it's incredible and very exciting and I could easily get lost in that place very happily for some years, but you have to be careful.'

→Turn to p156

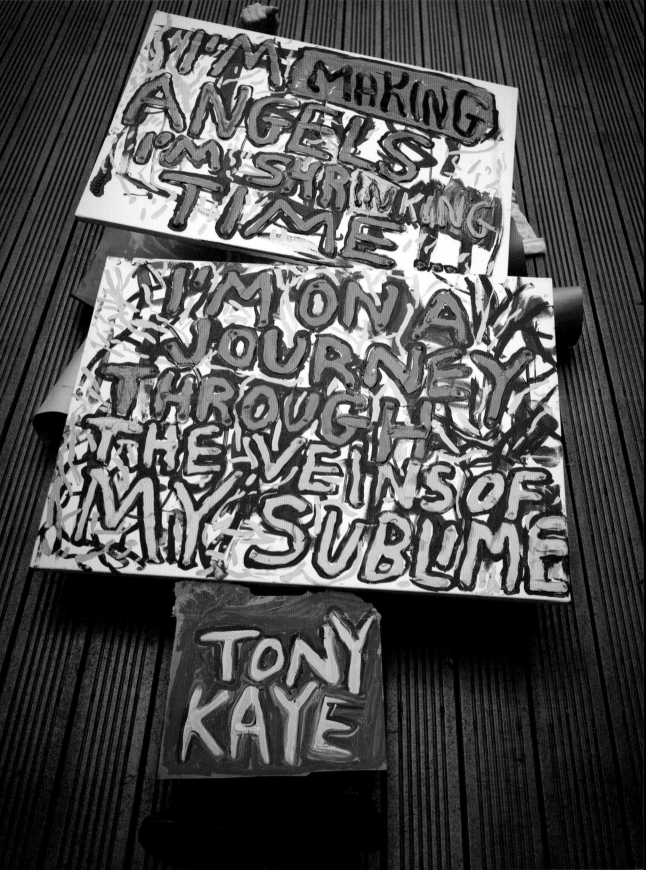

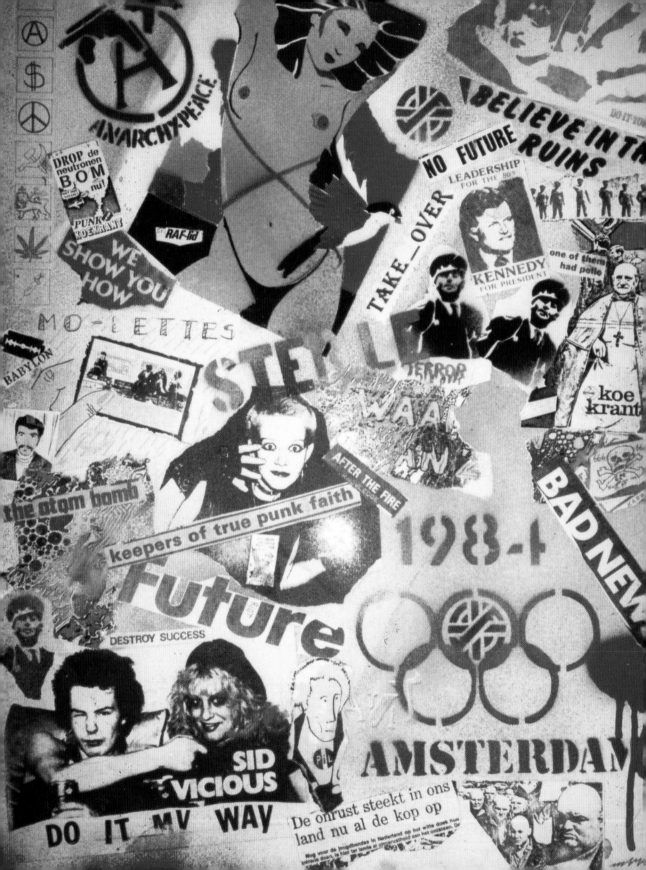

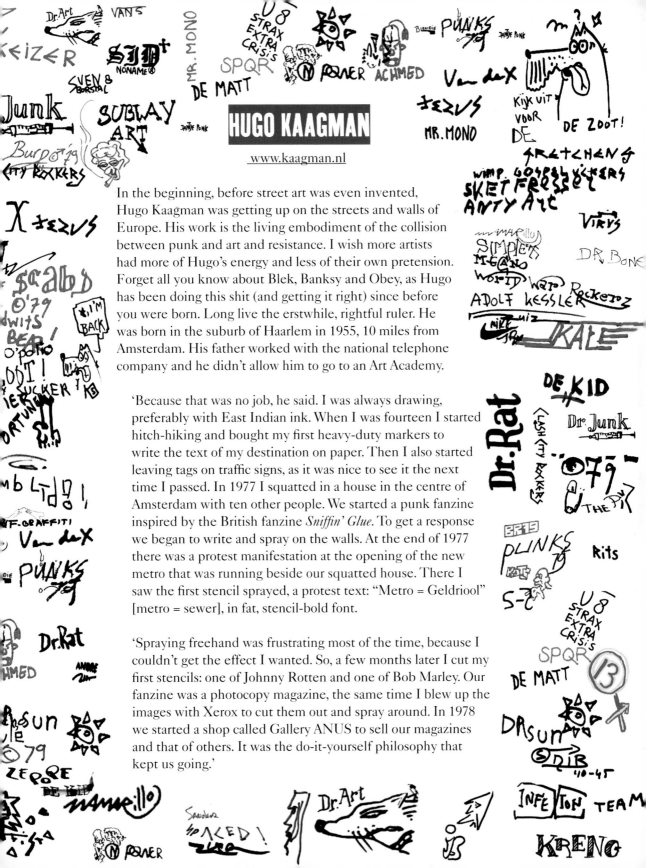

HUGO KAAGMAN

www.kaagman.nl

In the beginning, before street art was even invented, Hugo Kaagman was getting up on the streets and walls of Europe. His work is the living embodiment of the collision between punk and art and resistance. I wish more artists had more of Hugo's energy and less of their own pretension. Forget all you know about Blek, Banksy and Obey, as Hugo has been doing this shit (and getting it right) since before you were born. Long live the erstwhile, rightful ruler. He was born in the suburb of Haarlem in 1955, 10 miles from Amsterdam. His father worked with the national telephone company and he didn't allow him to go to an Art Academy.

'Because that was no job, he said. I was always drawing, preferably with East Indian ink. When I was fourteen I started hitch-hiking and bought my first heavy-duty markers to write the text of my destination on paper. Then I also started leaving tags on traffic signs, as it was nice to see it the next time I passed. In 1977 I squatted in a house in the centre of Amsterdam with ten other people. We started a punk fanzine inspired by the British fanzine *Sniffin' Glue*. To get a response we began to write and spray on the walls. At the end of 1977 there was a protest manifestation at the opening of the new metro that was running beside our squatted house. There I saw the first stencil sprayed, a protest text: "Metro = Geldriool" [metro = sewer], in fat, stencil-bold font.

'Spraying freehand was frustrating most of the time, because I couldn't get the effect I wanted. So, a few months later I cut my first stencils: one of Johnny Rotten and one of Bob Marley. Our fanzine was a photocopy magazine, the same time I blew up the images with Xerox to cut them out and spray around. In 1978 we started a shop called Gallery ANUS to sell our magazines and that of others. It was the do-it-yourself philosophy that kept us going.'

THE KLF

www.penkilnburn.com
www.jcautyandson.com
www.klf-communications.net

The KLF was a conceptual pop-group, the brainchild of Bill Drummond and Jimmy Cauty which in 1991 was the most successful selling act in the world. Then in their greatest publicity stunt to date, the KLF was disbanded, the entire catalogue deleted and £1M of royalties burnt in a ritual on a Scottish island. This is the stuff that true legends are made of. This shows how important the hype game is and what a crucial role it played in the rise of the KLF. Today, Bill Drummond and Jimmy Cauty are two of the greatest conceptual artists out there:

> 'We have been following a wild and wounded, glum and glorious, shit but shining path these past five years. The last two of which has [sic] led us up onto the commercial high ground – we are at a point where the path is about to take a sharp turn from these sunny uplands down into a netherworld of we know not what. For the foreseeable future there will be no further record releases from The Justified Ancients of Mu Mu, The Timelords, The KLF and any other past, present and future name attached to our activities. As of now all our past releases are deleted… If we meet further along, be prepared – our disguise may be complete.' KLF Press Release, 1992

Bill Drummond was managing Liverpool bands Echo and the Bunnymen and The Teardrop Explodes when he inadvertently discovered dance music during a chance visit to The Paradise Garage in NYC (>p54). This altered his whole perspective on music and he set about creating his own brand of hip-hop inspired pop music with fellow musician Jimmy Cauty, recording under the name the Justified Ancients of Mu Mu (The JAMMS). The myth began to build after the first LP *1987 (What the Fuck Is Going On?)* was banned after ABBA sued

(they'd illegally sampled the song 'Dancing Queen'). Bill and Jimmy drove to Sweden in the hope of being able to talk to ABBA and resolve the legal issue. They didn't and ended up burning some of the records in a field and dumping the rest into the North Sea on the ferry home. This experience gave them the idea of combining pop music and conceptual events; art and journeys. The fact that they took an *NME* writer and photographer on the trip says it all – they knew what they were doing from the start.

After having a number-one record under the guise of The Time Lords, Bill and Jimmy wrote a book, *The Manual (How to Have a Number One the Easy Way)*, and then proceeded to redefine pop music with the creation of the KLF in 1989.

The initial output from the KLF was acid-house with a twist. 'Pure Trance' was born and the tunes 'What Time Is Love?' and '3 AM Eternal' began their long journey. Using profits from 'Doctorin' the Tardis' Bill and Jimmy went out to Spain with a film crew and began shooting one of the most legendary films never to make it to a big screen near you (although you can download a rough version of the film) called *The White Room*. When the project hit some financial difficulties (shooting film is fucking expensive) the KLF released 'Kylie Said To Jason' in an attempt to raise some much-needed funds. The single died a death outside the top 100 and this led to the film and soundtrack being put on hold. Yet the KLF thrived off misfortune and it could be said that this is what drove them on to much bigger things.

Elsewhere, '3 AM Eternal' was picking up some serious props on the underground dance floors of Europe and was seriously rated by the rave DJs. It was this fact that led the KLF to rethink their whole approach to music and return to Pure Trance. The tune 'Last Train to Trancentral' was released and the KLF picked up some unstoppable momentum. In 1990 they released a string of more pop-friendly singles with guest vocalists and rappers.

'I am usually completely focused on what I am working on at any given time, I find it hard to think about things that I have been involved in, in the past. With the book *17* it was as if I was clearing out the trash bin in my head so as to make more room on my internal hard drive to put in new stuff. And once the trash bin has been emptied it has gone forever. I never think of what I do as street art; even though I have done a lot of graffiti it is not the sort of urban stuff that you see up in lots of cities around the globe. The stuff that I do is way too crude to try and compete with all that stuff. As for inspiration, it is more that I am just driven to do things, I never feel inspired in some sort of elated way, it is always just work that has got to be done before I die. More and more of it banging on the outside of my head wanting to get in and once it is in it is banging from the inside trying to get out. It just goes on and on and on.'

Bill Drummond

'Twenty years ago it was considered a crime to sample or steal from other artists… Now it's common practice and quite boring.'

Jimmy Cauty

→Turn to p68

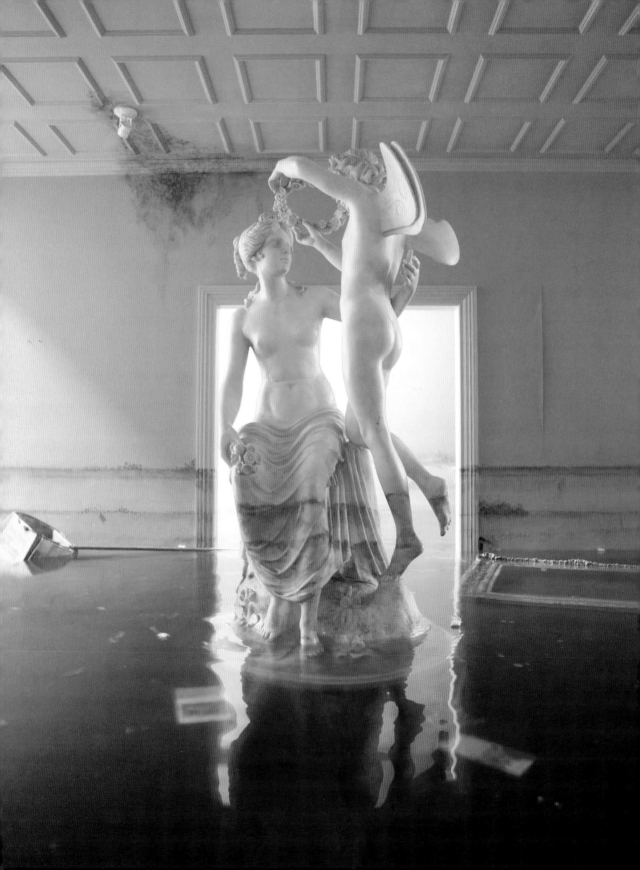

DAVID LACHAPELLE

www.lachapellestudio.com

David is the world's leading fashion and culture photographer. In the 1980s he moved from Connecticut to New York and enrolled in the New York School of Visual Arts. He was still a student when he was offered his first professional job to shoot Andy Warhol for *Interview* magazine.

David has constantly redefined the role of photographer, blurring the boundaries between art, commerce, biography, reportage, satire and documentary. He blew up with his killer portraits of Lil' Kim, Eminem, Tupac Shakur, Madonna, Amanda Lepore, Pamela Anderson, Uma Thurman, Elizabeth Taylor, David Beckham, Paris Hilton, Leonardo DiCaprio, Muhammad Ali and Britney

Spears. David has worked for the most prestigious international publications and has exhibited in both commercial galleries and leading public institutions worldwide.

He has taken elements of street culture and spun them into his work that, today, is hard to pigeonhole. It's art of the highest form, but with an edge, a cheeky nod to the past and one eye on the future. He also works as a documentary director (check out his krumping film *Rize*) and music video director for artists such as Amy Winehouse, Elton John, Christina Aguilera, Moby, Jennifer Lopez, Britney Spears, The Vines and No Doubt. There is no one else out there doing this kind of shit at the level that David is: truly inspirational.

→Turn to p52

MANDI LENNARD

Mandi is the head of her own PR agency and has had some of the best ideas to promote fashion in the last ten years. I love the idea of her being in this book as she plays just as an important part in the street art scene as the other talents, and it is paramount to me to show all sides to everything. I love her ideas that seem off-the-hook but work equally well on the high street as they do in more alternative places such as London's Hoxton or Shoreditch, as this is when you know you've got it right. I also love the way she promotes young talent that has caught her eye and then put her money where her mouth is to help them get their ideas out there. Mandi grew up in north Leeds in the heart of a Jewish, middle-class community.

'I even went to Jewish school. I knew nothing, I felt like a nothing, and I just wanted to be recognized for something which I think is where fashion comes into it, as fashion is all about clues, and I just wanted to let people know in a subtle way that I wasn't clueless. I appreciated living in a city, as we had stores such as Bus Stop, and there was a Biba concession in Topshop, but all the action was going on in Manchester so as soon as we all started driving we went there clubbing every night. I suppose *Top of The Pops* music chart show was a big influence and magazines such as *Smash Hits*, then [clubs] The Hacienda, Rock City all-dayers in Nottingham, and the Wag Club in London. There's always a soundtrack – to everything I do.'

I love her work ethic:

'I'm just riding the wave, breathing creatively, avoiding myself getting bored (the black hole of my childhood), and jumping to the beat. I'm an ideas person and I think faster than I can operate, which gives my work an innate sense of excitement – you feel as though you are going to hyperventilate. My biggest asset is my imagination. Once I know how I am going to tackle something, the worst thing I can do is have another idea as it makes more work for me, it's unnecessary, but I can't help myself, so my energy levels are constantly being sapped…'

148

→Turn to p168

'Street culture is the collision of ideas, rooted in the
moment – music, art, design – little gangs huddled
together at the start of their life journey young-minded

THE LONDON POLICE

www.thelondonpolice.com

The London Police are some of the most respected street artists in the world. They began life when two English geezers moved from London to Amsterdam in 1998 to rejuvenate the visually disappointing streets of the drug capital of the world. Ever since then they have been travelling the globe creating amazing iconic art on the streets and in galleries, as well as generally having a good time. Its members have numbered four, three, two and one over the years but today TLP is back to the core – Chaz and Bob – the optimum art tag-team. You will have seen their iconic characters on the walls in any number of cities as they get around and get up like nobody's business. I spent some time with Chaz and Bob in their Amsterdam studio as they worked on a new set of paintings.

'The characters came to life in two places. Antibes and Amsterdam,' says Chaz. 'They were born in a campsite reception in the south of France, where I was working. It was a really tedious job and there wasn't much to do all day except sit around and doodle. Such is my kind of lazy nature, to achieve as much as possible with the least effort, I liked to draw these stickmen over and over. These primitive figures (which would later evolve into the character I draw today) were enjoyable to make. I could draw many in a row in a short space of time and even though it was the same thing each time I was captivated that they'd all have different personalities. In essence, it seemed impossible to draw the same one twice regardless of how basic they were.

'If they were born in Antibes then they were nurtured in Amsterdam, and at the end of that summer I moved to Holland's capital. I didn't have much money and I found myself living in a squat quite quickly. I was still very much into drawing this character continually so I began to put the characters (I called them LADS) all over the walls. Pretty soon the whole place was covered with them – I look back now to that winter in 1998 and realise I must have seemed like a madman. But seeing where I came from and where I am now makes me feel like I was actually on the beginning of an amazing magical journey where a simple character was able to take me round the world for the next ten years.'

As we chat, Bob is working away on a canvas and occasionally cracking Chaz up with a wise quip or two – usually about the heavy German rent boy scene. The two geezers have taken to collecting gay flyers and planting them on each other in wallets or pockets so they pop out at the most untimely of moments. Only the other day, Bob tells me, one fell out of his wallet in front of his girlfriend and her mum and dad when he was paying for the dinner at a restaurant.

I ask him about their obvious friendship.
'Working together there is a certain amount of chemistry going on, it's quite easy. We're a couple of good friends who have known each other for over fifteen years. We understand what we're trying to achieve. When you work with someone on a project like TLP you gotta spend a lot of time in their company. Our personalities and, more than that, our two styles make a happy and cohesive partnership. His simple characters and my straight lines work perfectly. We both pretty much know what the other one is going to do. I know my role and he knows his.'

→Turn to p82

'My influences are my friends and family.'

'My art is about Life, Passion, Joy and Love.'

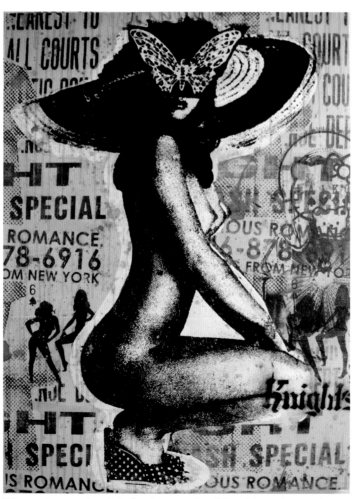

'My art has evolved through everyday life with real experience.'

LADY AiKO

www.ladyaiko.com

Aiko, AKA Lady Aiko or Aiko Nakagawa was one of the founding members of Faile. She has been working as a solo artist since 2007. Her art is east-meets-west in a pop-art/ street graphics tear-up. She is an amazing artist and all I'm gonna say is that I'd never kick her out of my art crew.

'I was born in Tokyo Shinjuku district, middle of everything concrete jungle, surrounded by high technology and high fashion. Street culture could be too new to understand but it is very important to make our life exciting.'

153

LONDON

London is one of the most multicultural places you'll ever visit. As soon as you get into town you'll hear a million different languages. I'm sat on the number 73 bus driving from Kings Cross to Islington writing this shit and I can hear Spanish (a gang of well dressed guys) Turkish (old boy on a cell phone), and I'm sat next to a Japanese girl listening to J-pop on her iPod, and there are a couple of Nigerian guys sat behind me discussing their many jobs.

London is also the capital of the world of street art and street style. I spent my teens running around the streets of London looking for the dopest street wear from Camden to Ladbroke Grove and hanging out in a range of clubs – ending up as one of the resident artists/idiots in the Brain Club on Wardour Street. The Brain was more than just a club, it was the last true hang out for London creatives. Trevor Miller, Derek Delves, Paul Daly (from Leftfield), Barnzley, The World Famous Temple of Shaolin, James Lebon, DJ Alfredo, George Michael, A Guy Called Gerald, Jefferson Hack, Robert Elms – all of them used to hang out and vibe off one another. The place was run by Mark Wigan and Sean McLusky and was about more than just music and dance. It had a profound effect on how I approached creativity and I am proud to have been part of it. This was when I discovered the true genius and application of original thought and ever since I have been travelling the world looking for and being inspired by other original thinkers and talents and creative souls. It was around this time that I was a student at Central St. Martins College of Art and this was when I began to actually work at a level that I considered was good enough to show. I had my first exhibition of my words and images at the Brain Club in 1990. This was the start of my career!

London has been the launch pad for many sub-cultures and fashion movements (>p302), and I have been a witness to and participant of these since the 80s to the present day. Street culture is all about the reality of urban life filtering into whatever creative discipline you are into (music, art, fashion, food etc) and the streets of Londinium have played a vital part in the whole culture.

East London has been where it is at for the last ten years (namely Hoxton, Shoreditch and London Fields) for the young creative-about-town, and there are a million great spots to eat, shop, and spot the freshest street art in the East. I love just mooching about the Old Truman Brewery and seeing who I bump into. And at night the place comes alive like a Cinderella Rockerfella. The Hoxton Hotel is just around the corner from the Old Truman Brewery and a great place to jump off. It's a budget designer hotel with wicked rooms that are affordable. A short schlep from the hotel is the best Indian in London, Tayyabs in Whitechapel – well worth waiting for in the queue at night. Go for the mixed grill for two and the chicken karahi. Most of the restaurants on Brick Lane are best avoided, as they are just there to fleece the tourist. There is a Bangladeshi supermarket halfway down on the right (when facing north) and is has the most amazing range of foods.

The West End of London is pretty much chock-full of high-street shit and tourist traps. Nothing of any cultural value or interest, in my opinion. I never go there, which is a bit of a shame as Covent Garden is a nice spot, but at the best of times it's rammed full of tourists. As for Oxford Street, don't get me started!

HOT SPOTS

Best food in town: Tayyabs 83–9 Fieldgate Street (www.tayyabs.co.uk)
Great hotel: The Hoxton, 81–3 Great Eastern Street (www.hoxtonhotels.com)
Best clothes shop in town: The Hideout, 7 Upper James Street, London (www.hideoutstore.com)
Wicked Gallery: The Black Rat 83 Rivington Street (www.blackratpress.co.uk)

→Turn to p202

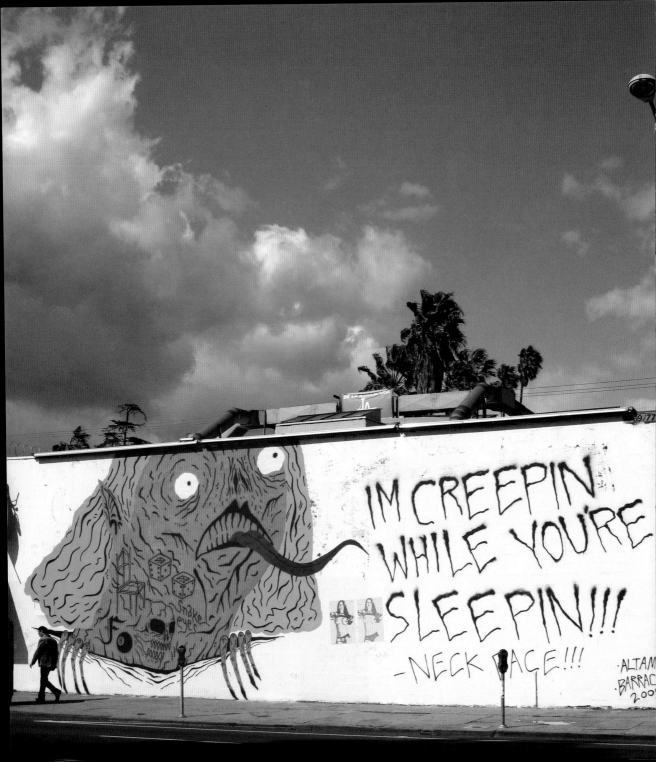

The thing that first strikes you as you fly into LA is how big the place is. And then you begin to get around a bit and you realize that it's actually a lot bigger than that. Times ten. On my first day in LA I pick up my car (no way around this) and drive to the legendary graff supply shop 33 Third in Crenshaw. I start shooting the totally bombed interior of the shop and the owner takes me out the back to a graff-filled yard. I'm wandering around shooting away when I spot a few guys hanging out in the nextdoor yard. These guys, I realise, are real-deal gang-bangers, talking business and rolling joints. Something inside tells me to put the camera away and back the fuck up. This is when I begin to understand that in LA there is a very fine line between the real and the fake. The real being the gangs and the fake the rest of the people!

The first night I step it up a gear by hanging out at the Roosevelt Hotel's pool bar. This is the place featured in Hockney's Splash painting – an oasis of excess where LA rich kids cavort with movie execs around the pool on large soft sofas. A girl comes to the bar and asks if she can remove her top and jump in the pool. The barman says he doesn't have a problem with that but the hotel security might and would probably ask her to leave - the ultimate social faux pas, seeing as you have to be there to be seen. But it was all just typical LA bravado; more about the idea of the act rather than the act itself. The girl walked off, kept her clothes on and stayed dry.

The next night I ask around and get a few recommendations of cool places to hang (Jones, The Coach and Horses, The Rainbow Rooms) and head off in my rented Chevy down Santa Monica Boulevard. Driving, driving, driving. Each bar I visit is kinda full but with no real feeling. Everything's a little on the fake side. Nice and neat, but with nothing really going on (everyone is behaving themselves). I make a point of asking every waitress – all hired for their looks in LA – about where I should go next, where the best spot is, the best place to be yada yada yada. And the mad thing is that nobody really seems to know where to go in their own city.

I watch, I listen and I remember. The alcohol-free beers begin to make me shiver as I hold on to the LA rollercoaster. I spend the night stuck in a loop of bars and fools and fools and bars… and by midnight I'm driving home, and we get stuck in traffic on La Brea and soon I find out why: a big jumping club with people crowding the pavement trying to get in. People who are mostly girls wearing very little. But by this time I'm ripped on jet lag and just want to get to bed.

I spend the morning hanging out with my mate Mike at his vintage clothing store Filth Mart and then hook up with screenwriter Trevor Miller, author of cult 1980s rave book *Trip City*. Trevor has been working in Hollywood as a scriptwriter/ scriptdoctor for such fools as Stallone, Van Damme and Segal for the last fifteen years. He's originally from Manchester and I knew him when we were both residents at the Brain Club. He has plenty of great stories and takes me to a killer Mexican

restaurant La Parilla in in Silver Lake, which is a cool Hispanic area well worth checking out. Just up the road is the Echo Park area, home to Obey/ Shepard Fairey's (>p186) gallery Subliminal Space.

Then I bowl back to Hollywood and hook up with an oke and this person is, like, totally connected and takes us out to the Rainbow Rooms (see how the local parlance is slipping in) – a throwback to the LA of the 1980s, full of hairspray rockers and their bleach-blonde bimbos, all trying to party like it's 1985 and it's still cool to be doing bales of coke and letting rip to Mötley Crüe. It's a weird trip and we get to hang out with Ron Jeremy, who is a mate of our guide. The place, in my opinion, is a fucking smelly hole full of wankers. I get ID'd on the way in and I tell the guy I'm fucking well old. 'Just look at his eyes, our guide tells the bouncer, who then lets us in. Yeah, cheers mate. So we eat some moody pizza and for some reason the waitress begins to diss us and it goes off somewhat and we have to leave in a hurry.

I spend the Friday morning walking down Melrose looking for street shit. As you can't really walk anywhere it makes my usual routine of wandering around a city looking for stuff to write about or shoot really hard. This is the stuff you can't do from a car. You need to be on the street. But I had a go anyway and spent the day jumping in and out of my car to shoot Banksys, Nick Walkers, Listers, Neckfaces and other street scenes from the year 2G+9. That night I get a call and told that I'm on the list at what is considered one of the hottest clubs in LA, The Villa, where you have to be a famous fucker or a Hollywood wannabe starlet to get in.

I spend the Saturday in Venice Beach, where I meet up with Retna from the Seventh Letter Crew, who is painting a large wall piece just off the beach. Venice is a cool, cheap place full of crazy fuckers and tourists looking at the crazy fuckers. One of Hush's (>p106) collectors, a divorcee from Beverly Hills, strolls by and I soon chat her into inviting us round to her place that night. She really wants to be down, is desperate even. She writes the address down on the back of a chewing gum packet and then I head back to Hollywood on the absolutely chocka freeway heading east.

The last night I hang out at Hollywood & Ivar, the street with the newest bars and clubs, mostly populated by gang-bangers from South Central. The thing about LA is that all bars and clubs close at 2 am. And so when the places mentioned above close, all the different cliques come out on the street and show out. Shirts come off, gang signs get thrown about and sometimes guns are let off. The police leave the place alone unless shots are fired, which is when they descend in heavy numbers, and put the place under heavy manners. It is a bit hairy at times but an experience you'll never forget.

HOT SPOTS

<u>Eats:</u> Pinks Hot Dogs, La Brea La Parrilla, 3129 W Sunset Blvd, Silver Lake
<u>Bars/Clubs:</u>
The Roosevelt, 7000 Hollywood Boulevard
Cinespace, 6356 Hollywood Blvd
Ivar 6356 Hollywood Blvd
The Echo 1822 W Sunset Blvd
Element, 1642 N Las Palmas, Hollywood
Le Deux, 1638 N Las Palmas Ave, Hollywood
<u>Shops/Galleries:</u>
33 1/3, 5111 West Pico Blvd, Mid City
Barracuda, 7769 Melrose Ave, Hollwood
Subliminal Space, 1331 W Sunset Blvd, Echo Park
The Carmichael Gallery, 5795 Washington Blvd Culver City

→Turn to p284

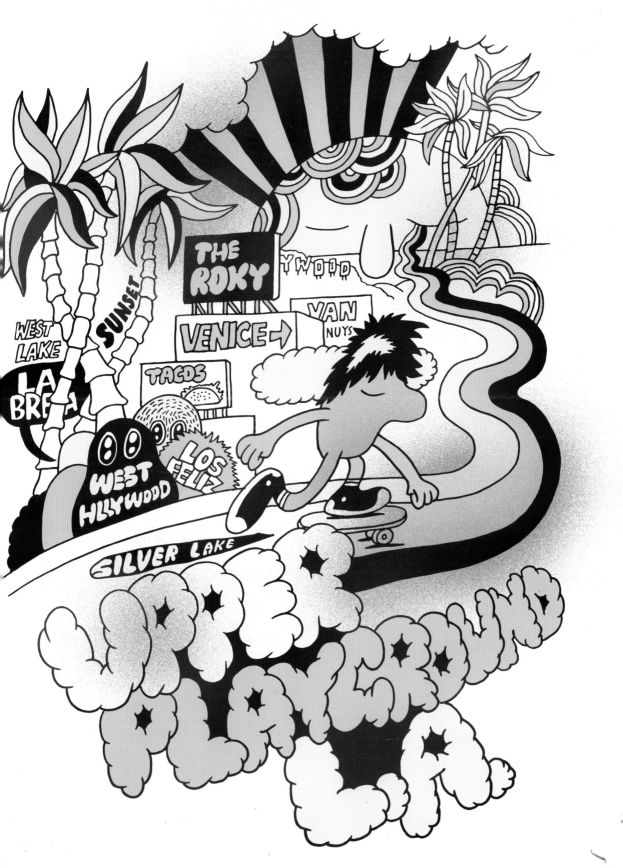

LOMOGRAPHY

www.lomography.com

In 1991 a bunch of students accidentally
rediscovered the Lomo camera at a flea market in
Prague. The Lomo is a small compact camera from
St Petersburg, which was (under Communism)
well-known all over Eastern Europe and the Soviet
Union. Soon after the rediscovery, word spread
and the camera got mad love for its easy handling
and for the colourful, arty, pictures it shot. Lots
of creative people fell in love with it and The
Lomographic Society was founded. Cameras were
smuggled out of the Eastern Bloc to Vienna and the
first exhibition hosted the first-ever Lomowall (a
huge photo-covered wall, which today is the most
important key visual of the Lomographic Society
and its community). The rest is history. Then the
international press discovered the Lomo as a great,
accessible product to write about, which sparked off
a huge argument between amateur and professional
creatives. The thing about the Lomo is that anyone
can take a decent art photograph and that this has
annoyed the self-styled professional photographers
of the world. Many a time I have pulled out my
Lomo to be dissed by a photographer with his
huge DSLR.

Lomography launched their website in 1996, so
people from all over the world could be part of the
Lomographic movement and contribute to the
ever-growing digital Lomowall. Ever since digital
photography has became the norm, people like
me are rediscovering analogue photography as it
produces imagery that you just can't get with a
digital camera, no matter how many megapixels
you have! What's more, unlike digital, you can fuck
with the process of analogue photography, which
makes it very individual because you are not able to
delete the pictures you've just taken, and you need
to wait for several days until you see the results of
your work. Most importantly, it is a process and a
personal development: you have to learn, if you
want to improve your photographic output.

THE TEN GOLDEN RULES OF LOMOGRAPHY

1. Take your camera everywhere you go

2. Use it anytime, day or night

3. Lomography is not interference in your life
but part of it

4. Shoot from the hip

5. Approach the object of your Lomographic
desire as close as possible

6. Don't Think (William Firebrace)

7. Be Fast

8. You don't have to know beforehand what is
captured on the film…

9. …or afterwards

10. Don't worry about the rules

→Turn to p108

MISS TiC

www.missticinparis.com

Miss Tic has been creating her unique street art since 1985 when she discovered the art of pochoir (the French word for stencil). Before she took to the streets she was a poet, newspaper critic and performer. She has published twelve books of her work (poems and stencil art) and continues to create her amazing art around the world. Miss Tic describes herself as a 'plastic art poet' who works with words and images in an urban environment.

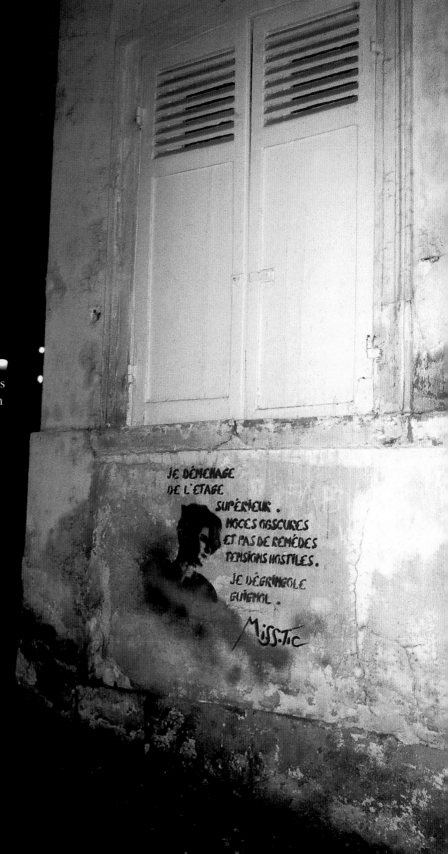

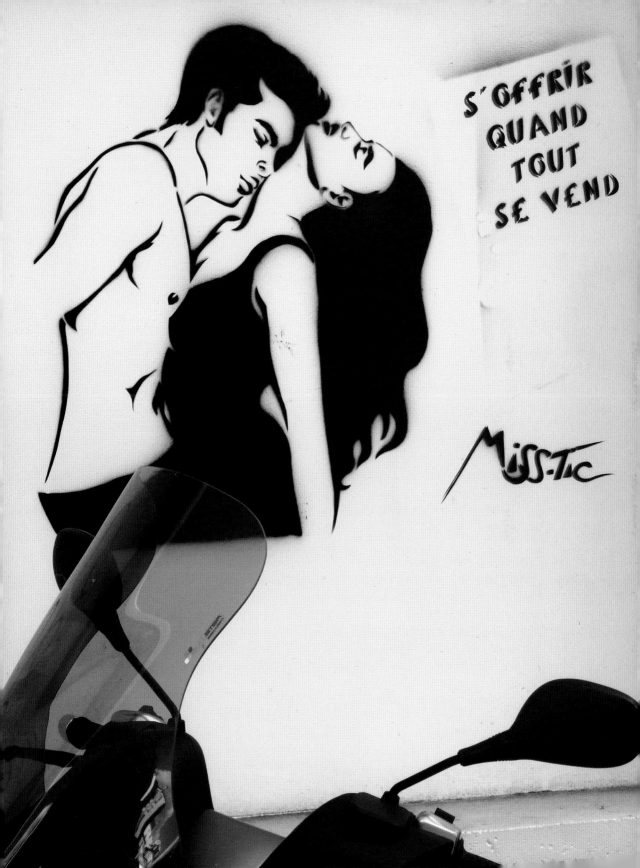

S'OFFRIR
QUAND
TOUT
SE VEND

Miss-Tic

MiXTAPES

Back inna day, DJ Kool Herc, Afrika Bambaataa and Grandmaster Flash (>p100) would record one of their DJ sets onto a cassette and then this would become known as a Party Tape which was the beginning of the evolution of the hip hop mixtape. This tape would then be sold or copied and become the sound of a million parties in the Bronx, Queens, and Harlem.

'I got into mixtapes after I was inspired by creative people like Green Lantern and Kid Capri. I wanted to make a contribution to the culture. The mixtape has replaced albums as the go-to place for artists to express themselves quickly and easily. I have so many favourites. Either classic Funk Flex joints or early Green Lantern stuff. And about half of Danger Mouse's Grey Album.' Mick Boogie AKA The Commissioner

Before the Internet there were mixtapes. They were like an analogue version of the web. Local DJs and producers would mix a cassette of their favourite tracks and put it out there. Some were free, some sold by the boot load (the usual method

of street-level distribution), some were shit but most killed it. Then came the mixtape mk II, where the DJ would take an acapella of a classic track and then get a selection of local rappers to ice the cake with their own take on the tunes. This took it somewhere else and before you could say 'pimp that', mixtapes became big business.

'See this whole DJ game? I've been peeping this shit from the get go and this young nigga right here, he changed the whole game up. He was the first nigga to put the mixtapes on CD. Matter of fact he was the first nigga I wanted to motherfucking kill due to the fact that he leaked one of my Biggie records.' P. Diddy talking about DJ Clue

KiLLER MiXTAPES
Kool DJ Red Alert Kiss FM mixtape (1987)
Kid Capri 'The Tape' (1991)
Biggie Smalls Mixtape #1 (1994)
DJ Clue 'The Professional' (2001)
Mick Boogie & Lupe Fiasco 'It was Written' (2006)
The Clipse presents Re-Up Gang (2009)

ALEX MAMACOS

Alex is one of my favourite documentary film-makers. You might not have heard of her but – boom! – now you have. Alex is Cape Town born and bred, and her life, her attitude to others and her films represent all that is good about South Africa. She has made two great docs about her life, and is currently still working as a cameraperson, to develop her skills. I pulled alongside her one winter's day in the Cape and she told me what was up.

'I'm still discovering what the point of documentary film-making is, but I think it's got layers of meanings for me. In the process of making a doc it's cathartic, it's a healing process, when you are making personal stories at any rate, but I think that extends to other stories if you handle them in a way whereby you don't put your own agenda into it, rather allowing the story to tell itself and be what it is. Whilst a doc has this ability of having a cathartic value, as a film-maker it's quite a responsibility to allow it to do just that, without interfering, and thereby eliminating that value.

'I think an amazing thing about documentary is that it gives the people voice. And it's a voice that goes out there, and that is an incredibly powerful thing. It is a tool for that person to really express himself or herself and have the camera bear witness to that, like with the whole Truth and Reconciliation Commission hearings, it touched such a small amount of the people who needed to go through that process of being heard and it didn't hear everybody it should. The documentary could give voice to and reach people who weren't reached in these hearings. There is also a lot of negative mass-media stuff about South Africa going around, and the doc is a way to tell a lot of the positive stories on the ground. I see the person always as being more important than the film at the end of the day. There is a lot of anger and pain still to be voiced in this country and people are very entitled to that, and it is through this precisely, that there are also a lot of great positive incredible stories of hope bravery and love. These are the stories I would love to be chosen to help to tell.'

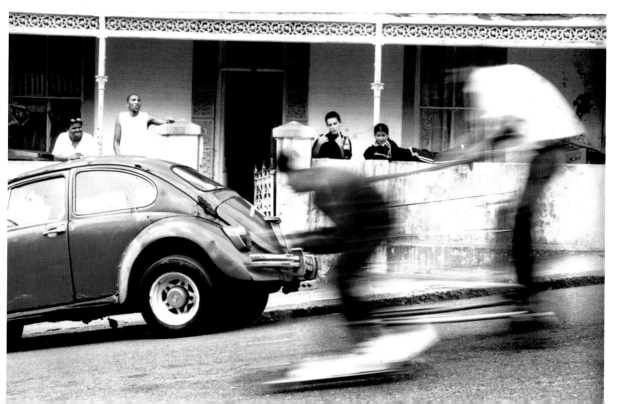

CARRi MUNDEN

www.cassetteplaya.com

Staight outta Nu-Rave, Carri is one of England's most innovative fashion designers, and has her own fashion label, Cassette Playa, and her own Nike Blazer. She is also in much demand as a stylist, working with brands such as Pharrell's Billionaire Boys Club, Nike, *Supersuper* and *ID* magazines, and has worked extensively with M.I.A.

Her fashion is an insane, undiluted mix of street and club styles which eye-balls Future Primative, as she defines it. Her family is originally from East London but she grew up on the south coast.

'As a teenager I was kinda part-chav part-goth/ metaller. I grew up surrounded by the hardcore (rave not punk) and jungle scene which has been a big influence on my work.'

She is blowing up around the world but this hasn't slowed her down or made her complacent.

'I'm proud to be English but I always saw Cassette Playa as a global brand. We now have international stockists, and opportunities such as Magic LV, Pitti Uomo [Florence-based fashion fair], Honeyee [Japanese web mag] and collaborations with Nike and Stussy have made this a reality. Each season, I hope, is an evolution, my inspirations follow the same threads but each collection is a new story, a new tribe. What really drives me is creating the graphic and digital prints. Each season I wanna make the next level, I also love the challenge of adapting my aesthetics to other areas, like film. There is sooo much I still want to achieve.'

'My heroes are Keith Haring, Tank girl, & Amir Khan'

→Turn to p210

MELBOURNE

Unknown to a lot of people on this side of the world, Melbourne has been the stencil capital of the world for many years. The city is probably one of the most artist-friendly you'll find in Australia, and in some areas street art is (almost) legal. The two main areas in Melbourne to check out are the city centre and Fitzroy.

The city centre has a couple of infamous laneways, which provided the natural environment for Melbourne's street art scene to explode. There are two main spots that always have the fuck bombed out of them: Hosier Lane and Centre Place. These are both easy to get to from anywhere in the city. In Hosier Lane you'll find yourself amongst the swarms of peeps who go there to gawk, take photos or have their wedding shots done in front of the murals. Centre Place used to be a dead end full of stinky rubbish bins and rats. It still is, but now it's coated top to bottom with artwork supplied by peeps such as the Rats of Melbourne, Ghetto Make Over and a million other graffiti groms (beginners).

The neighbouring alley has developed from a dead-end street to boutique mecca, bringing with it thousands of shoppers, hipsters and commuters every day. Fitzroy and Collingwood are the first suburbs immediately north of the city. Their main drags are Brunswick Street and Smith Street. These run parallel to one another and create the loose borders for one of the world's largest and most amazing street-art galleries. The outsides of just about every café, bar, clothing store and house are painted with every kind of graff you can imagine. The local council here has been the most tolerant of any in the city towards graffiti over the last decade. This is now paying off culturally with first class, large scale, negotiated walls being painted continuously.

'Melbourne is the cultural capital of Australia and has a gluttonous amount of galleries, artists and general good things going on. I'd met a couple of people who had moved there and after visiting them I decided it was the place for me. My mate Ben Frost was living with this crazy Maori artist who was into stencils and introduced us. We got along real good, started bombing a whole lot, and the rest is history.'
James Dodd
(>p50)

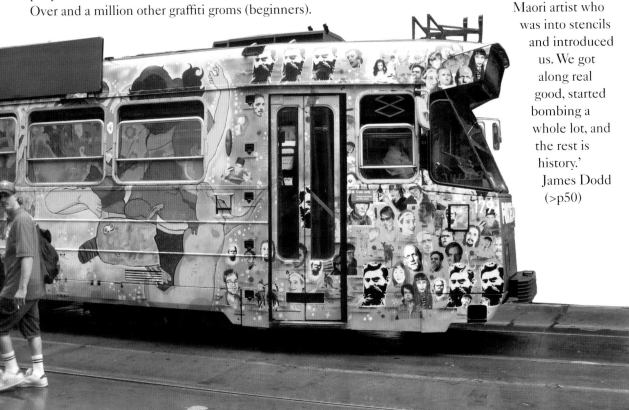

Melbourne has the best café and small bar scene in Australia. It has distinctly different liquor laws to the rest of the country, which have allowed many bars to be started with fuck-all money. Most are fitted out with only cheap materials and ingenuity. Melbourne's intimate bars make for a very warm and comforting escape from the chilly winter.

Combine your visit to the Centre with a cheeky beer at Hell's Kitchen which overlooks the hustle and bustle of the lane. For the best coffee on Brunswick Street check out Atomica. Melbourne is often jokingly referred to as New Zealand's third capital city. Here you'll find thick Kiwi accents, dubwise tunes and plenty of natty hairstyles (bro). A couple of metres up the strip is the Black Cat, the perfect street-side beer garden for people-gazing and relaxing.

HOT SPOTS

Eats:
Cutler & Co (www.cutlerandco.com.au),
55–57 Gertrude Street, Fitzroy
TOFWD (The Organic Food and Wine Deli)
www.tofwd.com.au, 28 Degraves St.
Coffee: Atomica Caffe, 268 Brunswick St, Fitzroy
Kent Street Café, 201 Smith St , Fitzroy
Drinks:
Hell's Kitchen, 20 Centre Place
Black Cat, 252 Brunswick Street, Fitzroy
Hostel: Nunnery Hostel, (www.nunnery.com.au)
116 Nicholson St, Fitzroy

→ Turn to p256

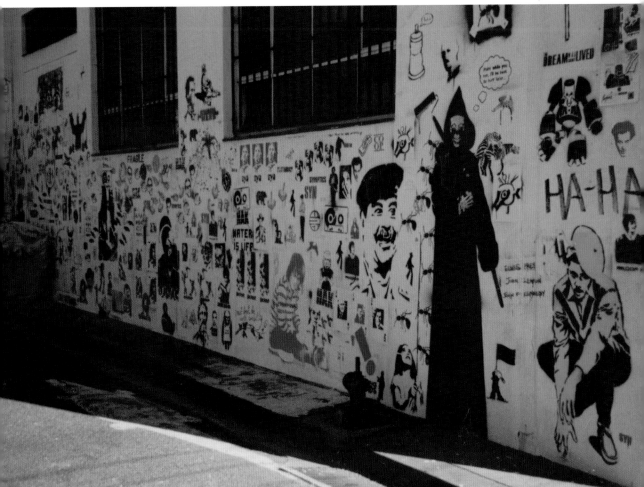

MADCHESTER

'And on the sixth day God created MANchester' reads the mosaic mural in Short Street, in the Northern Quarter of Manchester. Perhaps it should read 'Madchester', as this was the name widely adopted at the time. Go back to 1988 and the start of the second summer of love (>p122) and local producer A Guy Called Gerald's breakthrough hit 'Voodoo Ray' was one of the classic sounds of the time. Swiftly followed by The Happy Mondays' 'WFL'. Madchester was about being northern, not giving a fuck and having a good time – something that you weren't supposed to be doing in a grim northern city.

'It sorta started as a small nucleus of people – we all knew that we had something to say and were opinionated in our own world. Eventually we were gonna find a way of getting ourselves heard. We'd meet up in the corner, under the balcony in the Hacienda, and once that shut at 2 o'clock there was fuck-all else to do. So we'd end up going to places like "the kitchen" , an illegal party in the flats in Hulme, or to Shebeens in Moss Side. It was all about having a good time. We'd leave there and pretty much go straight into the studio the next day.' Pat Carroll (>p34)

In 1986, the Hacienda nightclub (owned by Factory Records) was the first club in the UK to take house music seriously with its Friday Nude nights. The night not only pushed the whole house scene forwards in the UK, it also turned the club from a loss-making dodo into a full-every-night cash cow. No door policy meant that everybody could get in, and it was cheap. It was at the Hacienda that 'Voodoo Ray' was first played. Gerald Simpson was from nearby Moss Side and changed the face of house music by creating a unique sound that was influenced by Manchester as well as Detroit, which was where the record ended up getting exported to and played on the dance floors.

Factory Records owner Tony Wilson was the first person to show punk on TV with his *So It Goes* show between 1967 and 1977. He was the pioneer who helped make Manchester become the city of punk, after it moved north. Manchester made a serious impact on the musical sub-culture with Joy Division. And then came the legendy Happy Mondays, who took dance music and fused it with English rock, to change the face of English music.

'Central Station, Bez and me ended up living together in a house in Fallowfield. We'd get back from the Hacienda at 4 am and the queue outside would be even bigger than the ones to get in the club. Best place we ever lived.'
Shaun Ryder, Happy Mondays & Black Grape

→Turn to p34

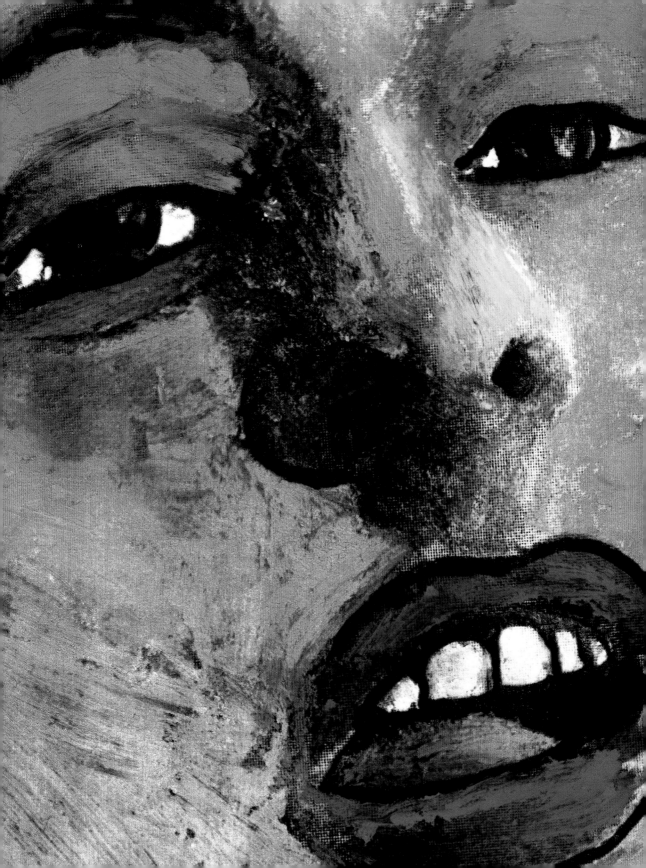

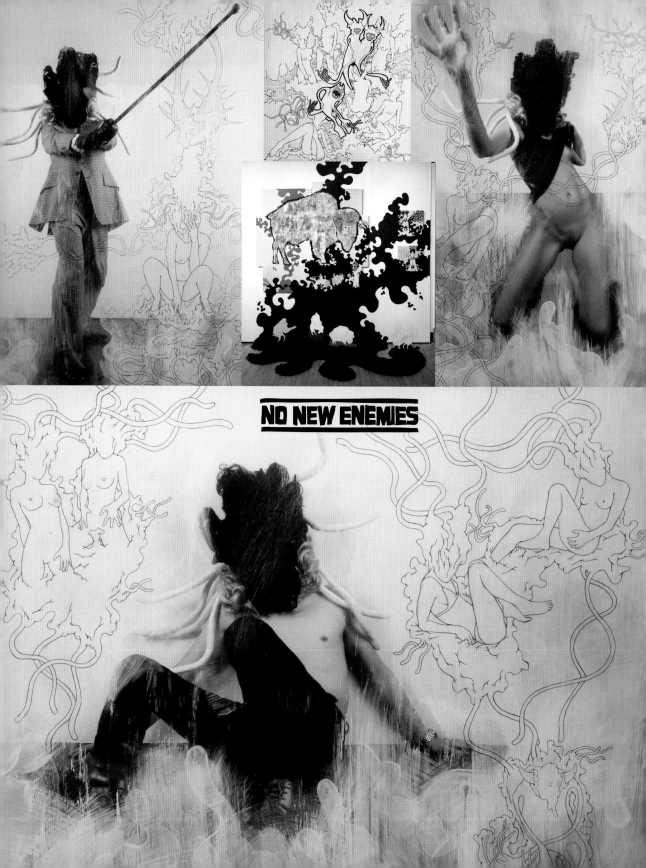

NO NEW ENEMIES

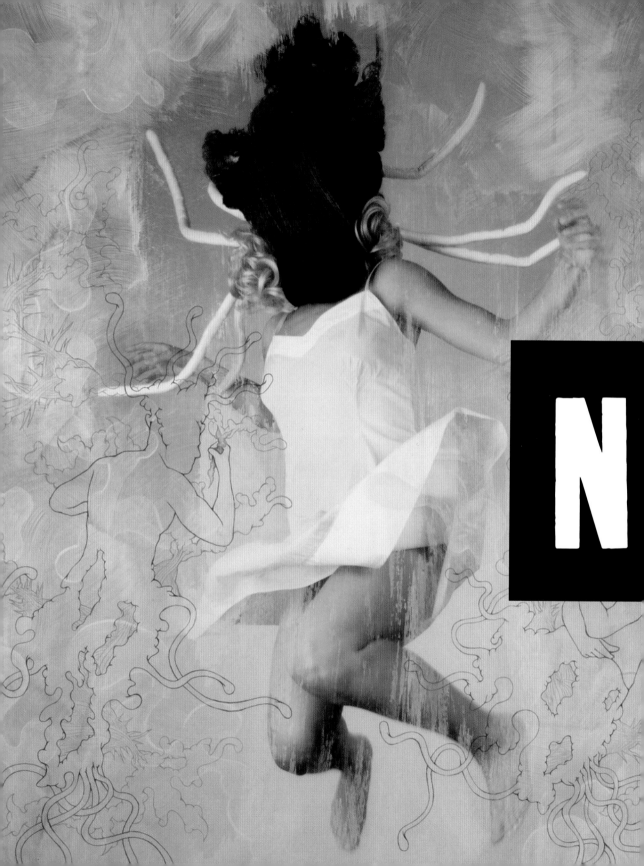

Imagination sets the boundaries of Free Will.

NO NEW ENEMIES

www.nonewenemies.com

No New Enemies is an international art and design collective with the following core values: community, failure, media aesthetics, love, possibility, pleasure, struggle, new spaces, sincerity in place of seduction, and movement. Its founder, Harlan Levey, reckons, 'I think the only way to give people a coherent answer about what we do is to guide them towards the heaps of information on our website. A more direct answer is that the work of NNE is all about the people working on it and what they are trying to question or express.

'For the past few years NNE has been fortunate to have many stimulating collaborations running on each other's tails. I'd like to collaborate with considerate, brave and determined people who would challenge me at all steps. Part of the grounding optimism (and energy to keep kicking), which fuels the No New Enemies network owes a great deal to the knowledge that these criteria make for a very extensive and open-ended list of fruitful, fun and potentially meaningful collaborations.'

NYC is perhaps the most influential city in the world. Okay, so London has had its moments (as you have already seen) but NYC is the one place that has spawned so much: the hip hop/graffiti movement (>p100), the Downtown scene, Pop Art to name just three massive influences, and then it also has the greatest range of food, fashion and culture on offer. It is the city I've visited most in the world, and so I took a trip there to remind me what makes it so great.

'Fun! Dangerous (guns, knives, abusive cops) but exciting and new lots of great street art too.' Kenny Scharf on what was New York street life like for an artist in the 80s

I always fly into Newark Liberty Airport, a 20-minute train ride ($15) away from Manhattan, and much better than the black hole that is known as JFK, which is a $45 cab ride (plus tip) away from the action. And in an hour I'm walking up the steps to the apartment I stay in on St. Mark's Place. St. Mark's was once the hang-out for the original punks of NYC (New York Dolls etc) and even though they're trying to smarten it up a bit it still has a real greasy vibe. Search & Destroy and Trash & Vaudeville are the two best shops for vintage and original punk/downtown clothes. Scene kids would go ape-shit in here.

A West-Coast 1970s rock classic blares out of a small transistor radio as I shoot a lone hard-hatted black construction worker on the roof of an on-the-up skyscraper. The opening guitar hook catches me and wraps me up in the music and the sunshine of a June day in NYC. I'm rooted to the spot and can do nothing but stand and bask in the moment, digging the song, even though deep down I know it's shite. The song plays out and I walk away, thinking about how there are so many buildings going up in NYC, but the sight of the guy on the roof listening to his FM soft rock stays with me as I slowly walk down 1st Avenue.

'Yo! Yo! Yo!' The guy shouts at me.

'Hey brother!' I reply to the smiling but toothless Bowery bum, who's desperately trying to get my attention.

A 'What's up my man?' is all he wants. He's not after anything other than acknowledgment, so I ask, 'What's up my man?'

'Not much, just checking in…'

'Cool… You take care now,' I tell him before he shuffles off towards a small group of other tatty bums on the corner.

Welcome to the L.E.S. – the Lower East Side of Manhattan. The L.E.S. is the only 'real' part of Manhattan left. The East Village (above the L.E.S.) has been taken over by the rich and trendy, forcing the remaining real people down into the 'Belly of the Beast' and out into Brooklyn. And to experience the real L.E.S. you have to get down with the Bowery bums. They are the kings and queens of the streets, they have the experience and knowledge.

The East Village hangout for all kinds of people is Tomkin's Square Park. Skaters and bums, the homeless and the well-heeled who come to walk their dogs in the two dog parks (one large, one small). I chill on a bench one afternoon filming the skaters and watching the homeless (all really young) going about their business. Holding it down without a frown I traverse the avenues, fly over the streets – the numbers counting down until they become alphabetical: 3, 2, 1, A, B, C… I glide through the

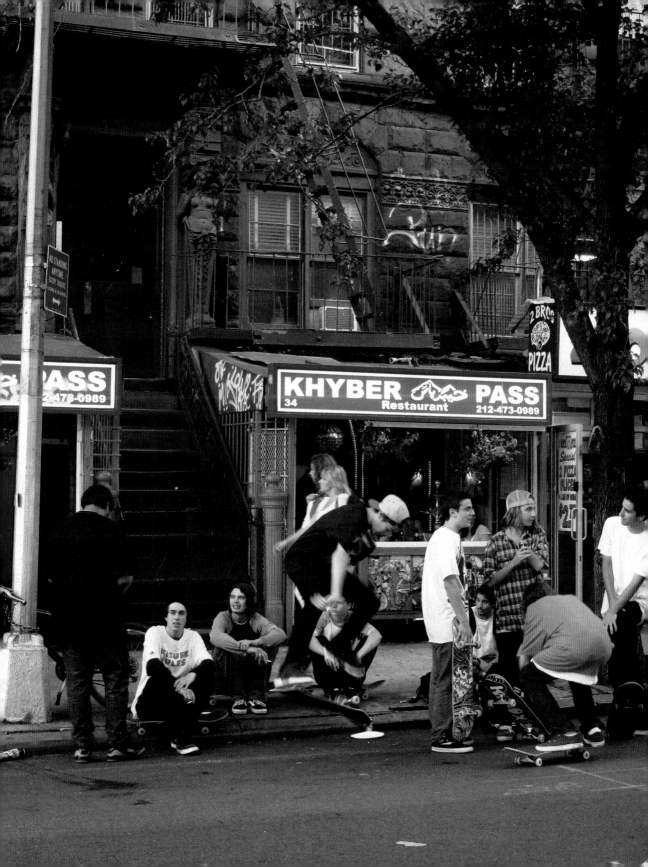

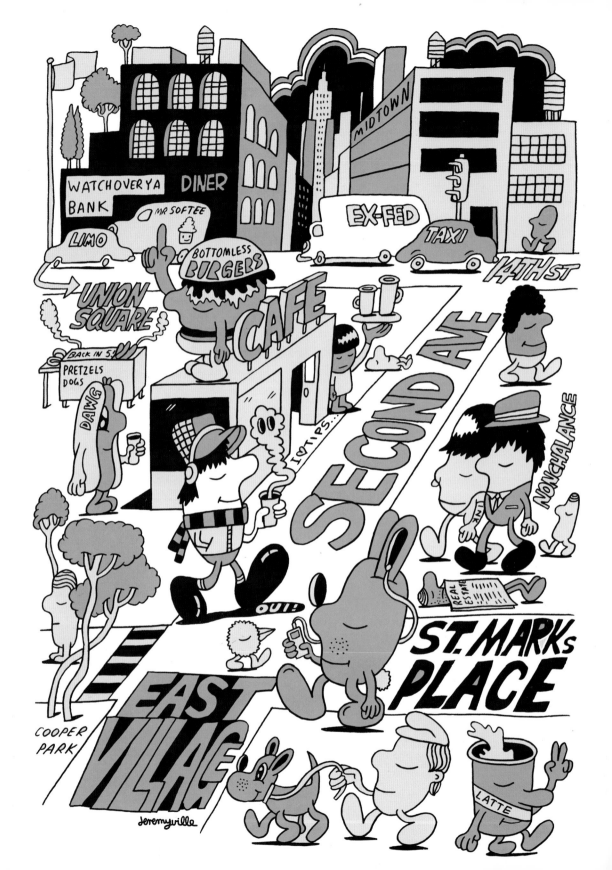

corner spots past the gangs of homies, who are still living large, still holding it down. (A good place to score is the Salvation Army East Village Residence on Bowery – not that I check this out, because if I was busy taking drugs you wouldn't be reading this!)

The next day I mooch out for breakfast (two eggs over-easy – whatever that means – on country bread with home-style potatoes) in the *Cafe Pick Me Up* when this shirtless crackhead appears and shouts 'Do you know who you are?' at me. I look around for some ground support, but no one else in the place even bats an eyelid. At that very moment my agent calls me, so perhaps someone else can answer that question for me. The crackhead keeps repeating his question and it's only when he drops an over-sized can of 99 per cent proof malt liquor out of the plastic bag he's holding, that he stops. I get my camera out but this seems to anger him slightly (an understatement). Eventually he moves along and I shoot him harassing some chi-chi girls in their D&G glasses trying to have a quiet coffee. He repeats his question to them and I breathe a sigh of relief that he's asking everyone, and not just me. But he did have a point, in this crazy-assed city: 'Do you know who you are?'

When I'm in town I never go above 14th Street as the L(ower) E(ast) S(ide) is where it is at. It used to be the place for all the skaters/boho/artists/cool fuckers, but then the money moved in and forced the prices up and the nice peeps moved out. Then I'm on my way to have lunch with veteran skater Rodney Smith (Zoo York/Shut). After checking out his killer store at 158 Orchard Street he takes me to an equally killer Chinese restaurant called Congee Village. Rodney is an old friend and I was honoured to have him as one of the original talents in *The Urban Cookbook*. Major respect to the pioneers – always. We chill and chat about skate shoes, skate brands and skaters, while chowing down on hot and sour soup, snow pea leaf with garlic and beef fried rice. Best Chinese I've eaten in NY. Ever.

After an intense week in New York I find myself sitting in Newark Liberty Airport eating a pepperoni slice and drinking a root beer. I spot the Manhattan skyline, and scan the buildings and realise that as the skyline reaches the LES, the big skyscrapers disappear. The LES is about being low and down on street level and if the skyline is a barometer of dopeness, high being wack and low being down, then the LES is definitely dope. My week in NYC went fast, too much to do in too little time. I got down with some amazing people and got to check yet another angle on the world of urban culture. New York is still the godfather of urban. It's still holding it down.

HOT SPOTS
<u>Eats:</u> Congee Village 100 Allen St. (www.congeevillagerestaurants.com) Katz' Deli, (www.katzdeli.com) 205 East Houston Street.
<u>Bar:</u> Lit Lounge 93 Second Ave. (www.litloungenyc.com)
<u>Shop:</u> Alife 158 Rivington Street; Shut Skates, 158 Orchard Street; (www.shutnyc.com)
<u>Hotel:</u> Hotel Chelsea 222 West 23rd Street. (www.hotelchelsea.com)

Turn to p128

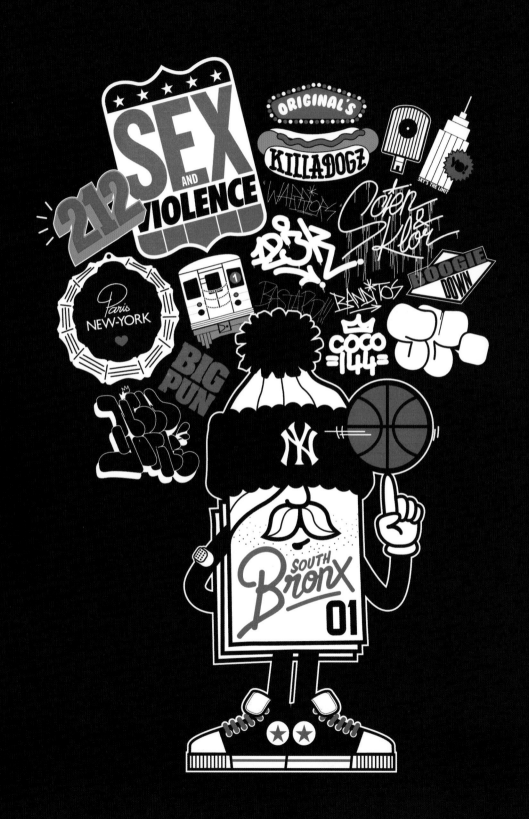

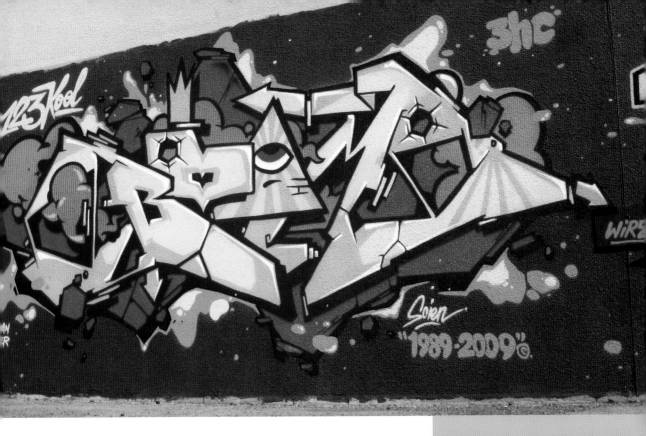

123 KLAN

www.123klan.com

123Klan is one of the most creative graffiti, art and design studios out there, founded in France in 1992 by Mrs Klor and Scien. As time went by, many of the best graffers in the world have joined their ranks. They are currently based in Montreal, where they train young recruits in hard-hitting communication.

'Our goal? Put together the first international network specialized in new strategies and tendencies. Our posse is getting big and our posse is getting bigger.'

→ Turn to p210

OBEY

http://obeygiant.com

Obey, AKA Shepard Fairey, is America's most prolific and stand-up street artist out there. His work can also be found in the Smithsonian in Washington DC, the Museum of Modern Art NYC, Los Angeles Museum of Art and the V&A in London.

Barack Obama acknowledged Obey's work in the following way: 'Your art, whether seen in a gallery or on a stop sign, has the ability to encourage Americans to question the status quo'. Shepard's 'Hope' poster and street campaign definitely helped Obama get elected. It encouraged a whole new generation to vote, many of whom had never been turned on by politics in this way. Obey blew up with his wicked 'Andre the Giant Has a Posse' sticker which he created while studying at the Rhode Island School of Design, to demonstrate how you could literally use any image to get out there as long as you used it enough.

'First of all, the mere feeling of freedom getting up provides is reason enough, but when you add the ability to communicate with a large audience and inspire, there aren't many better reasons to get out of bed. For 2009 I'm making street art promoting human rights and the environment to go along with my usual repertoire.'

→Turn to p250

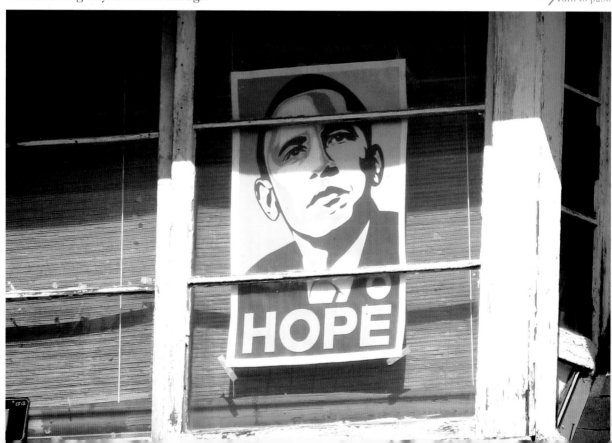

100PROOF

www.100proof.tv

It all started with 100proof. Without it your hands would be empty right now and probably be up to no good. 100proof is a global street culture crew with members around the world which began publishing/creating the seminal PDFs *1percent* from 1996 to 2003 and then *100proofTRUTH*, which stepped it up and is what this book is a direct descendant of. I am the founding member and creative director of all projects, which basically means that I take a look and say 'yeah – that kills!' Apart from that, 100proof is just there to encourage people to do the best they can, in whatever discipline they have chosen. The secret is that 100proof has never made any money. As there is no commercial interest we can help create the purest, most artistic work possible. All you gotta do is check the excerpt from *100proofTRUTH* Issue 5:

'This is what it was like: I wasn't sleeping at night. I'd wake in fear – of what I didn't know. I started to feel bitter towards other people, other races, other lives. The rage began to rise inside of me. I became permanently angry. I drank coffee and smoked cigarettes to wake up and then through the day consumed a lot of booze and took every kind of drug just to make myself feel better; to stabilize, or that is what I told myself. I became addicted to annihilation. I spent all my money (£50,000) on living large. I pissed everyone off in the industry that I worked in (advertising, then film production) and then some. I ended up fucking up: broke, alone and on the other side of the world – a long way from home. I have never felt so alone, or scared. And yet at the very lowest of lows I was completely free. I was flying. I just didn't know it, because at the time I thought I was drowning and in fact I was swimming.

What I was experiencing was the beginning of the end: the end of the millennium, the end of the age; the end of innocence. The consumer programming was beginning to work, the fear was rising and this was before 9/11. The bullshit about money, power, fame and success was beginning to get through my defences and I was in total danger of becoming just another wanker with a lot of money and no morals whatsoever. So what happened was that my autopilot kicked in to teach me a lesson, to stop my transformation into something else. And there I was lying face-down in the gutter.

The truth is that there is indeed a conspiracy about new world order: A cleverly disguised and executed plan to keep everyone distracted from really what is going on. Crap movies, the Internet, sports, drugs, porn, video games, bad TV shows that never actually end, newspapers, TV 'news', fear, real terrorists, fake terrorists, fake celebrities, all there to keep you occupied from wondering what the fuck is really going on. If you choose not to believe the previous sentence, then chances are you're probably going to smoke a cigarette, check your e-mails, kill someone in an F.P.S. (first person shooter), smoke a joint, drink a drink, knock one out, instead of really reading this to the end and getting a tiny droplet of truth. Chances are that you've already checked out. For those who are still there:

Welcome to the ride. Now ask yourself these questions: Is this just a dream? Am I awake or am I asleep? This issue is dedicated to freedom. This issue is dedicated to real counter-culture action. Not the fake-assed counter-culture that 99 per cent of the youth think they're down with. I've collected together some of the most original talents of our generation to contribute to telling the truth. Show it like it is. Simple, but effective. We have to think our way out of trouble, just like the hot summer day when a Tennessee State Trooper wanted to search my car and there was an ounce of Hydro in there. I thought my way out of it and as I was a little smarter than the cop, it was me who came out on top. And not on the bottom in some deep south cell.'

→Turn to p290

this is for the 1 percent.

north south east west - we

salute you

skaters, hackers, breakers, photoshop manipulators, the urban architects, freestylers, bblunted headz, hip-hop innovators, roools and culture reggae generals, the 1 french underground, the

queer folk the street poetz, the

bonteheuwel head-drillaz; whoever.

1996 Sleeve Artwork

ONiLi

www.onili.com

Onili is an Israeli-born singer/
songwriter/producer who was raised
in Paris. She blew up when the
'Superman Lover' single she sang
on was a global hit. She then moved
back to Tel Aviv and set up her
own studio.

'I'm a natural born singer who,
in need of independence,
learned music production and
management. I even started After
Effect [motion graphics program]
and graphic design studies.
Everything I do is around my
music, aiming to reach out to the
world from the small city of Tel
Aviv, Israel. My music is evolving
from my rock roots to a broken
electro, mostly songs but lately
also club tracks.

'When I was six, I realized that I
wanted to be a singer and since
then I do everything I can to
make it happen. While working
on my first projects, I've learned
a lot from sound engineers and
producers about mixes and
software. I always get new tips
from other producers. Street
culture is the most important
form of art to me, it's all around
and always around, in the
ordinariness of my life, street
culture reminds me where the
frames are by breaking them.'

→ Turn to p254

Pilpeled is my brother from another mother. He is also Israel's most original, gifted artist, illustrator and designer. From his range of killer T's to sleeve art to the cover of *Time Out* magazine, he produces inspirational and unique work.

'I liked school. I liked the corridors but never like class,' he says. 'Never learn anything in school except drawing. I used to draw a lot. For the last few years I've been doing a lot of work for some of the biggest events here in Israel. I found this to be the best type of schooling.'

Pilpeled (Nir to his Mum) inhabits his own world, a world that he sometimes lets us see experience through his art.

'To create my art I wait for everyone to go to sleep. And then I'm crawling silently to my computer, plugging the headphones, roll one, and what's next I can't tell yet. I have no formal training. My whole life I've always drawn and painted. When I was sixteen I began using Photoshop, and started doing some work for friends, working mainly on party flyers, album covers, logos, T-shirts and more.'

Growing up in Tel Aviv was different to how most people reading this book grew up, but it's this difference that makes his work so unique.

'I was enlisted into the army as a fighter in the Haruv unit and it was one of the hardest parts of my life. All I remember is a non-stop angst. I suffer from being locked away, being like a robot. I couldn't handle not having my freedom. I never before had any kind of routine, so after a year and after a lot of mess, I moved to a much different base very close to my house and worked as a gardener. My life changed completely in a moment. I had the best, best job in the Israeli military, which gave me the time to draw again, and in a short time I started drawing posters like crazy for my friend's bands, week after week. I remember I almost never slept, as I used to work all night. The times I was at the base was like my rest time and I really miss those days now. After that year in the Haruv unit I really appreciate life much more then I used to and try not to miss any moment in my life while I'm free.

'I think Tel Aviv is much different and special, more then any other place in the world: small and developed but contains all kind of different people, most of them are creative people and some of them just love the action. There's always something around the corner. It's a non-stop city, and the streets are always full of people at all the hours of the day, lots of beautiful ladies and a lot of graffiti, fly-posters, and street art. It's a small place so you know them all. Tel Aviv is always growing in huge steps, which makes you want for more. I wouldn't be what I am today if I had grown up in a different place.

'I guess in five years I'll still be working my ass off. I have a huge list of things I'd like to do in my life (except graphics and painting) before I'm starting to enjoy life. Right now I'm enjoying building, studying and working. I hope to realize all of my wishes.'

→Turn to p31

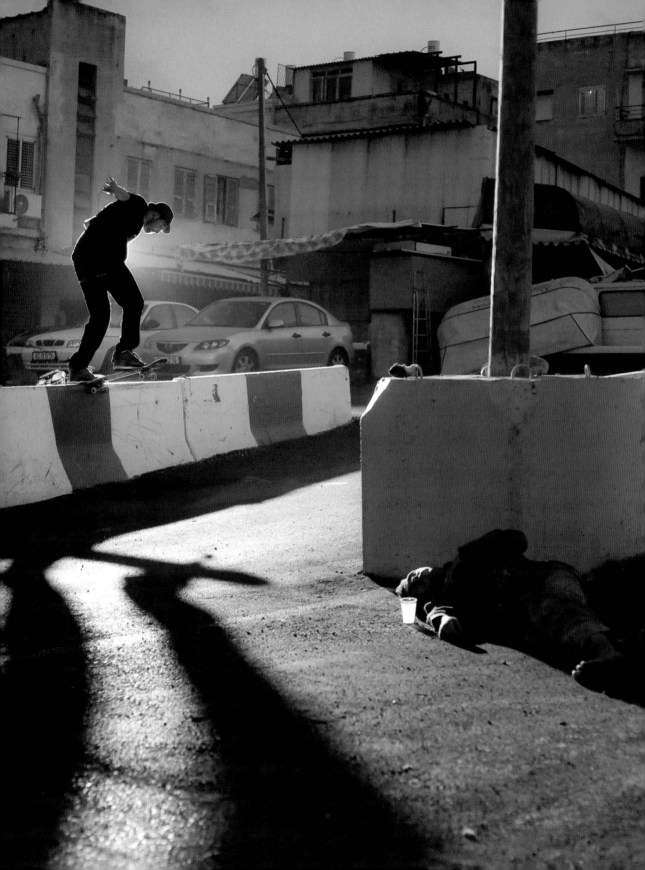

GUY PiTCHON

www.guypitchon.com

Guy Pitchon is an amazing skate and street photographer who has been documenting the Israeli scene for the last ten years. His work always blows me away. He also shoots other street-related images.

'I guess my work is about what I like, and finding realness in what I see, if it's a portrait or a defining moment. I usually shoot my own world, where I feel comfortable, and can find real moments rather than a bunch of people acting to the camera. My work in other media, like drawing and such, is usually about all the bad things and sadness in the world, or in mine, but not in a dark way: death and violence is an integral part of our world. I'm trying to talk about it and show it, but not really actively change anything.'

It is important to know your own limitations and stick to what you're good at. This becomes apparent when I ask Guy about how his work has evolved.

'I guess at an early age, skateboarding – the way it looked, and all the graphics and lifestyle around it – captured my imagination right away. I always think that if I was a really good skater I'd just do it and not shoot it. But that's the way the cookie crumbled, and I'm glad I can go on doing my thing for a long time, and not just until my knees caved. And show the rest of the world.'

The landscapes and surroundings are so important to an artist and shape their work. Coming out of a place that is unusual is a great thing.

'I grew up in a city next to Tel Aviv. It was great. I have tons of great memories from there. On my street there were lots of kids and not too many cars, and we used to play outside all the time, skating, riding bikes, climbing trees, stuff like that, it really wasn't about computers and TV at the time. I'm very happy about that, and I hope my kids one day could have something like that, but I guess it's not where the world is heading.'

LEE 'SCRATCH' PERRY

Okay, so you may not be that familiar with the name Lee 'Scratch' Perry, but you will undoubtedly have heard his influence on music through his pioneering work with Bob Marley, reggae and dub. You may be inspired to start smoking copious amounts of ganja and running around with an electric fire strapped to your head after learning that the life and work of Lee 'Scratch' Perry offers living proof that riding on the edge of insanity has never offered such prolific rewards. So it might not work for you, but for Lee 'Scratch' Perry, blurring the thin line between genius and crazy is what made him such a maverick, and let's face it, the myth would not be the same if he was a straight-talking, straight-up super-producer who creates the super clean sounds today in a sterile studio somewhere in Stockholm.

The fact that Scratch began his career getting ripped off set the tone for what is a rollercoaster ride through musical history, beginning in rural Jamaica. Scratch was a country bwai, abandoned by his mother after his parents split up and left with his father, only to become little more than a slave around the house. He ran away, ending up working as a record boy for Clement 'Coxsone' Dodd. He soon graduated to DJ and then writer/producer, having his first hit with 'The Chicken Scratch', which is where he got the name from.

'Me have a lot of songs that they take from me, and not even my name was written as the writer. They just take them cause me was a country boy and me can't say anything otherwise they'll beat me up!'

Lee became one of the world's true pioneers of music. In 1968 he set up the Upsetter record label and released a serious amount of tunes, without having a regular studio. In the early 1970s he singled-handedly gave reggae its unique sound, and then, with King Tubby, invented dub with his 1972 album *The Blackboard Jungle*.

He soon went on to pioneer the remix. In 1972 at 5 Cardiff Crescent, Kingston, he built the Black Ark studio and had another prolific run of hits, writing and producing for a diverse range of talent (from Marley to The Clash), before burning the Black Ark to the ground in 1979. Scratch had had enough of everyone continually taking from him: record-label bosses stealing his music and money, and musicians like Bob Marley giving him a seriously hard time over money that had not been paid due to the record label skanking: a vicious circle indeed!

Lee fell out with Bob after he sold the rights to the Wailers to Trojan Records, which increased their fan base a hundred times and led to Bob Marley and the Wailers becoming superstars in Europe and the rest of the world. 'The way black people was treating me, how could I be one of them?' said Lee of that era. He decamped to Europe (Amsterdam then London) and began working with Adrian Sherwood and Neil 'Mad Professor' Fraser. Before settling in Switzerland, where he lives today.

Recently, Lee has completely stopped smoking, drinking alcohol and eating meat. He did this to become healthier so that at his advanced age he can still tour around the globe and perform for his fans.

FURTHER LISTENING

Upsetters 14 Dub Blackboard Jungle AKA Blackboard Jungle Dub (1973)
Super Ape AKA Scratch the Super Ape (1976)
Time Boom X De Devil Dead (1987)
From The Secret Laboratory (1990)

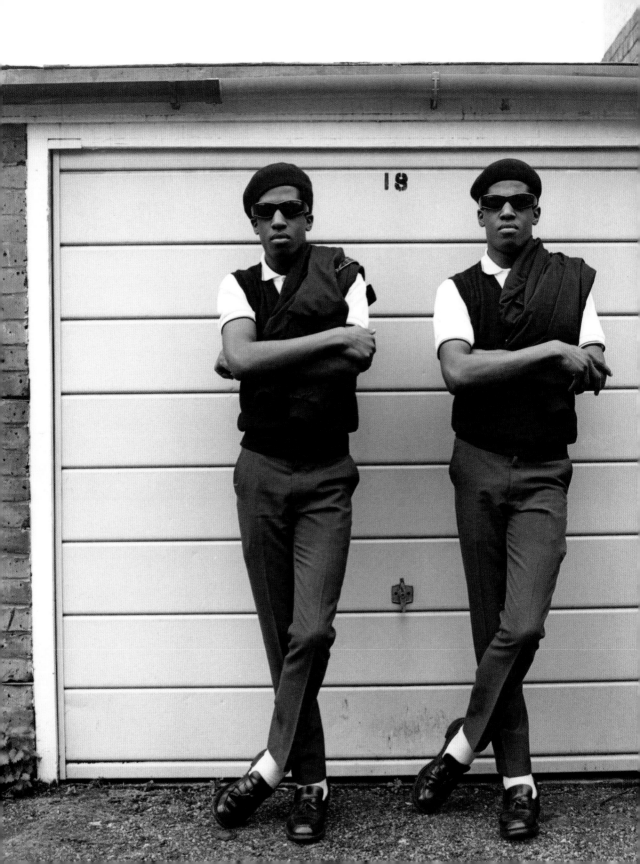

PYMCA

www.pymca.com

PYMCA (Photographic Youth Music Culture Archive) is a great project dedicated to the documentation of youth culture, street fashion and street life in general. Started by Jon Swinstead in 1996, PYMCA now has an unparalleled archive of the shit that really matters. Many of the great street culture photographers are connected to the project, such as Gavin Watson, Dave Swindells, Syd Shelton, Paul Hartnett, Eddie Otchere and Pete J Walsh, who all contribute to the visual history of the energy and ideas of the youth. Everything is covered: Mods, Psychedelics, Hippies, Punk, Skinheads, Casuals, B-boys, Two Tone, Goths, New Romantics, Acid House/Rave, Hip hop Headz, Emos…

I got down with Jon and asked him what was up.

'PYMCA is all about global youth cultures. We represent photography, moving image, design and writing relating to youth culture. I set it up as I couldn't believe no one else was collecting a history of youth culture in this way. Our content goes back to the 1940s, right up to today, all over the world. We set out initially to collect photography with a UK youth culture bias but now we have expanded and represent all kinds of digital content from all around the world. When we set up, the Internet was a baby so everything was hard copy. Now it's all digital and we have a website where literally anyone can register with us and enjoy different levels of access to our archive. We sell rights, host exhibitions, give talks and lectures, and offer cultural research to a range of clients around the world. Next up, PYMCA will be launching a community website offering anyone interested in youth culture a forum to discuss and share content and opinions. Maybe one day we'll have our own museum!'

Where did you grow up? What was it like?

'I grew up in the village of Frensham, Surrey. It's good to be brought up in the country, there are lots of positives but you always feel like you are missing out on what's going on in the towns and cities. So I left home and moved to London the moment I turned eighteen.'

What or who are your influences?

'I guess early on your family and environment influence you. My parents gave me a lot. After that time defines our experiences so the 80s and early 90s probably shaped my thinking. Rave was an amazing movement, changing everything. I'm diverse, though. Once I got interested in youth culture I spent more time looking at all cultures. I draw from all areas of it the pieces that I connect with most.'

Twins, Chuka & Dubem, in Ska, Rude boy styles, London 1981. Photograph by Janette Beckman/PYMCA

Turn to p110

JiM PHiLLiPS

www.jimphillips.com

Jim is a pioneering artist. His has created some of the most iconic skateboard art. Ever. His father was 'all army', and his family moved from one fort to another, all around the US and Panama. In 1951 his father went off to Korea, and bought the family a little house near the beach in Santa Cruz. This was the beginning…

'I didn't know how really great that was then, it was sort of taken for granted. We were a block off a beach we referred to as "our beach", because it was always empty, aside from the stray fisherman. Down the beach was the Sunny Cove, where I hung out with some of the other kids from the Live Oak Elementary down the street. There the cliffs jut out on each side, blocking the rip currents. The cove also provided plenty of long rides across the wave-washed sand on my homemade skim-board. I made it around 1959 when I was fifteen. I managed to get a piece of marine plywood, which cost a fortune then. I left the tail square so the corners dragged to keep it from spinning. The nose was fully round with a beveled underside to skim over the water. Hot rods were the biggest thing around that time, so I painted it black, and then put red scallops with white outline pin stripes. This was the prime equipment and I lived the free summer ride.'

Jim got a slow start at school with the disruption of army life, going to eight different schools by second grade. He needed to do something in class so he would draw.

'They give you paper and pencil and a desk, right? Friends would notice and ask for my drawings at the end of class, especially when it was a cartoon of them. In that way I became known as an artist, and it molded my life. One day a senior asked me if I could paint a Big Daddy Ed Roth monster on the dashboard of his custom 50 Olds. I secretly thought he was crazy

for trusting me with enamels on his car but I kept my mouth shut, and told him, yes, and that I was a great fan of Roth. Roth was so far out there, artists today are still searching for some kind of originality that doesn't trace back to him. Pretty soon a friend asked me to paint a monster on his surfboards, and this time I tried to do my own thing with it. I was a long-time comic reader, and there was a treasure trove of high-quality art talent in that genre. I was inspired deeply by about a thousand comic book artists and emulated all their techniques. And when skateboarding finally grew up and demanded full-deck graphics, the comic book style of art became the perfect key-line that is needed in the silkscreen method of printing, which was required to print those wooden decks. Comic books are mostly put away in plastic bags and cardboard boxes to resist decay, and the art itself languishes in unending obscurity. So as it turns out, the art was inspired by books created on desks and drawing tables and had nothing to do with the street. But the street skate came along and became the perfect vehicle to carry the art.'

Jim soon became attracted to street culture.

'That's all you have if you are broke. You are out on the street. If you are broke and on the street, then you gotta use what you have at hand and ride the streets and sidewalks, or cruise the streets checking beaches for other free rides like waves. Gas was only twenty eight cents, so we could ride our woodies [estate cars with wooden sides] around all day for fifty cents. The very spirit of America.'

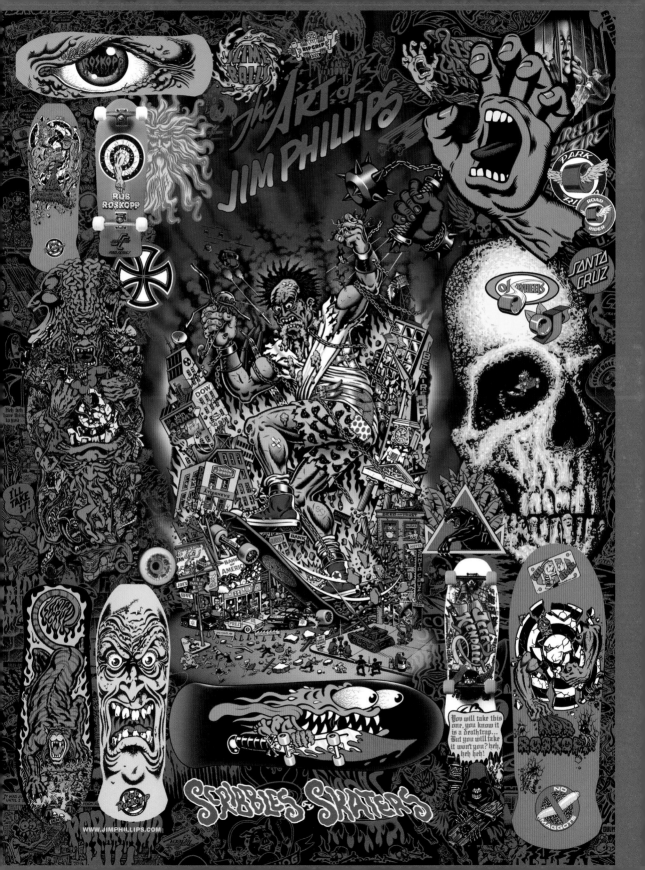

www.quiknyc.com

Quik, AKA Lin Felton, is one of the original graffiti writers from New York (one of the legendary RTW crew, no less) who has made the jump to successful black American painter. He tells it like it is and we hung out one sunny afternoon looking out across the water at the island of Manhattan.

'It's been a long, strange trip. I believe that's why I really keep at it for the adventure. Whether it's God or Yahweh, Muhammad, whatever, something has given a very strange talent from my brain to my right arm and a lot of colour comes out. I've almost been around the world due to this very strange talent. I nurtured this talent in university. I've always been drawing and making little cartoons; let's say I have a wild hand. My hand has to do something, has to be busy, so eventually the graffiti kept my hand busy, and also my body. It's like a sport when you are a child. I definitely wasn't one of the best graffiti guys from New York, it took me maybe eight years to get good. I began in 1972 and I really didn't begin to make my mark until 1979, and even by then I was more into the destructive aspect of it. I was an angry, confused, dysfunctional lad. As a child I always thought that the graffiti would always remain on the trains, I certainly didn't believe that it would lead me into a career in art. Coming up in New York you evolve alone, you see what life has to offer you, and New York in the 70s was really a hard place, in a sense I wouldn't wish it on another teenager to grow up in such an environment. I came from a very nice environment; sorta like *Leave it to Beaver* TV sit-com, but two streets away you had the gangs. All that was a bit confusing and it was dangerous, and the subway was an absolute pit and the things I saw and was exposed to as a child within the subway system, simply going to and from school, was horrific. There was no warning that these things were out there in life, there's no preparation. Although I was a curious child, there was something very unbalanced about this New York atmosphere. Quite often I wish I had not been born in New York, and perhaps simply taken a job in a bank. Fortunately I had great parents and they sent me to very good schools and these type of schools trained you to be the best you could be.

'I'm popular for graffiti because I was chosen among Futura (2000), Ramellzee, Blade, Seen, Lee, Crash and Daze in the early 80s and since then I've kept the momentum going. But you also need the momentum to create a career and then again that goes back to this relentless energy I have to paint. You know, if I'm going to university and the professor says to work on something 8 x 10 inches, well, maybe that's not going to be the best format for me, when the evening before I painted a kilometre! This was real fucking energy, some sort of energy I needed harnessing. I needed guidance, unfortunately I did not get that acceptance in university, therefore I painted more and more trains.

'So the gallery world gave me a different outlet, it gave me a different audience; we want to be seen. Even if we are fairly anonymous folk, we do want people to see what we create. I certainly like a more mature, intelligent audience, not that my work is all that deep and meaningful as I just tell a story, like a diary. There is an audience for that, for my voice. I'm not a graffiti artist, I've outgrown that, I'm a black American Painter.'

Turn to p36

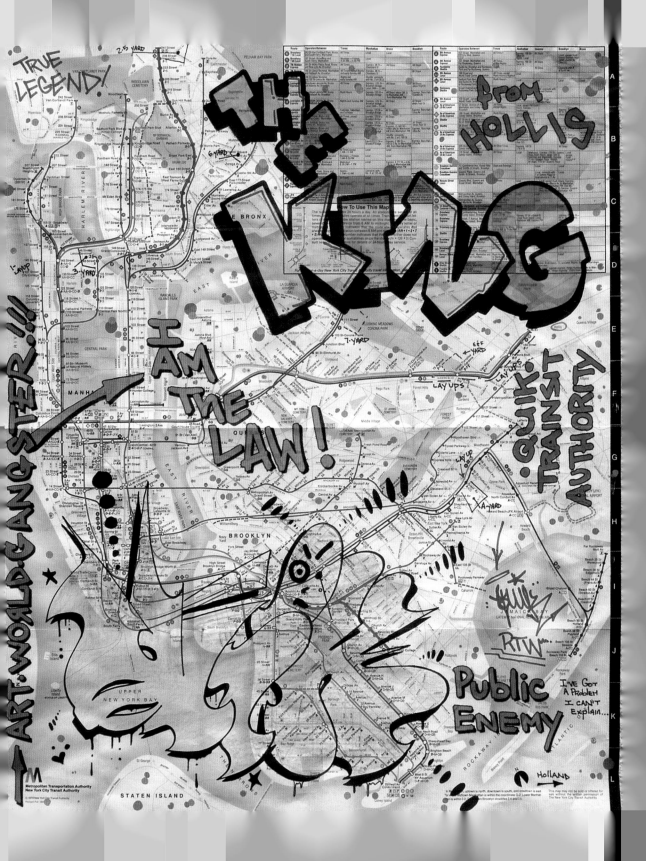

QUEENiE YEHENALA/SHANGHAi

Queenie is the face of Chinese street culture NOW! And a shining example of how global the movement has become. By day she works for Nike in brand design, and then she is out there living the life of an urban youth on the city streets. Her energy is up there with the best of them.

'My work methods run like this: listen, observe and study, and they have evolved and become complicated by Googling and Wikipediaing too much. The coolest thing I like about my job is that I get to curate good exhibitions with decent budgets.'

Just like the culture that she is a part of, Queenie has already travelled far in her short life.

'I was born in south China under supervision by my too-loving grandma and then totally released my alter ego out in the wild nature of New Zealand in my teenage years. My work is 100 per cent street culture. My influences used to be my old boyfriend but it is now the Internet!'

She is based in Shanghai, the largest city in China, which also has one of the largest metropolitan areas in the world. In other words, it's a big place with a lot of people, all hustling and trying to make their mark. This is a good place to be for urban culture, but it also has its problems with too much too soon visual overload.

'Shanghai is changing fast. If I Ching says there is 64 hexagrams in the universe, then Shanghai may have 512. None of the fancy clubs can stay in business for more than two years except if they keep renovating, re-inventing themselves. Even fast food joints like KFC and McDonald's are changing the menu and promotions every single month. If you go shopping only once every two months on the Changle road [Shanghai's hippest fashion street], you would find 20 per cent of the shops on that street have changed names. People are forgetting what things used to be like here before the change, and now are much harder to please. They like the world's attention and are spoiled by it. However, all these changes create excitement. Forgetting the past means that you need to constantly consume. Nothing will stop the attention because the opportunities are almost everywhere you look here.'

→Turn to p.38

www.stonewall.org.uk

Repression always gives way to expression. Hip hop ultimately came out of slavery and when the 1967 Sexual Offences Act came into force in England and Wales, it decriminalized sexual acts between two men over 21 years of age and in private. This was really important because if you shoot back to 1895 and the trial of Oscar Wilde, who was sentenced to prison for two years hard labour, you will find that before this you'd be getting men dressing up and cavorting in front of the camera and really working a wild look. After Wilde's landmark case everything became very dangerous. Behaviour was forced underground, and dressing-up parties became a way for gay men and women to get together under the pretence of fancy dress to have a gay old time. It was acceptable, and if the police raided the party, you would only get arrested if you were wearing ladies' underwear. It was safe as long as you had the right underwear on.

If you then go forward to New York on the night of 28 June 1969, the Stonewall riots began after the Stonewall Inn was constantly raided by the police for being an openly gay bar. In the US the Gay Liberation Front and Gay Activists Alliance was set up in reaction to the riots, while in the UK, the Committee for Homosexual Equality was formed. This was really important, as although the Sexual Offences Act came into force in 1967, it took a while for people to be brave enough to make an overtly gay film or write a gay novel or publish a gay publication.

In 1970 the first ever organized Gay and Lesbian Pride march took place on 28 June on the streets of New York to commemorate the previous year's Stonewall riots. In 1972 *Gay News* started, the UK's first gay newspaper, and then it was the beginning of the disco generation with major clubs such as Heaven in London and the Paradise Garage in New York opening (>p54). By 1981, HIV/AIDS

dominated the news, contributing to a big backlash which saw the introduction of Section 28 by the Thatcher government, a piece of legislation that banned the so-called 'promotion' of homosexuality.

All of this had an effect on creativity and design, because design, music and fashion were a reaction to the law changing in 1967. It was also a creative reaction to the Americanized discos coming over to the UK. Punk rock (>p302) was very gay, sexy and very fetish. What punk did was bring a lot of hidden elements out onto the high street, which was the most shocking place for a pair of PVC stockings to be seen, or leather chaps to be worn. Today, we look at these items as alternative wear, but wearing leather trousers in 1976 was really OTT. It was shocking. To actually wear a T-shirt with two naked cowboys screened on it (designed by Tom of Finland) and walk down the street was fucking wild. A lot of these trends have been absorbed and assimilated into mainstream culture, but few people know the history of a look.

Taboo was one of the most influential club nights ever and ran from 1985–87. It was run by Leigh Bowery and his gang of merry smackheads such as Trojan. When Leigh decided he was going to create a club, he wanted to open it where no one else would dream of doing it, so he chose Maximus, Leicester Square. Most people at the time who were opening alternative clubs were holding them in piss-stinking dungeons and crappy cellar bars out in zone five. He chose a big naff, glamorous place, right in the middle of the West End.

When people used to have clubs they would promote them with black and white Xeroxes and send them out with a bit of felt tip scrawl here and there. What Leigh did, however, was take playing cards and a sewing machine and stitch little things onto each playing card, then on the back in silver and gold he wrote about the club and handed them out to the kind of people he really wanted to be there.

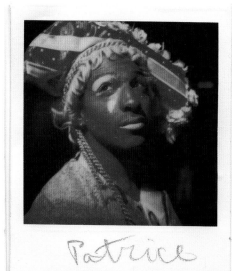

Patrice

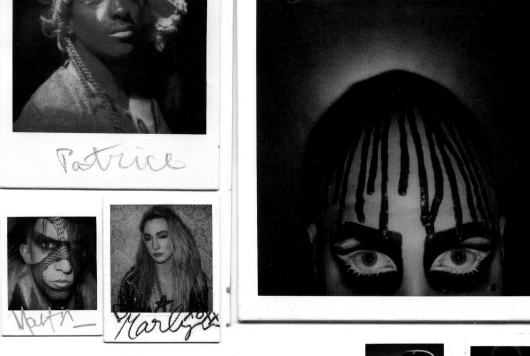

Leigh Bowery

Martin

Marilyn

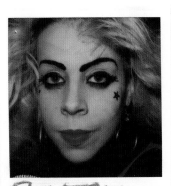

BEVERLEY HILLS

MICHAELG

YA DAD

SUE xxo

Daniel x

TEX !97

xXasty 9 9Nx

JO°

Photographer Paul Hartnett was there from the beginning.

'Taboo first started as a fortnightly thing. On the first night there might have been seventeen people there. It was like a private party where no one had turned up or made any food, the dance floor seemed enormous and it was kinda embarrassing. It was as if people were standing around waiting to be discovered. Two weeks later it was just the same, and three weeks later I think there was a dip. By the fourth night a few people had heard and there was a bit of a queue and there were punters actually paying to get in and then it just went nutty-butty. I think by that time one or two German magazines had been in and *ID* had run a piece, and *The Face* came by. The people started coming in from the provinces and with them came one photographer and a film crew too many and the drugs that were going on – it just went mental. Mental, and heading for one direction only: the slab. No, two directions, the slab and fashion history. There were so many bottles of poppers being spilt on the dance floor and in the ladies the ambulance chasers were sucking on this, swallowing that, snorting whatever, jacking-up and jerking-off. After eighteen months it was kinda on the way out, it was getting naff, as people who would have not been allowed to get in before were getting in, so staff would get paid. The diversity of "looks" had really gone downhill and the age of e was creeping in: the piss-stinking warehouse party scene was beginning. I just said to Leigh one night, standing by the fruit machine outside the main dance area, "You should really close this place down, it's getting so naff. I could do a little drugs news story and end it." Old Bowery raised his right gloved hand to his mouth and said "Do it!" The next day I went to the *Daily Mail's* YOU magazine and a couple of weeks later the club closed, with a resounding bang.'

What was interesting about Taboo was that it was all about the culture of dressing up – England dressing up. From 1850 onwards there has always been this thing in the UK about dressing up. In 1290 there was the first mention in English common law of a punishment for homosexuality. In 1300 treaties in England prescribed that sodomites should be burnt alive. Henry VIII introduced the Buggery Act in 1533 and brought sodomy within the scope of statuary law and made it punishable by hanging. In 1885 the offence of gross indecency was created, the first ever specific anti-homosexuality act, otherwise known as the blackmailer's charter. This is really important because for many hundreds of years gay men had been underground, but always with their little clubs, cruising areas and coded ways of dressing, such as a little ring on the little finger, the wearing of certain colours (purple being a popular indicator), and subtle things like the tilt of a hat. There were lots and lots of little things going on – and that is street style.

→p54

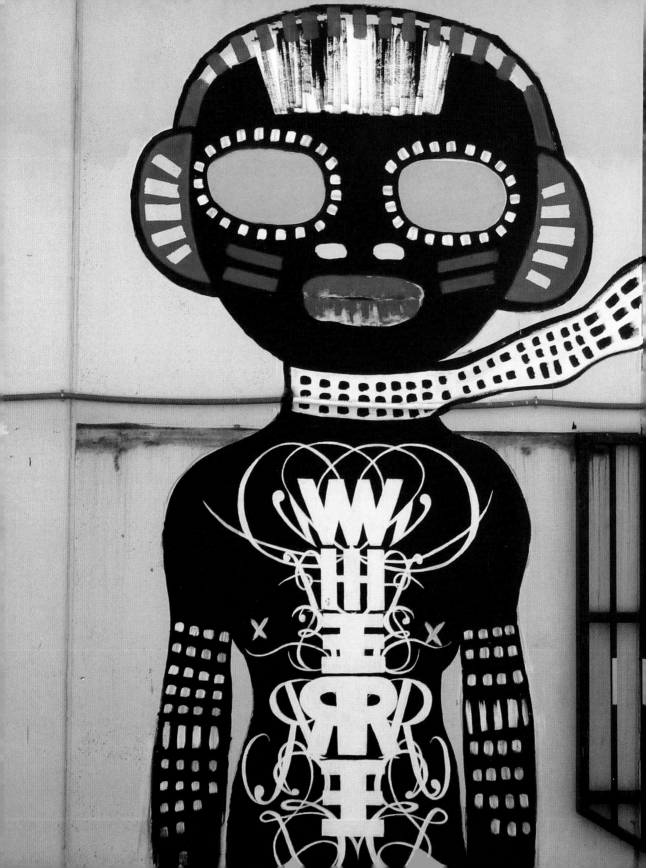

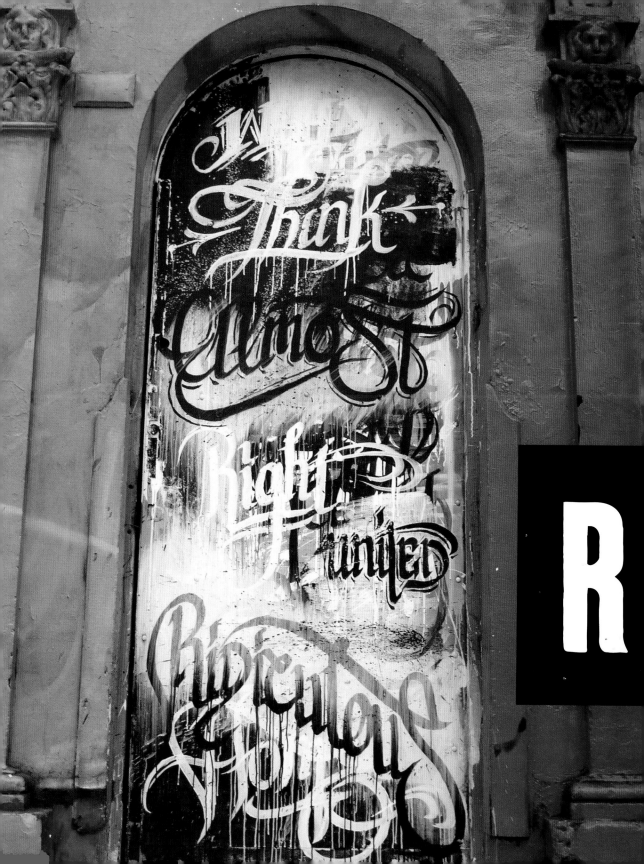

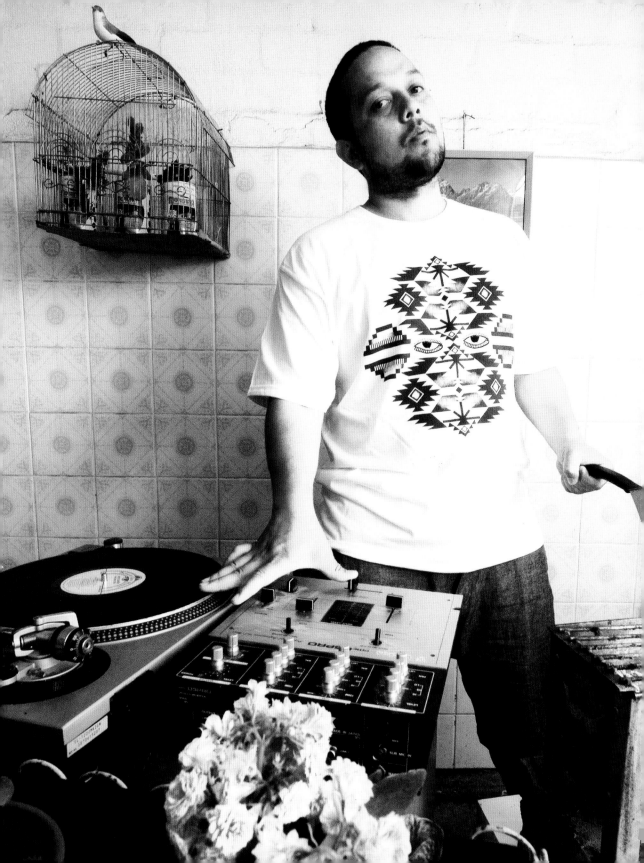

RAPH RASHiD/BKTM

www.blanktm.com

Raph is a multi-talented guy coming bang outta
Australia. His crew BKTM is one of the freshest
producers of quality clothes down under, and he
also runs a record label, Crookneck, and works as a
photographer. One of his projects is a book called
Behind the Beat which is a look at the usually unseen
world of the hip hop home studio. It features the
studios of some of the world's most influential
producers, including DJ Premier, J Dilla, DJ Spinna,
Taskforce, DJ Shadow, Dan the Automator, Chief
Xcel, Cut Chemist and Mario Caldato Jr. He resides
in the Brunswick area of Melbourne and quotes
his influences as (music) J Dilla to Sleda; (style/art)
Brendan Huntley to Ghost; (food) Nasi Goreng to
Halloumi pies.

What is your life and work about?
'My work is just about being me and feeling proud
to put my name to all my projects , every T-shirt we
design or photograph I take I want to feel confident
that it can live forever, and not be caught up in any
certain trend. I am just about to shoot my second book,
follow up to *Behind the Beat*, so I am interested to see if
my photographic style has changed at all. I definitely
have a greater understanding of detail and minor
things, the subtle things you don't see is what I like
to focus on.'

Where did you grow up? What was it like?
'I grew up in Frankston, Australia. It's a seaside town
which was at times very violent, as the town was a
mix of low socioeconomic and also a richer end of
town. It was pretty fun though: an hour from the
city of Melbourne. We would travel into Melbourne
most weekends, being in Frankston gave me a good
perspective on things.'

Turn to p170

ROADSWORTH

www.roadsworth.com

Roadsworth is Canada's answer to Banksy or Obey, but with a difference. He only creates his art on the surfaces of roads (or sometimes pavements), usually enhancing the existing road marks to create objects of beauty. Pure street art! He began his street art journey in 2001 when he began to paint bicycle symbols around the streets of Montreal, the same symbols that are used to designate the city's bike paths.

'An important aspect of my work is how it integrates itself with its surroundings. I often introduce a relatively small visual element to another pre-existing element thereby altering the significance of both. The piece then becomes not only about what has been added but also about what has been added to. While I've worked most commonly with street markings and other aspects of the urban infrastructure, I tend to apply this

basic principal and approach to most of the work I've done whether in the street, on a wall, in a gallery or on a canvas. My tendency to use street markings as a starting point stems not only from an interest in the political, symbolic, sociological or environmental significance of the road, but also from an interest in the language that street markings represent and the susceptibility of that language to subversion.'

He was arrested in 2004 for painting a Christmas ribbon on a road junction and during the search of his house much evidence was found linking him to all his previous work. This marked the beginning of the first Free Roadsworth campaign.

'I used to always create "one-liners" so to speak, a simple visual pun on a given aspect of the city's infrastructure. As I've received more and more commissions I've been able to develop the "one-liner" into more of a narrative of sorts, the pieces often unfolding over a longer distance, with a beginning, middle and end. The piece is read as one moves physically over it, often finishing with what I can only describe as a visual punch-line. I've also begun to use a more varied palette of colours over time.'

Roadsworth grew up in Toronto in a fairly white-bread part of town but went to school with people from all over as Toronto is a very multicultural city. Most importantly he was exposed to the arts early on as his mother is an artist and his father a musician who were always inviting artsy types over to the house for dinner.

'Street culture is about expressing yourself in the street, in public without necessarily requiring a permit or the backing and/or approval of a corporate or government sponsor. All of the things that we consider "street culture" today such as hip hop, graffiti, street art didn't start because an executive or a bureaucrat decided it was a good idea.'

ROME

The killer spot. Rome is a wicked mix of old-school and urban. It has the best climate (bearable winters and incredible summers), the friendliest people and the food is off the scale. Okay, it seems a bit expensive when you buy a drink in a bar, but there is always a bar snack included in the price (Italian-style tapas) – which is the best idea ever! The tourist spots such as the Coliseum and the Vatican are best avoided (unless you really want some 'culture'), as they are ram-jammed all-year round. Just head for the little streets in and around the centre of town. This is where you'll find the real people living their lives away from the mad tourism of the rest of the city.

The Trastevere area, on the left bank of the Tiber, just over the Ponte Sisto, is one of the coolest spots you'll ever hang out in, day or night. The streets are narrow and cobbled and lined with bars, restaurants, pizzerias, workshops and boutiques, all painted in the dark Rome ochre colours, with street art all over the place. Not to mention an endless stream of beautiful boys and girls lamping past. A great family-run restaurant is the Al Fontanone, Piazza Trilussa 46. When my granddad moved here to work at the film studios of Cinecittà in 1966 he ate here every night. Great country-style Italian food (try the polenta dish).

Another great area is the Suburra, near the Cavour metro station. It's home to fashion houses, Indian, pizza and seafood restaurants, bars and cool spots where a cool crowd of fashionistas hang out. There is an amazing Sicilian cake shop just around the corner on Via Leonina down from the metro station. It's called Ciuri-ciuri and the cake to buy is the cassata.

Forte Prenestino is a mental place. Situated in an old military fortress sunk in a park in the eastern suburbs, it is an underground, totally illegal, club/ rave venue, pub, BBQ, art gallery, recording studio, café… and squatter camp. Complete with moat, tunnels and hobbit-like hill-side huts (where most of the residents live). The authorities leave the place alone and this is a great testament to what a relaxed place Rome is. I guess the authorities have bigger fish to fry. There is usually something going on most afternoons and evenings, but Friday and Saturday night are drum 'n' bass, techno, trance and grime parties with a truly underground festival experience, unique considering this is suburban Rome. When I went last, the peeps living there were watching Roma beat Lazio on a number of make-shift screens hanging in the tunnels, drinking the local brew and getting stoned. I wandered around shooting photos and generally being nosy and everyone was sweet. No worries on any fronts, and even the many crusty dogs (who usually go for me like the proverbial) left me alone. There is the highest concentration of street art and graff of anywhere in Rome. Stencils, stickers, freehand, art covers every surface of every wall. They hold impromptu art exhibitions and many international street artists have come here to paint.

HOT SPOTS

Places to hang: Forte Prenestino, Largo Federico Delpino, 1 (www.forteprenestino.net)
Eats: Al Fontanone, Piazza Trilussa 46, Trastevere
Snacks/cakes: Ciuri-Ciuri. Via Leonina 18/20 (www.ciuri-ciuri.it)
Gallery: Dorothy Circus, via Nuoro, 17 (www.dorothycircusgallery.com)

RADICAL CROSS STITCH

radicalcrossstitch.com

Radical Cross Stitch is an informal (on and off-line) movement celebrating and building on centuries of women-led creative resistance. It's about providing a space for craftivists to create, share, network and inspire. Based in Australia but with global links to other craft organizations, RCS is a truly inspirational underground movement. The craft scene is changing, radically so I got down with Rayna to find out who, what, when, where and why.

I first asked her how she sees craft influencing the urban landscape.
'What really interests me about craft in an urban space is that it is so unexpected and so surprising, that it is often left alone. If I went and spray painted a political slogan on a wall it would get painted over pretty quickly, yet a woven woollen slogan will be left there until it disintegrates. I also see public craft as a way of challenging the inherent masculinity of public space, in particular urban spaces. As a woman, living with a disability and as a mother I am quite aware how exclusive the concrete jungles can be. Bringing textile-based art into a public space can radically transform the way the space is perceived. There's a lot of public craft interventions that have had a safety aspect to them, either protecting a space or protecting the people that use it. I think craft can work really well in that regard.'

What are your influences?
'I think my biggest influence is the centuries of unknown women who have worked tirelessly in their communities to make life better for their kids, families, neighbours and friends. I'm inspired by those that do it because it needs to be done, rather than those who do it for the glory. Artists and activists that I would say influence my work would be Emma Goldman, Sylvia Pankhurst, Rayna Knyaginya, Assata Shakur, the women of the Chilean Arpillera, Lisa Anne Auerbach, Sara Rahbar, Cat Mazza and Metiria Turei.'

What do you think of the street art scene?
'I find the street art scene overwhelmingly inspiring! Especially living in a city like Melbourne where it's everywhere you go. There's nothing that gets me fired up to do some creating like a good wander through the Melbourne laneways. What I most enjoy about the street art scene is that it's art for art's sake. Sure, there's a lot of crossover now between the street and the gallery. But still the dominant driver for street art is to get the viewer to think or get mad or have a giggle, as opposed to making money. I think that has a massive impact on the kind of art that's produced. As a conscious artist I am naturally more drawn to street art as a way for the art community to really engage with the wider community. And I think there's some really exciting stuff being produced to really draw attention to the bigger issues that we face. A really important role of the creative community is to act as a mirror for society, both reflecting what the issues we face are and also the visions we have. While you hear people talk about the role of the creative class in this respect, I think it's street art that's really achieving this. I can't remember the last time I got really inspired in a gallery – with the notable exception of the indigenous collection at the Ian Potter Gallery in Melbourne, always worth a visit if you're in town!

I asked Rayna to explain the images (left).
'The speculators image is a "cum rag" we created as part of a fence-stitching project. It was painted on a curtain fabric sample and then tied to a vacant block fence with ribbon. The second image is a cross stitch I made after a fifteen-year-old kid, Pihema Clifford Cameron, was stabbed to death because he was about to tag some guy's fence in Auckland, New Zealand. The public reaction to the killing was of sympathy for the killer! That horrified me and this stitch was about being pro youth and pro street art.'

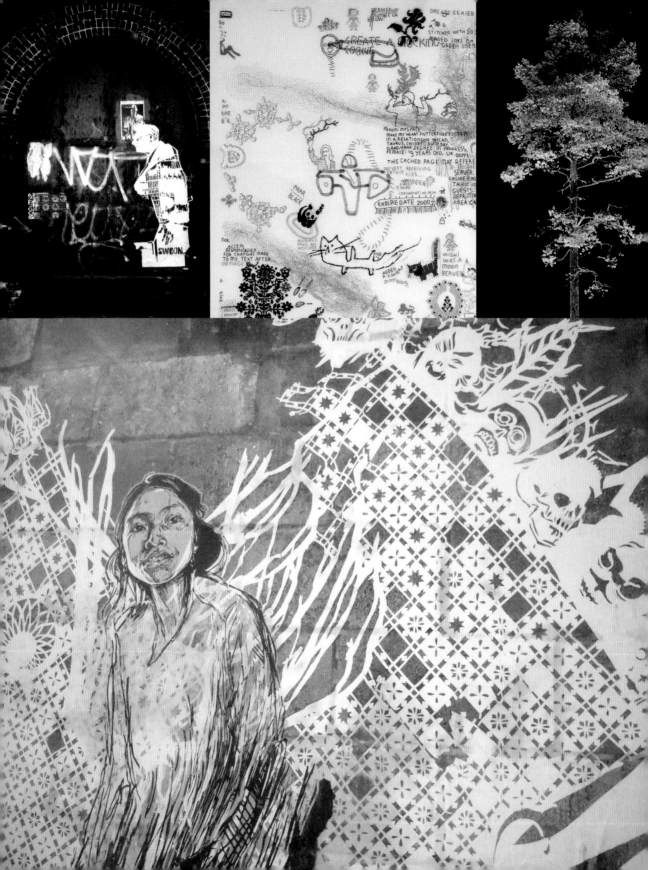

SWOON

Suburban Florida. Sometime in the 1980s; Somewhere near the home of the world's most famous beach (but deep down you know that's not really true). This is the stomping ground for an American girl who is going to go places and see the world. The city is also the headquarters for NASCAR and is like totally seasonal: busy as fuck in the summers and at certain race weekends (like the Daytona 500), but dead the rest of the time. It's out of this environment that one of the most talented and original artists of this century emerges.

'I grew up in Daytona beach,' says Swoon. 'When I was small, we were mostly out in the sticks, and it was all bare feet and falling off horses onto barbed-wire fences and pig shit; when I was a teenager it was the suburban Americans trap, classic.'

Swoon is an American street artist who has created her own style of art, using lino-cuts, cut-outs and life-sized figures, playing with negative space and positive images. She is one of the only street artists in New York's prestigious MoMa museum and I

have been following her work since the beginning, as she is one of my all-time favourite artists. Her work is so beautiful and her characters have such a fascinating human dimension that when you see one in the street you want to stop and talk to them. She is the real deal Holyfield, and the world she creates on city walls is an amazing place fuelled by her imagination and love for the people of our world.

'Empathy, human connection, moments of pause in the city, how a joyfully inappropriate thing can change your whole day, adventure, exploration, reaching outside of yourself, making a whole world of your own with your bare hands and your best friends.'

This is what gets her out of bed each day. She floated through school and made it out of the boonies, wandering up north to study at Pratt Institute, Brooklyn, which is where she became Swoon after a random dream her friend back home had in which she was a world-famous artist called Swoon.

'Well, I started painting and now I am making floating travelling sculptural city rafts. It's a direct line of evolution, I swear.'

If you were to ask her what street culture meant, she would tell you:

'The spontaneously generated culture of people who live in cities.' And if you ask her who she is influenced by she would say: 'just a couple: Kathe Kollwitz, Gordon Matta-Clark, Poppa Neutrino.' And the last thing you would ask would be about her inspirations: 'Can Masdeu [a squat and social community in Barcelona – www.canmasdeu.net] and Sambhavna clinic [charitable trust helping the survivors of the industrial disaster in Bhopal, India].'

→ Turn to p189

ViNCENT SKOGLUND

www.vincentskoglund.com

Asking Vincent to define his photographic work is an impossible question.

'If I could answer that then I would not need to do it. That said, I realize that it is something that comes out of my past, growing up in the middle of the forest and then having the opportunity to travel the world and seeing so much. The five years I spent living in London also is interesting because it made me see the place were I grew up with completely new eyes.'

Vincent grew up in Sweden in a little village called Kniva, near to the city of Falun.

'I wanted to skateboard when I was a kid but there was just dirt roads everywhere. Not much to do there. I liked to walk around in the forest and get lost. Get a bit scared and then try finding my way back. Sometimes it took hours.'

He approaches his work as a constant journey, one that's evolving all the time.

'Most of all, my work in snowboarding has been a fantastic way of learning about people, the world and life in general. All the travels and new discoveries have had the biggest impact on me. Photography-wise, shooting so much as I did when I did snowboarding full time was really what made me evolve. I started young so it was like a life school. Also, the work commissioned by companies was so loose there was so much room to be creative. The brief would be, like, "Vincent, we love your photography, just keep doing it". It was also open for any type of photography, portraits, landscapes, action, life.'

What does 'street culture' mean to you?
'The total sum of the life in the urban area at any given point. It is constantly changing no matter what, and we are all a part of it. It is accessible for everybody at all times, I like that.'

TiLLEKE SCHWARZ

www.tillekeschwarz.com

The urban aesthetic has mutated into many forms, and embroidery is one of the most interesting and original genres. Traditionally a very arts-and-craft village-hall kind of thing, when it gets urbanized it transforms into something seriously wicked. Tilleke's work is just that. Her work is about the oddities of life and the strange way in which we communicate.

'My main technique is actually drawing (expressionistic but more poetry). My first embroidered works were traditional samplers, after that I made works focused on color and texture, then content became more important and texts were added (first like a diary) and then it evolved into a personal mixture of images, icon, symbols, texts etc. Actually it is now a mixture of graphic quality, content and fooling around.'

She has exhibited and been published all over the world. She grew up in a small village in the east of the Netherlands. She had a good childhood with lots of freedom, as she could play with everything she enjoyed in the garden and at home. She was allowed to make a mess of her crayons, paint etc, as long as she cleared up the mess afterwards. This is a great foundation for an artist.

'Street culture means freedom of expression and fun to make. My work is personal and I make it alone. I love folk art, especially Dutch samplers, Pop Art, graffiti and contemporary art (after 1980). I collect images and texts that intrigue, move or amaze me. Anything can inspire me. Most important are: folk art (especially samplers), cats, daily news and scraps of textiles.'

O, DEAR!
HA SUMMER DOC...
MUCC.H.
DIP...

DIP.

YANG HUIYAN
11,5 BILLION
EURO

PARAN-
O-A

EN NU
EVEN EEN
DROPJE

any reply
may be
read by me
or other

DO NOT STRESS

SHOW

AFTER
WE SAW
THEM
...FRIENDLY?
FIRE...

DEADLOCK
WET LOOK

HO

LAST

DOUBLE YOUR FULL
UK BREAKFAST
FOR JUST 2£ MORE
SURVEY
CHEE
NAME
TOUR OR
MEETING OR
VACATION
REPUTATION
YES NO
ZIP

PEOPLE WITH
PACEMAKERS
MAY
VOID THEIR
BECAUSE OF
STRONG
MAGNETS
ELECT
-RO

PRE RINS

EVEN
CLEAN HA
NDS CAN
DAMAGE!

the PURCHA
-SE
OF
A CAR
in 1917
ALLOWED
MATISSE
TO TAKE:
ALL HIS PAI
NTING E
QUIPM
ENT
OUTSI-
DE

SCRUBBE

FLIPPIN
AWESOME!!

ZEN

ALL
ANIMALS
ARE MICRO
IN THI
SPUNK
PEEP.

WE DID THE LOO FIRST
AT THE

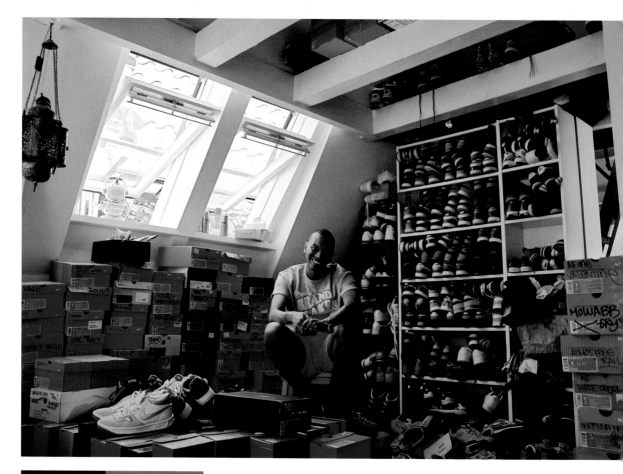

SNEAKER FREAKERS

I remember going to a party at a rugby club in the early 1980s, not too far from London, wearing a pair of white Nike McEnroe's. I thought nothing of it, but within about ten minutes of my arrival, the topic of conversation in the place was my choice of footwear. I kept getting asked, 'Have you turned black?' (or words to that effect). The reaction was amazing. Most people at the party were talking about what I had on my feet. I knew I was making a statement by wearing Nikes, I was trying to rock a certain look but I never thought it would cause such a stir. I had to leave the party as someone 'offered me out' for turning my back on my white middle-class upbringing (or words to that effect). That was then, back in the bad old days, before the bomb dropped. Now we have sneaker freakers, sneaker heads, sneaker addicts: collectors who travel

the world (or just spend all their time on eBay) searching out rare and limited edition sneakers like their lives depend on it. Which they do. My taste in sneakers back then was always for box-fresh Stan Smiths with the fat white laces. These days I only rock the Vans Half-Cab. Ever. Catch me in something else and you'll win a prize. Start sending in those limited editions.

Khaled Tajzai from sneakermaniac.com is the man to talk to about sneakers. 'The sneaker culture has matured a lot in the past fifteen years. The styles/technology put into footwear fifteen years ago doesn't even come close to what is done now. Just compare the Air Jordan I to any new Kobe or LeBron shoe, the difference can be told in just a few steps in either shoe. I could say though that before it tended to be only one brand taking over the market, now we have a lot more brands that are actually giving the big guys a run for their money.

'My all time favorite shoe would have to be both the Air Jordan XI and Air Jordan XII. Reason for the Air Jordan XII is because it was the first shoe I had ever gotten. My family wasn't rich at all, my dad was a cab driver and my mother worked at a fast-food restaurant, making it impossible for me to get anything new. One day to my surprise my mother had purchased me a pair of Black/Red Air Jordan XII. After a while I didn't purchase anything till I got a bit older and the retro Air Jordan XI black/red came out. The funny thing is, I wasn't there to purchase them but my grandmother and aunt got it for my birthday. I still have both pairs and they are completely beat! But I wouldn't sell them if people offered me thousands... just too much meaning for me behind them.'

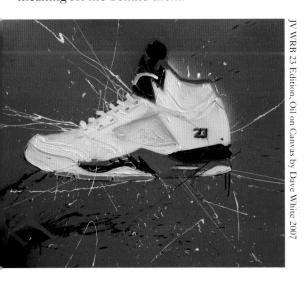

JV WRB 23 Edition, Oil on Canvas by Dave White 2007

This side of the pond it's the same story with a European twist. For Josh Cole, photographer and sneaker addict, the love affair began when he was at school.

'For me, my obsession with trainers is all about nostalgia – when I was a kid there was a couple of kids in my year that were always dipped the latest Nike running shoes and Jordans. My mom could never afford that stuff so I used to wear the cheapest no-brand duds and I was always pissed off and jealous. I used to watch McEnroe and

Agassi, always watching the trainers and dreaming about owning some. Around nineteen I got my first full-time job earning about £90 a week. First wage packet came and I took it straight down the sports shop and bought my first pair of Nikes. From then I built my first rotation, three or four pairs. I'd get the guy in my local sports shop to order tennis and running shoes in specially. From there the obsession grew. These days I collect trainers, but to me it's not about fashion, it's about nostalgia. The ultimate shoe for me is the Air Challenge (Agassi's signature range) in all its forms. But I'm also a big fan of the 87 Windrunner, Huarache LE and the 80s' Jordans especially 3 and 4. The trainers from this era were design classics and represent individuality and creativity, pushing the boundaries while keeping that classic silhouette. I love "flossin'" or showing off rare shoes. It always gives a collector a buzz when you hear those immortal words "where did you get those?" or "I had those when I was a kid."'

Adidas Decade low x 123Klan, Fall/Winter 2007 for Footlocker 'END TO END' project line.

SOMEOTHERGUY

www.myspace.com/livyandsomeotherguy

Someotherguy is a great example of the evolution of street culture, as he is the new face of music and creativity, being literally born out of the Manchester scene of the 1990s (>p172) and dropping his first album with seventeen-year-old singer Livy Wood in 2010. I got down with him in a killer curry house in Back Piccadilly in Manchester.

'It's mad when I think about how it all started, it's hard to pin down. I grew up in a pretty creative environment, so I didn't really know any different. We lived in a three-storey house in Manchester, me and my folks on the top floor, Shaun (Ryder) and Bez on the second floor, and some mates from that scene that were mega characters on the ground floor. It was just a full-on party gaff, and the biggest thing for me thinking back was that there was always tons of people around, or just passing through, with loads of different music on rotation. I remember being up all night with Bez listening to Can [one of the original 'krautrock' bands] and my uncle and his mates would be round playing all the early electro and hip hop stuff, like Man Parrish and Freeze Force, Arthur Baker's Breakers Revenge and De La Soul. Our Paul [Ryder] was playing old funk and soul records, like Sly & the Family Stone and Parliament, and my Dad used to listen to all that old American stuff like Link Wray, Leadbelly and the Ramones. It was top to have that much going on around me when I was a kid.'

His heritage is impeccable, as his parents are Pat and Karen from Central Station and his uncle is Shaun Ryder from Happy Mondays.

'My mum and dad were really young when they had me and they'd just set up Central Station. Everything was pretty chaotic and they were in the thick of it all. Once it started to kick off, I just had to dive in and go along with it. One of my earliest memories is going to Glastonbury when I was four. We went down on the Mondays' tour bus for their headline gig in 1990. I remember being side of stage, looking out on a sea of people going mental, the atmosphere was brilliant! It had a massive impact on me.

'I spent a lot of time in rehearsal rooms and the art studio. It was a big warehouse space in an old run-down building in town – we used to play football in there. We had a massive painted Madchester banner that we used as the net! I didn't realise it at the time, but all these experiences had a big influence on everything I'm doing now.

'I don't separate anything creative into different boxes; music, art, whatever. If anything I've always thought it should all go hand-in-hand. So when I started doing my own stuff I didn't want to limit my influences to just music: being out and about, seeing things, films, books, it all goes in. I got into production, DJing and putting on club nights, incorporating street art and guerrilla marketing into it all. It's now come full circle and I'm working on new art projects with Central Station and finishing the album. I was able to bring some new energy to the table cause I'm sorta hooked up to the mains! There's something about being able to stay in a creative frame of mind. I've never had the dough to spend on instruments and equipment, but all you really need to come up with interesting ideas, is time. I'd rather have time than all the other shit you're supposed to aspire to.'

SHAWN STUSSY

www.stussy.com
www.s-double.com

Back in the early 90s I used to rock the Stussy Bob Marley Shirt that read 'Feeling Pretty Darn Irie!! Get up and Skank to da Rydim!!!' on it in the Stussy-style writing. This was one of my all-time favourite shirts, as it represented reggae, skating and street shit in one shot and these are my favourite things (plus food). Shawn Stussy grew up in California and spent his weekends at Huntington Pier. One day his sister gave him her old surfboard, and he stripped off the fibreglass and shaped his first surfboard. This was a pivotal moment, the beginning of his love affair with surfing and shaping surfboards. A few years later he began working as a board shaper at Chuck Dent's shop in Huntington Beach, and then stepped up his game after meeting Bob 'Ole' Olson, a woodwork teacher at his school who also ran the Ole shop on Sunset Beach.

'Ole was the guy who really taught me how to use the planer,' says Shawn. 'I would get out of school early for "work experience" and go open Ole's shop in Sunset Beach and shape a board till he got there later in the afternoon.'

From 1973 to 1980 Shawn spent his winters skiing in Mammoth Mountain, California, then returned to Huntington Beach for seven months of shaping, surfing and going to Kauai (the oldest Hawaiian island) for the fall and spring. It was in 1979 when he began to write his name in a whole different bunch of ways, dreaming of making his own line of boards. He moved to Laguna Beach and set up his own surf shop in the Canyon in March 1980. Needless to say, Shawn took the art of shaping boards seriously:

'Shaping was something I could not mess with or whore out. Board shaping was sculpting in the purest form to me. Magic boards were just that, born out of the creative process. Okay, it might sound corny, but this shit mattered to me.'

As he could only really shape and paint one board a day, in 1982 he began screen-printing his board signature onto T-shirts and started to supplement his income by selling these.

'The T-shirt design thing made sense to me. I could goof around with the design, pass it on to someone else for production, then ship it myself. This situation let me continue to shape boards while developing the clothing part of it.'

By the mid 80s Shawn was selling his clothes in NY and building up an international crew of like-minded peeps: the International Stussy Tribe, an organic crew that sported custom-made personalized track jackets and had bundles of tongue-in-cheek flavour to spare. His fresh-to-death clothing, influenced by skaters, surfers, artists (including tribal art, especially African), reggae musicians and hip-hop DJs, kept selling and built a mad-loyal following around the globe. By the end of the 80s his small company had become a global street brand. After becoming a father, Shawn sold Stussy in 1996 to concentrate 24/7 on his family life. I wholeheartedly applaud this.

'I felt ready for the family adventure part of my life. Deserving 100 per cent of my attention, I put the business side of life on hold to focus on raising our boys.'

2010 sees the launch of Shawn's next project, S/ Double, the next generation of Stussy!

'Yeah, starting to work on a few things... I have always had the passion for designing things, and now seems like the time to engage myself again, both in surfboard and product design. I had a lot of fun during that time being part of the International Stussy Posse! I got to go to Tokyo and DJ at the first Japan gathering of the IST. All the guys in the IST were my good friends so we would always hang out, make mix tapes etc and swap notes on the newest latest [no Internet then!] .'

Turn to p20

STÜSSY
INTERNATIONAL
STÜSSY POSSE
CHARTER MEMBERS: PAUL BEATING,
JEWELZ and SLIM TONEE...
COLD LAMPIN' N.Y.C.!!!
YO, THAT'S HOW WE'RE LIVIN'!!!
PHOTO: JAH SPIKE

STREET FOOD

For me one of the most exciting aspects of street culture is the food. No doubt about it. Food is the one thing that unites everyone in the world regardless of race, religion, gender: we all have to eat, no matter what. For as long as I've been travelling the world checking out street culture, it is on those streets that I've had to eat, and this is where the street food comes in. Don't get me wrong, street food is not fast food; it maybe quick and easy but at the same time it's seriously tasty and nutritional. Don't be afraid of eating street food, as it's the absolute bomb. For me I absolutely love getting on the road and trying out new dishes and then working out how to recreate that magic at home. The whole idea of street food has been recently adopted by some of the world best chefs, who try to recreate the food in a (s)wanky setting, as they know that the only place to really go is down to street level to get the freshest ideas for their menus. Places like Singapore, Kuala Lumpur and Hong Kong are the Meccas for tasty food. . Over there it's part of the culture and everybody eats on the street. These are my Favourite Street Foods:

PAD THAI

The most popular, easy to make and tasty Thai dish. The staple of many street food vendors in Asia, and one of the true kings of Street Food, combines noodles, with seafood and peanuts. Eat at any street food stall in the Far East.

PIZZA

An Italian invention that's been well hyped by the US: Eat it in Rome for the most authentic version or across the pond in NY at Ray's (most famous) or Lombardi's (first ever Pizza joint).

CHICKEN TIKKA BURGER

Big up all Pakistan and Indian rude boys chowing down out there! This is the ultimate crossover: east meets west in a street food extravaganza! I discovered this in a local place called 'The Flame Grill' just next to Batley Bus Station, in deepest Yorkshire.

KILLER KEBABS

From North Afirca to the Middle East there is a serious choice of kebabs. Not kebab as in doner (the world of meat) but kebab as in marinated meat (Lamb or Chicken) skewered and then grilled over hot charcoal.

SABICH

I discovered this with Pilpeled on the streets of Tel Aviv. He couldn't believe that I'd never eaten Sabich and afterwards neither could I. Very healthy, vegetarian option to all that meat out there…Egg Plant, Boiled Egg, Tomato + Onion salad, Tahini and Hummous all in one pitta.

BUNNY CHOW

This is a recipe straight outta Durban, South Africa, home to the largest Indian population outside of India, but today the Bunny is now eaten all over SA. The dish originated from when some kids wanted some curry from a street stall and didn't have any plates, and so used a holed-out loaf of bread instead.

EGG BIRYANI

My great pal John Roderick from India, who used to run the legendary 'Eat Vell' Hotel (that's what café's are called in India) in Kotagiri, Tamil Nadu, taught me how to really cook Indian food… And Egg Biryani is one of the favourites on the streets of Southern India.

CHIPOTLE STEAK

Straight from the Dirty South! I was on a road trip through the deep south and one day I pulled off the I-85 and drove into Durham. The outskirts weren't that upmarket but I wasn't sweating it: I was hungry for something other than the fast food or stodgy waffles that had been my staple diet for the last few days. Soon I passed a roadside BBQ (or a grill as it is called in the US) with two immaculate 40-something homies, dressed head to toe in Nike, hyping the food to passers-by. They served me up some Chipotle!

→Turn to p102

THE SKATEBOARD

My introduction to skating was aged eight when I got a blue GT Coyote mark II skateboard for Christmas, complete with a Jofa helmet. Before that I'd made a few boards with a plank and old jacko roller-skate, but the Coyote meant that I could step up my game.

Skating was invented one day in the 1950s when there were no waves and some Californian surfers decided to create a land-locked version using a roller skate with a plank or wooden fruit box (plentiful in California). Due to the hard nature of the wheels, the ride was never smooth and if you hit a stone you'd fly off and land on the concrete. In the 1970s Frank Nasworthy created a polyurethane wheel, called the Cadillac. This not only revolutionized skating, it allowed it to take its place in popular culture.

Skateboarding has become synonymous with street culture, and it is one lifestyle that I am completely in love with, and if I had to trade being a writer for one thing it would be for a pro-skater. I even had my own signature board when I designed for Bone Idol [Brighton Skate and Surf brand] but my all-time favourite set up is: a Fibreflex board, ACS 650s, Green Kryptonics, a bag of weed and a empty swimming pool in the LA suburbs.

Big up the Z-boys AKA the Zephyr Skate Team from Venice, California (core members): Allen Sarlo, Jay Adams, Tony Alva, Darius Anderson, Chris Cahill, Stacy Peralta, Bob Biniak, Paul Constantineau, Jim Muir, Peggy Oki, Shogo Kubo and Wentzle Ruml) who created a myth with not only their skate style, but their behaviour when not skating. Massive respect to the Soul Artists of Zoo York, Andy Kessler (RIP), Puppethead (Jaime Affoumado), PaPo (Catalino Capiello Jr), Ricky Mujica, Frankie Courtner, Ali (Marc Edmunds), Eric Haze, Revolt and Zephyr – a collective of skateboarders and artists who took street skating to another level in the rotten apple of NYC in the 1970s.

→ Turn to p178

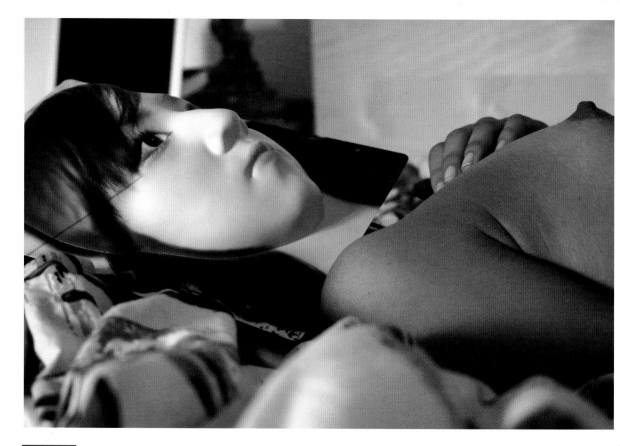

TOFER

www.kingtofer.com
www.christoferchin.com

Tofer Chin is an artist and photographer from Los Angeles. He's been living in Hollywood since he was nineteen.

His paintings 'fascinate the way a kaleidoscope does a child' and his photographs 'confuse the gorgeous and the grotesque.' His influences are Kelly Wearstler, Jeff Koons and Ryan McGinley to name a few.

I discovered his work when someone sent me his book *Finger Bang*. His youthful street imagery intrigued and rocked me and made me sit up and take notice. He followed up with *Vacation Standards* – more killer photos from life on the streets of LA and around the world. In this day and age of generic street style, his work is a total breath of honesty, street shit. Sex drugs and hip hop are on the menu and his eye ensures that the moment is distilled onto the page. Don't go changing.

Turn to p221

TOMATO

www.tomato.co.uk

Tomato is a collective of artists, designers, musicians and film-makers. Its members include the band Underworld, and its clients range from Guinness to Lyle & Scott. Tomato create original visual communication across all medias, from album covers and videos for everything Underworld have released, to the titles and end credits for the film *Trainspotting* (>p284). I got down with one of its members, Simon Taylor.

'Tomato was set up in 1991 to allow its members to work in collaborative groups under a single umbrella. This gave us a shared space and identity with a support mechanism that allowed more freedom to experiment with our output. Our mantra became "Process". In its purest form this is what Tomato explores and presents.'

'What does street culture mean to Tomato?'
'Probably different things to different individuals. In a way, that's also the definition of street culture. I've felt for a long time that cities and their peoples are the most inspiring points of reference because the variety that you find there is the result of mixture, either literally or in hidden ways, like the mixture of different eras on a place. Often you can see the disparate elements in a city forced together. Sometimes elegant, other times kicking and screaming, they become a new and surprising part of life.'

→Turn to p278

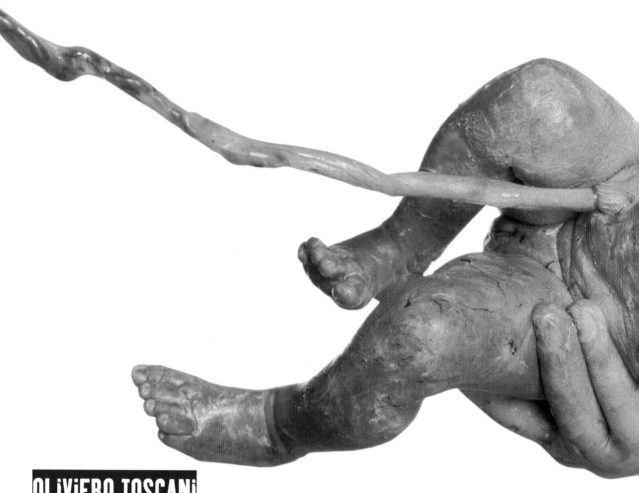

OLiViERO TOSCANi

www.olivierotoscani.it

Oliviero is an Italian photographer who rose to fame through his amazing work as the Creative Director for Benetton.

'I am a photographer and an imagineer, I try to produce images that will become the historical human memory.'

His United Colors of Benetton campaign was a ten-year creative run of beautiful, thought-provoking ing and controversial ads that not only raised the profile of the brand, but also drew much-needed attention to the issues they were portraying: a priest kissing a nun; a new-born baby still covered in blood; a black stallion fucking a white mare; a colourful assortment of condoms; a white baby breast-feeding on a black breast; the exposed hearts of three different races revealed during surgery; emancipated AIDS victim David Kirby seconds before his death; starving refugees fighting for food at a ship's cargo net; and the bloody uniform of a Bosnian soldier who's just been shot.

In the 1990s Oliviero co-founded *Colors Magazine* with Tibor Kalman, (another pioneer) and continued to develop the multicultural motif he began with the Benetton campaign.

'My work has evolved with the changes in time, social conditions and politics. I try to take the right images for the right time.'

→Turn to p12

CANDiCE TRiPP

www.candicetripp.com

Candice originally wanted to go into fashion, but discovered painting when she needed to create a portfolio of work to get into college. She then had to kill some time waiting to get the money together for the college fees, and it was during this time that people began to offer her money for her paintings.

'I thought, "let's see where this goes!" I struggle to define my work. I suppose it's because I never really sat down and thought about what I wanted to say or achieve with my painting. I suppose I really just stick to what amuses me and I'm slowly recognizing my repeated efforts to keep a claw in the things I fear I'll forget about childhood. Like the simpler way of thinking and an unvarnished emotional response to things.'

She grew up in the suburb of Marina Da Gama in Cape Town and spent most of her childhood outdoors.

'It was fantastic. In the early 80s it was a new area; all the houses had to be regulation white with a grey roof – to keep things tidy. Behind my house was a park my father and the other neighbourhood dads built. We spent a lot of time in the man-made waterways we called "the vlei". It surrounded the suburb and connected to the beach, adding to the feeling of safety it gave us.

The city centre and Cape Town's "alternative" scene was a 30-minute drive away. The beach was ten. And we could see the mountain from anywhere. I was a lucky sort of sausage.'

Life for Candice got a bit frustrating when she hit her teens: a shoddy public transport system meant she had to rely on adults to drive her about. And mix that with a scarily high crime rate.

'We didn't really move sideways on our own for fear of "asking for trouble". That's what our parents called it when something awful happened to a kid walking around on their own. It also meant just getting an after-school job was that much harder because getting to and from it became a complication. We were mostly cooped up and skint.'

Her work has evolved and now she is represented by Steve Lazarus, who represented Banksy for many years.

'Well, I've long kicked the obligation of filling a whole bastard canvas. And I suppose because of that, I really enjoy playing with negative space. You know – the things you once hated become the ones you love (I always thought that only really applied to other kids and foodstuffs. Like green beans.) I'd like to think that my canvases are getting if only a little bit better technically. There's been a bit more detail and the canvases themselves are getting bigger. When I started out, everything was small. I think it was very much confidence related. I still wince a little bit when I think about my bigger canvases.'

→Turn top106

REGAN TAMANUI

www.regantamanui.com

On the street Regan is known as Ha-Ha, and is the most prolific and well-known Australian stencil artist. He is the Aussie Banksy. He is also doing very nicely thank you in the art world and galleries of Melbourne and Sydney with his multiple-layered stencils (some up to sixteen colours). He is a really great bloke and I had a couple of cold ones with him and got the scoop.

How did you get to be the premier Australian stencil artist?

'I think I just happened to be in the right place at the right time. I used to cruise around the streets of Melbourne around 1999 and I'd see three to five stencils by this guy called psalm. His stencils would pop up in random spots around town, and there were other political stencils with a satirical message to them, so I thought I should try doing stencils and I did, properly in 2001. But I was more into bombing, so I took that approach and became a stencil bomber. Instead of planning a spot to put it up, I'd cut out stencils of robots and put them up everywhere (it was way easier then tagging) and an image of Ned Kelly [the famous Australian criminal who killed cops, robbed banks etc]. And also my stencil technique has evolved as well over the years where most people I know haven't gone beyond the two to four layers. The name Ha-ha is interesting, it's a laugh and everyone on the planet laughs, it's easy to remember even for people who ain't into street art.

'My work is about the here and now of Australian popular culture in general, sport, the cult of the instant celebrity phenomena (*Big Brother, Australian Idol*), corruption in big business and politics, criminals, Boganism [Aussie chav], sub-cultures or themes within mainstream societies (street art culture, emo kids or surf culture) and cult religions (I'm not religious).

'My work is a reflection on that kind of subject matter. I like the dark side or stuff that people don't like to talk about – I find that interesting. I started off doing one-layer stencils, then two to three layers. I used to use Photoshop at this stage then my computer broke down but I couldn't afford to get a new one, so started to trace the image by eye using a semi-clear plastic as a stencil; then I started to do six to eight layer stencils, then twelve to sixteen layers until I mastered this technique. Now I cut images that are up to 42 layers, all done by eye, unaided by a computer, I call it the ha-ha technique (funny, that sounds like a B-grade kung fu film). I see urban as the voice of the people. I see it more as protest against mainstream ethics. If I were living in the Middle East where there are innocent people being killed I would like to see anti-war street art targeting the aggressor. If I was living in a racist suburb in Australia, I'd like to see anti-racist street art, or if I was living in a western city dominated by multinational corporations I would love to see anti-corporate slogans, street art etc. That's how I see street art influencing the urban landscape.'

→Turn to p50

257

Underwear,
'Our Couch.

Blind
Ambition

Do anything... To get ahead!

NO
REGRETS

HOLLYWOOD

IT TAKES A LIFE TO BUILD A CAREER
BUT JUST ONE NIGHT TO RUIN IT

UPPER PLAYGROUND

www.upperplayground.com

Upper Playground is influenced by people who take risks and don't die; people who mutate and evolve; who learn from their mistakes but aren't afraid to make them; people who get lemons and make lemonade; who don't believe that anything in life is impossible. People like Lyor Cohen, Damien Hirst, David Choe, David Ellis, Claude Brown, Mary Boone and Al Davis.

'True Street Culture is actually just a mirror of what takes place in everyday life in major metropolitan cities worldwide.'

Upper Playground are interested in collaborating with companies and individuals who are interested in doing things that push the boundaries and people who are interested in giving back to the culture. Not just dollars and cents propositions.

Upper Playground is an art, design, fashion, media and music collective based in San Francisco. They have mutated from selling a couple of T-shirts in 1999 to producing over 400 products a year in 2008. They started out sharing a record shop and have now opened stores in Berkeley, Portland, Seattle, LA, London, Mexico City and Taiwan. Many of the artists who debut with a show at Upper Playground's gallery go on to be some of the most successful painters of our time. I sat down with UP founder Matt Revelli and asked him what it was all about:

'Upper Playground is about no boundaries and doing whatever, whenever we want. Answering to nobody but the people who support us. We strive to create products that reflect a creative lifestyle that our customers participate in.'

UNDISCOVERED TALENT

Everyone's gotta start somewhere, so the next two pages are dedicated to an assortment of bright, young and restless talents that have caught my eye. The only one bit of advice I'd give anyone wanting to get into something creative connected with street culture is that you've gotta come correct, and so wild style and stencil artists need not apply.

READ

www.moreyread.com

Read is the freshest thing since sliced bread. He combines graphics, illustration, street art, and mass-media to create a unique view of things.

BRiAN HART

http://brianmatthewhart.googlepages.com

Brian's light drawings stopped me in my tracks. For me, this is what art is about. Picasso began the idea back inna day and Brian is running with it and taking it to the next level.

'When I first started doing light drawings, it was 3 am, and I was camping with some friends along a river in Iowa. I had just bought a decent digital camera, and thought I'd have a go at writing my name with my cell phone on a long exposure. Now, I know this is not an earth-shattering idea, but something clicked; something started whirring away in my mind when I saw that picture. Nothing like, "Wow, this is totally new and wild," but something about how the camera was a much more malleable tool than I had thought. I don't know, something like that, it was a little while ago.'

URBAN EARTH

www.urbanearth.co.uk

Urban Earth is a killer project created by Daniel Raven-Ellison. It's about walking across an entire urban area. The length of the walk represents the size of that urban footprint and the route reflects levels of deprivation. Where the 20 per cent most deprived people in the city occupy 5 per cent of the land, roughly 5 per cent of the walk will be through these types of areas. The route is systematic and unbiased in an attempt to reveal a slice of real life. Over the course of the walk one person takes a photograph every eight paces so that when put together, a stop-motion film is created, revealing an alternative view of the city somewhere between a photo, film and map.

'Urban Earth is a project to (re)present the places where the majority of people now live, urban habitats. Media, culture and memories distort how we see and experience cities, enlarging in our minds areas of extreme wealth, poverty, danger, safety, tension, excitement…

and where we are told are most "interesting" by guide books. Think of the main images we see of city life – slums, skyscrapers and historical landmarks – the majority of any city is not made up of tourist sites, financial or cultural centres, but the spaces of the everyday: terraced homes, shopping parades, alley ways and A roads. Urban Earth seeks to (re)present cities in a different proportion to show the everyday and reveal the real geography of the places that we inhabit.'

The project is also about freedom in space, flows, fair politics and community. Newspapers instill in us stories about violence and conflict, as do the anecdotes from friends that reveal memories of places of perceived fear rather than safety. Such stories create barriers, borders in the maps we form in our mind of no-go areas. The process of walking across a city asserts the walkers' right to public spaces, creates opportunity for people of different communities to see, hear, smell, taste, feel, experience each other, talk, engage and potentially reduce conflict that can be created by ignorance.'

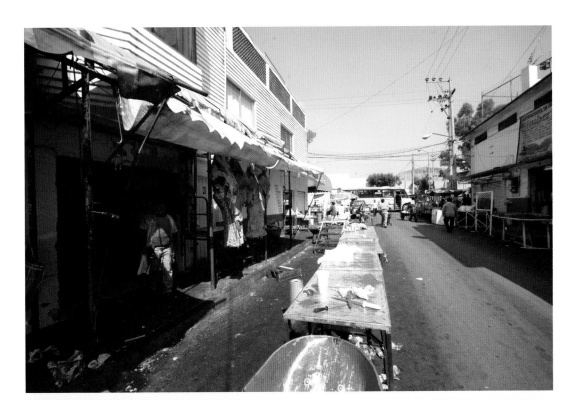

www.wmaker.net/parkour
www.foucan.com

Parkour AKA freerunning, and streetball are the two main sports to blow up on the streets. I used to film the AND1 streetball team and spent some time with the French parkour crew who created the films *Jump*. The guy on the right is from Rwanda and that shows just how far this shit is travelling!

Georges Hébert is the godfather of parkour. He was a French naval officer who, on a trip to Africa, was totally blown away by the physical fitness and dexterity of some of the tribes he met. He returned to France and created a méthode naturelle training session, which consisted of ten of the fundamental groups of exercise: walking, running, jumping, quadrupedal movement, climbing, balancing, throwing, lifting, self-defense, swimming. This was developed and adopted by the French military as the standard training and when used with an obstacle course became known as parcours.

What we now know as parkour was created on the French streets in the 1990s by David Belle. After leaving the French army he moved to the town of Lisses, which was a perfect place to develop what – in an interview with actor Hubert Koundé – he termed Parkour. In 1997, a group called Yamakasi was formed (members: David Belle, Laurent Piemontesi, Sébastien Foucan, Yann Hnautra, Charles Perrière, Malik Diouf, Guylain N'Guba-Boyeke, Châu Belle-Dinh, and Williams Belle) and the rest is history.

Parkour has become a bone fide urban sport documented in the following films:

Jump London (2003, Mike Christie)
Jump Britain (2005, Mike Christie)
Yamakasi – Les samouraï des temps modernes (2001, Ariel Zeitoun, Julien Seri)
Banlieue 13 (2004 Pierre Morel)

Streetball is basketball's street-smart little brother. With fewer rules and no limit on the size of teams, streetball is played the world over. In 2001 the AND1 Mixtape Tour on ESPN took the game to another level and I was hooked. Mixing hip hop, MCing, street shit and streetball, the show broke the mould with regards to sports on TV. It is the only sports show I've ever watched.

Streetball is the opposite of the NBA as its accessible. This is the game of the projects and the talent comes straight from the street. There is never any problem finding a game as all you need to do is to get yo'self to a court, stick on a mixtape and bounce! My favourite streetballers of all time are Phillip 'Hot Sauce' Champion and Grayson 'The Professor' Boucher. They kill it every time so go google the motherfuckers!

Go check: AND1 Mixtapes 1 – 10 (DVD). There is really nothing more to say.

→Turn to p184

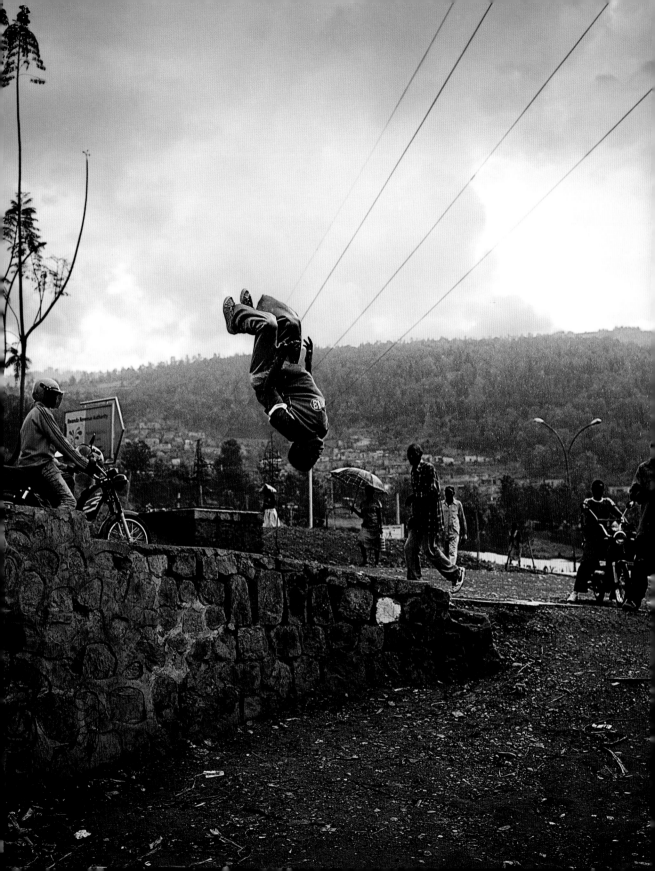

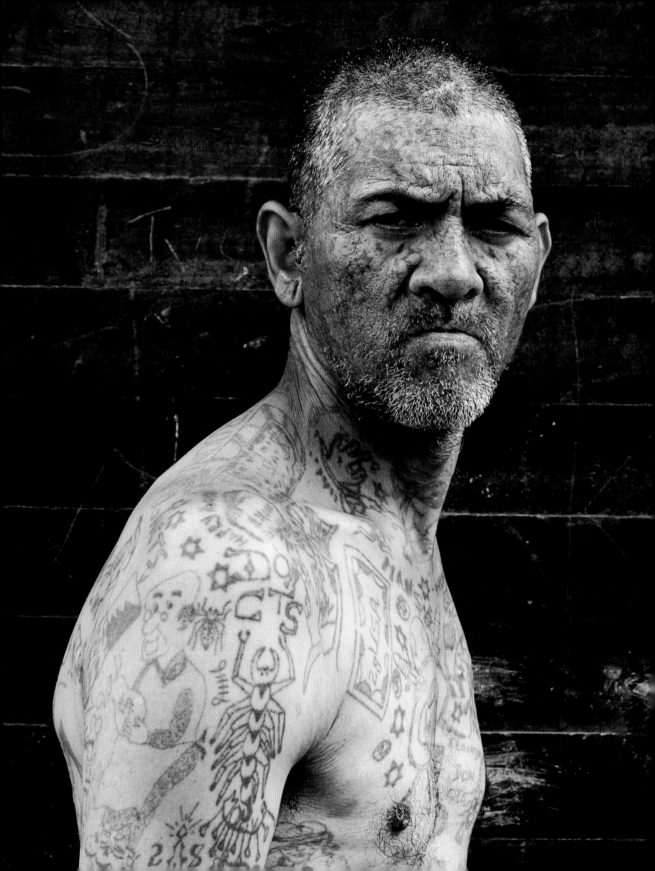

UNDERGROUND

When the South African government began bulldozing District 6 – a multi-racial district of central Cape Town in 1966 – the dispersed inhabitants were mostly sent to new-build apartment blocks in a dusty desert-like plain outside of Cape Town called the Cape Flats. By the year 2000 the Cape Flats had become a no-go area for most whites, blacks, policemen and any other person who simply wants to live. The gangs run the place, gangs that go by names like The Young Americans, Hard Livings, Nice Time Boys, Mongrels, Scorpions and Laughing Boys. Most gang members like their tik, guns, customized/modified cars, hip hop and dagga (weed). They speak in Cape Slang, a mix of English, Afrikaans and Cape Malay. These are not black Africans. They are Muslims, descendants from Malaysia. Commonly referred to as Cape Malay or Cape Coloured. These are the real South African gangsters. Forget *Tsotsi*. That was just a crap film compared to what's going on in the Cape Flats.

I got to know a DJ, let's call him X, who was a founding member of South Africa's most famous and widely travelled hip hop crew. He'd DJ to the rich whites up town on a Saturday night and then take his shit across the tracks, into the Cape Flats. One night he let me carry his records.

The Saturday night crowd was wild – at least they were wild for the rich: coke and e, a bit of semi-nudity, some bump and grind. They thought they were wild. I watched and waited. Two hours later I climbed into a heavily modified car and headed north, towards the Cape Flats: 2 am and the streets are deserted, the rich southern suburbs slide past as we fly through with the amp in the boot cranking out multi-lingual hip hop. This is the real. MTV could never even think about showing these scenes.

The road we take is called Lansdowne and it takes us across the tracks, from rich to not-so rich, to okay to poor. Then it enters Mannenberg. This is the heart of the Cape Flats. This is where my heart skips a beat and when it finally begins to kick again, it's like a 808 bass drum kicking for dear life. Boom.

We walk into the house and everyone greets X with pure respect and joy. Then they look at me and their faces drop.

'He's English, he's okay,' X tells them, which makes them thaw enough to let me live. The air is heavy with the smell of cocktail spliffs and the place is packed with young, coloured, Saturday night party people. It's 3 am, time to get ready. The crowd stops moving and stands sill. X checks the faces and then begins to cut in and out 'My Name Is?' by Eminem. Eventually he lets the tune drop and the crowd goes wild. Wild, considering the rapper is white and this is the real deal Cape Flats. I move around, checking out the peeps. I spot a couple of firearms in waistbands. The owner of one of these guns clocks me clocking him and pulls out his gun. He beckons me over with a tilted head and walks out into the garden. I follow, doing what I'm told. Outside he lets off a couple of rounds, in perfect time to the beat, to show me that he is the real thing. No one looks around, no one cares. This is not something unusual. I look around the garden and spot a couple of garden sheds at the back.

'They like to do some gardening?' I ask.
'No man, that's where the buttonheads go,'
'Buttonheads?' I ask.

We enter the shed and the place smells like a chemist. It is full of young men sat on benches around a couple of buckets. One of the boys fills a broken bottle top with weed (dakka) and then proceeds to crumble a large pill on the top of the weed.

'What's the pill?' I ask.
'Mandrax bra, Mandrax.' (Quaalude.)

The boy fires up and smokes the contents of the bottle top. Smoked-out, his head drops, the bottle top drops and he begins to drool into the bucket. My man turns to me as if to say 'that's what the bucket's for.' Biggest props to all the Cape Malay skollies and rough-necks living large.

VHiLS

Vhils, AKA Alexandre Farto, first started out writing graffiti. For a number of years he was focused on train bombing and hardcore graffiti. For a while this was all he was into.

'Graffiti is still an essential part of my life today, but after a while you want to experiment and explore new paths and try out new things and you start questioning both what you're doing as well as where you're doing it. While I was undergoing this stage I started to think more objectively about what I was really doing. When you write graffiti you're only focusing on the people who can understand you – other writers. It's a very tightly-knit circle, a small group of initiates. When I started thinking about all the people who walked past my stuff and weren't able to understand it, I realized there was so much more to do, so much more to explore, that there was real potential if I started communicating with them as well. Nowadays, my street work is all about trying to raise the limits of communication with people.'

He grew up between the south-bank suburb of Seixal, and central Lisbon, in Portugal. Lisbon is a city with its own rich history of street painting, which emerged after the revolution of 25 April 1974. After the revolution, the streets became covered in political and non-political paintings, murals and stencils. It was quite unique in Europe, more of a South American thing.

'Portugal was perceived as a very strategic country and a NATO member, and some feared it would turn into a European Cuba, so there was a counter-revolution supported by Western Europe and the US. The country was turned into a moderate centre-right democracy, and from then on all those revolutionary murals were contrasted alongside Coca-Cola ads. For me, the notion of street culture is way too small to define a world scene that includes graffiti writers, stencil artists, painters, illustrators, designers, video artists and others who share a common perception of what growing up in a more or less uniform urban environment in the early twenty-first century is all about.'

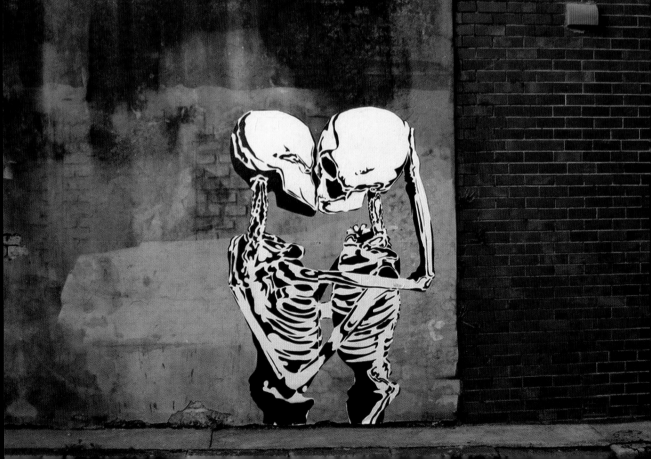

VEXTA

http://vexta.com.au

Vexta's world is all about visions of the future seen through neon fluorescent eyes.

'Images taken from my life, a fusion of reality and dreams, pieced together to create my understanding of the world that we live in and the future we are striding toward. Bright, neon clashing paintings and giant stencilled paste-ups, depicting skulls in ruin and animal-people hybrids accompanied by larger than life domesticated animals, posed ready to take back the centre stage of life on earth, as if waiting for human civilisation to retreat. These are urgent times we live in, precariously living on the edge of a dystopic or even apocalyptic future, a time when many think the western world is on the verge of crumbling much like the Mayan and Roman cultures before it. Hell, if we are going down we might as well go down dancing!'

Her work has evolved from taking photographs of her friends and then going out at night to spray paint them in the streets, progressing to illegal art shows where Vexta and other like-minded artists would take over old empty theatres, warehouses, abandoned apartment building sites and then spend days surreptitiously filling them with art, and then have insane opening parties where hundreds of people would show up, hang out, explore the building, make music, eat and drink. And now these days she exhibits her work in commercial galleries around the world.

'And I'm still running around the streets at night painting and pasting as much as I can. I grew up on the north shore of Sydney. We lived close to a national park and so we had a lot of wildlife around. We had a creek running through our yard with loads of frogs, one eel and two giant weeping willows that I would use to swing across the water. Every night thousands and thousands of flying foxes would fly over our house.

'I got my first camera when I was about eight and I spent hours exploring the mysterious places in the forest, making things, drawing and taking photos. There weren't many fences between all the houses so all the kids in the neighbourhood would hang out together riding our bikes, swimming in each other's pools, playing with our dogs, making forts by the creek. I would go into the city occasionally and be completely overwhelmed and repulsed, and yet loved it at the same time. I'm still completely torn between my love for the wild places and the city.

'Street culture to me is when my friends and me get together and take back public space for art, when we paint out a laneway in the city just for the love of it. It's when I was a kid and we used to have street parties where we would close off the street and put out tables and eat and drink with our neighbours. It's when people take a sound system to the park and everyone dances in the morning sun. It's when the guys who live up the street block off the back lane, set up a huge ramp and hold handmade go-cart races, that go all day and end up with everyone drinking and dancing in the street. It's when my friends hold a new year's eve party so big 400 people take over the park next door, break into the pool to go swimming and we dance on the rooftop. It's when we do these things because we want to and we won't be told we can't. It's freedom.'

ViNYL TOYS & CHARACTER ART

The vinyl designer toy scene has blown up since 1997, when Michael Lau released his Gardeners action figures that looked like a classic GI Joe but who rocked Nikes and Kangol and baseball bats and all that street shit. No one had ever seen toys like that before. So to have a toy that you could relate to or that even represented you was insane. It sparked huge interest and started the ball rolling. The possibility of a platform figure and the infinite possibilities of artistic interpretation and the impact that these toys had on artists' careers. From Be@rbirck to Dunnys to Qees, these toys opened up a huge global community of artists very different to Lau. As they can show ten completely different styles with one series of toy, which then brings the artists to attention in ways that hadn't been done before. The toys themselves became the medium for the message.

Tristan Eaton, creator of the Dunny and Munny toys told me, 'I felt lucky to have met Paul Budnitz – the owner of Kid Robot – because he had passion, the organization and business mind to make it happen which in turn allowed me to supply the art and design. This led to a very comfortable circumstance, and I felt drawn into the world of art toys.'

'My personal history fits well into that world as I had grown up doing graffiti, illustration and toy design. I felt that the world of art toys was all these things put together. By the time I worked at Kid Robot I was ready to create the Dunny and the Munny and I had the background of everything that went into it. There's DNA in all my toys from the natural way I draw, which is what I hope to be a recognizable style. With the Dunny, it was also acknowledging all the toys that had come before and wanting to create something new that provided something different for collaborating artists. With Dunny especially, I wanted to play with organic shapes that were sleek and beautiful as a blank surface as well as a painted one.

'When designing the first Kid Robot toys, I was living in Crown Heights, Brooklyn, and it was the summer of the Nas and Jay-Z battle. Every car and every window was blasting those tracks. The original Dunny figure was a grim reaper type devil bunny, then hearing that track [Jay-Z's 'Tha Takeover'] blasting "I didn't want to do it to you, Dunny" all day every day, it just seemed right. It was already part of the urban lexicon. So that's how I named it. Munny's name, on the other hand, was from Monkey/Dunny more than anything, but subversively it was done for the Money/Munny.'

→Turn to p252

ViDEO GAMES

The first computer game I ever played was a Game & Watch in 1980. It was a game where you had to control a stick man and juggle balls, made by a then-unknown company called Nintendo. For a lot of people, including me, the first serious amount of time spent gaming was on a ZX Spectrum. (Or a Commodore 64 or ViC20 if you were a geek). The coin-ops were always the street kings, they were our apprenticeship – I used to play Scramble and Galaxian for hours in a Chinese/chip shop, but they cost beaucoup moolah to play, and with the home PC, once you'd made your investment (or swapped some games) you were set for a few weeks' work mastering whatever game you were into. Before that, the Atari 2600 'woody' was the first home video system with Space Invaders, Pacman etc, but the graphics were shite and the game play sluggish. Like the coin-ops, they were not cheap (£100 for the console and £30 a game, which back then was a lot). I spent hours playing on my mate Ali's system and the square joysticks would seriously mash-up my hands. That was the beginning, but the advent of the affordable home computer was the one thing that pushed the development of video games forward. That was the revolution that has brought gaming to where it is now.

English inventor Clive Sinclair created the ZX80 (£99), ZX81 (£49.95 in kit form and £69.95 ready-built) and then the ZX Spectrum (£125 for the 16K and £175 for the 48K). Acorn released the BBC computer which was the rival to the ZX Spectrum. These two computers revolutionized home computing. Over the pond, Commodore produced the Vic 20 (the first computer to sell over a million units), followed by the Commodore 64 (one of the best-selling computer of all time at over 17million units) which meant that there was a serious market for games. These early computers paved the way for PlayStation, Nintendo and Xbox consoles as they created a multi-million dollar business other companies were keen to get involved in.

The first 3D video game was 3D Monster Maze on the ZX81. This took the player into the game and took games to another level. In 1983 Matthew Smith created Manic Miner on the ZX Spectrum, which changed a lot of people's lives (sadly, including mine). These were the two games that defined how games would develop. 3D Monster Maze was the prototype to the first-person shooter genre that today takes the form of games such as the Call of Duty or Grand Theft Auto. Manic Miner pushed the platform game and paved the way for the huge Mario Brothers franchise.

Video games today cost around £20million to develop each, and then there are massive marketing costs. Things have changed so much, with the gaming market's revenue outstripping that of mainstream movies. Both of which seem to rely on gratuitous violence and imagery to sell sell sell. Video arcades have become rare places indeed, as who can compete with the technology you can have at home if you hook your PlayStation360 up to a 50" wall-mounted plasma with surround sound? I used to love going to Las Vegas arcade in Soho and sinking a small fortune into a coin-op. They were pretty seedy places stinking of smoke and ganja. But they were a fucking cool place to spend an afternoon.

KEY

STAND
DRAW

Cladding
frames

⑨

Bla	B5a
	E5a
Jlj	C5a

Coding of
window &
door units

51

D2a	Pla
J2a	Jla

121

ground line

92

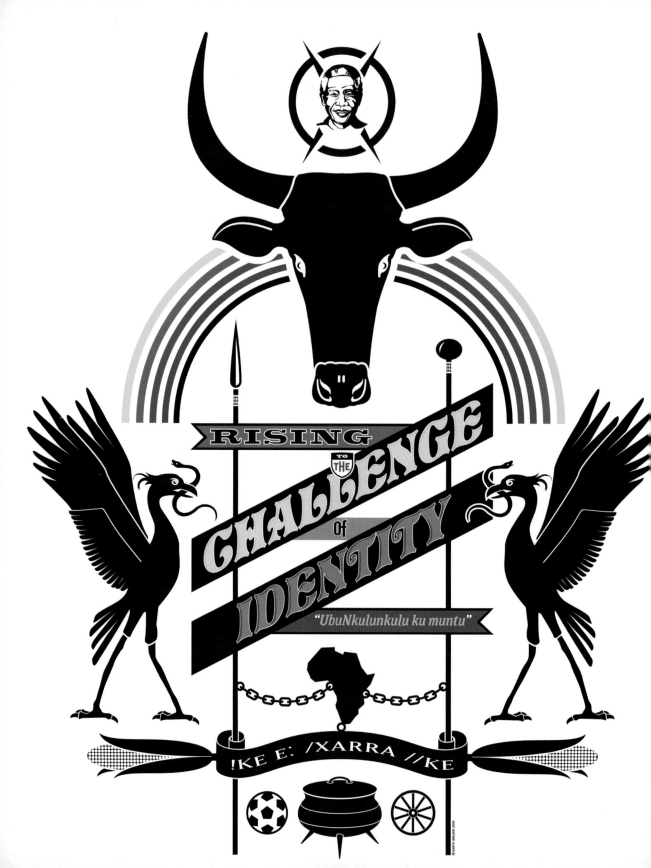

www.irvinewelsh.net

Irvine is a literary legend. He is the pioneer of the modern urban novel who in the early 90s brought the literary scene kicking and screaming into the here and now with his killer collection of tales. From *The Acid House* to *Trainspotting* (natch) to its sequel *Porno*, Irvine has crafted some unbelievably readable stories. His books play out in your head like a movie with the dialogue and action taking place right in front of your eyes. Or is that behind your eyes? I had the honour to spend some time with the man and as we walked around Edinburgh...

<u>I asked him what motivated him to write back inna day?</u>
'I was always a scribbler as a child. As soon as I could hold a pen/crayon/pencil I was compulsively drawing, painting and writing over everything. At primary school I was teased by the other kids and harassed by the teacher as my sum books were covered in drawings of monsters and symbols. The funny thing was, I wasn't an introverted nerd. I could be a quiet dreamer, but when I came out my shell I was a cheeky, mouthy little fucker, up for mischief, so it made for quite turbulent times. I hated maths but loved the design of numbers, and making up new numbers. As I learned how to write I'd develop narrative for my creations, write stories about them. So I was always intrinsically moved to express myself creatively. Unfortunately, it gets knocked out of you. Schools back then, and it's probably the same now, are set up to meet the needs of society and the economy and function as bureaucracies. They don't want some snotty little daydreaming cunt creating his alternative universe; they want a neat, tidy, obedient little chap who will do as he's told, work hard at his sums and not cause them any bother. And go on to work diligently in one of the local or global enterprises. So I didn't like primary school very much. In secondary, it was better, basically because there seemed more "problem" kids around and the teachers had bigger fish to fry in trying to contain the wannabe gangster element without concerning themselves with problematic would-be artists. Mrs Tait in English was very good. She encouraged me to write and pushed decent books my way, not necessarily the ones on the official curriculum. If you go to a large comprehensive on a sink estate, and you have artistic tendencies/aspirations, you need teachers like that or you'll go down.'

<u>How has your work evolved?</u>
'I started to take more of a note of my environment. As a kid, it seemed that everybody around me was a story-teller. It was that Celtic oral tradition – they would never think of writing it down. So I became conscious of how the environment people lived in, the type of house they lived in, the sort of work they did, became important to how they told stories.'

<u>Where did you grow up?'</u>
'I was born in the old port of Leith in Edinburgh, which is a vibrant, dockside community, largely comprised of old Victorian stone tenements. It had fallen into disrepair, and parts of it were scheduled for slum clearance, including our part. The council housed us in Pilton, in prefabs, which were fantastic in the summer because of all the space and the huge gardens which were like jungles.

<u>What or who are your influences?</u>
As I've said, the people that I grew up around. If you live next door to a merchant seaman, or a waitress, or postman, or a thief or a whisky bounds worker, you're going to get interesting stories. I was influenced more by the energy of musicians like Iggy Pop initially, then more narrative ones like Lou Reed, Nick Cave and Shane MacGowan complemented the books I was reading; Russian lit like Dostoyevsky and Tolstoy; English like Orwell, Waugh, Austen; Scottish like Grassic Gibon, Kelman, Gray, and, most of all, American such as Bukowski, Burroughs, Volman, Dick etc.'

→Turn to p172

WiLMA $

www.wilmastone.com

Wilma is creating art like no one else and that blows my mind. Using all mediums and techniques, she defies categorization, defies being either 'craft' or 'art' with the sole intention of subverting tradition. Wilma strives to create artworks that articulate the spirit of rebellion.

Who are your heroes?
'Anyone who manages to produce beauty with raw, expressive and fearlessly honest mark-making. This applies to all art forms, be that writing, film-making, music…'

Craft or art?
'I'm outside both worlds looking in with horror and dismay.'

Turn to p42

NiCK WALKER

www.theartofnickwalker.com

Nick Walker has been getting up since the early 80s, massively inspired by the pages of Subway Art. He grew up in Bristol.

'It was a good place to be and still is. In the early 80s it had a great underground music scene and some of the DJs had strong links with New York which meant we got to hear some of the newest beats at that time – there was some great parties back then. Back then there was only a handful of graffiti artists in Bristol and to my knowledge it was the first city to hold a graffiti exhibition in the UK [hosted by the Arnolfini Gallery in 1984].'

Nick moved to London in 1992, when he decided to combine stencils with his freehand work.

'This allowed me to juxtapose almost photographic imagery with the rawness which evolved from conventional graffiti styles. Stencils introduce an impact element to my work. The appeal of stencils is that they allow me to take an image from anywhere – dissect any part of life – and recreate it on any surface.'

He has continued to build his name around the world and after the 2008 Bonham's auction when one of his pieces sold for £54,000, he blew up over-night. Nick had a show in LA that sold out immediately. People queued for his last London show at the Black Rat Gallery for 36 hours.

'I try to add an element of humour or irony to some paintings to add a little light relief to the walls. The Morning After was a particular body of work which concentrated on a character – a quintessential bowler-hatted city gent who embarks on a quest to cover famous landmarks and cities with his chosen palette – a kind of rework of the phrase "painting the town red". Painting is a form of escapism for me and if my work allows the spectator to do the same thing, then I've achieved more than I set out to do.'

He has witnessed the street culture go from sub-culture to mainstream:

'I remember seeing for the first time an old lady wearing a pair of shell toes and thinking, "Damn, shits getting out of control". In the 80s that would have been a cartoon sketch in one of my black books. The advertising industry got hold of it and has subsequently used elements of street culture on almost everything possible – cars, phones, bank, iPods, you name it – so eventually it just becomes the norm.'

Nick is open to a wide range of inspiration:

'Everything inspires me. Everything and anything. I was inspired by the colour scheme on a pair of socks my daughters gave me for Christmas last year. I'm inspired by the colours and design of a Maersk shipping container passing me on the motorway, the rust-encased letters on the side of a waste skip, when a mass of birds in a tree all take to the sky all at once, the folds in fabric, grainy black and white photos and huge cities.'

Turn to p24

GARTH WALKER

www.misterwalkerdesign.com
www.ijusi.co.za

Garth is one of South Africa's finest graphic designers/street culture observers and creative director/founder of *I-jusi* – one of the finest magazines you'll ever get your hands on. I discovered *I-jusi* when I lived in South Africa and was immediately blown away as I had never seen anything so fresh and graphic. It was what inspired me to produce *1percent* (>p188).

'*I-Jusi* is basically a published platform to encourage and promote a more "Afrocentric" approach to visual design (including writing). Most all South African graphic design is Eurocentric, yet we live in Africa (and not London Paris or New York). I started a new studio, had no work, and lots of free time. So I decided (this was 1994 and our first Democratic elections) to design a "magazine". I started with material I had to hand, namely African crafts, so it sort of evolved into a more "African" publication. I was then approached by a printer who was looking to promote their services to the advertising industry, and this was seen as an ideal start. So we printed issue #1 in early 1995 and we've had 24 issues so far. I want to try and keep it free (we don't charge or have subscriptions) and to update and redesign the website.'

Garth has always been fascinated by street graphics and signage and this has been an influence on his work.

'I'm interested in "what makes me African". The journey is then to explore that theme based on "the stuff around me". My work started out with my own interpretation of African street vernacular (basically inventing a personal language). I now find I'm doing more of a marriage between street vernacular and, let's say, 1960s Swiss. But the reality is it's still virgin territory. Oh, and more use of photography in the messaging.'

<u>What does street culture mean to you?</u>
'Whatever is happening on the streets and townships (both cities and towns). Increasingly, one could add suburbia, as the integration between (suburban) colour, class, creed, economic standing, lifestyle and so on increases rapidly. This is most evident in suburban architecture, interior décor and gardens. My influences are what I've said above. Plus my lifelong obsession with photography and my documenting whatever is in front of my camera.'

→ Turn to p268

WiCKED STUFF TO CHECK

www.shutnyc.com

www.meandyu.com

www.inflamable.com

http://hello.eboy.com

www.inkie.co.uk

www.cnduk.org

www.zerocoolgallery.com

www.steakzombies.com

http://dj716.blogspot.com

http://miss-k.ultra-book.com

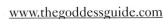

www.bigtomatocompany.com

www.thegoddessguide.com

www.hiphopassociation.org

http://thebookerycook.blogspot.com

www.water-gate.de

http://aidtoartisans.org

www.pilpeled.com

www.thelazydog.fr

HE CHURCH OF LONDON

www.thechurchoflondon.com

www.alife.com

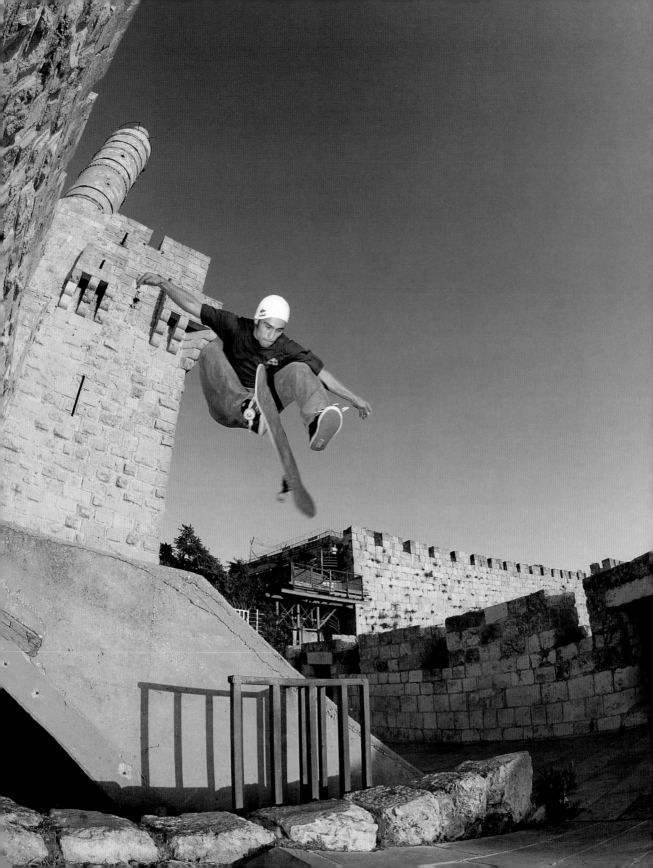

XENZ

www.xenz.org

Xenz paints floating landscapes, dark cities, stormy skies and birds. His art is like snapshots of a never-ending horizon from various viewpoints, as if the viewer were a bird flying over a massive rubbish dump.

'My earliest memory of art goes back to when I was about four. My dad taught me how to draw the shapes of the continents in the atlas. I remember learning to spell Egypt that way. I became fascinated with getting the shape of Britain right, then I began drawing imaginary treasure maps with swamps and bridges. Then I think I saw *Superman* with the flying letters and became fascinated by 3D logos and copying cartoon characters. I think this laid the foundations for graffiti art for me. I started with classic letters and gradually introduced backgrounds and themes for murals, and my letterforms have evolved into surreal visions. I paint skies and floating landscapes because I began to really experiment with spray cans

and what they can do. The paint I used first was only designed for touching up scratches on cars, and the paint available today is developed specifically for mural painting. I live and work in my studio. I paint on many different things, from antique boxes to handmade metal panels. I see each painting as a small detail from something huge, a bit like a jigsaw puzzle where each canvas is a small piece of the bigger picture but each one is created in response to a current influence, and inspiration giving each its individual charm or curiosity. Painting graffiti has lead me along a very influential road. My friends are the ones who keep me in check, making sure I'm not insane for wanting to spend a month painting a dead pigeon. First and foremost I'm an artist, whether I use spray cans or pencils, my art is a way of translating what is making me buzz into a language that others can understand. Someone once said drawing is extracting, like sucking a straw. I'm influenced by what is around me. Like a chameleon I change but I'm still the same chameleon. I'm currently surrounded by all the rubbish from the 2012 Olympics building site. I see the beauty in many things. Art isn't supposed to tell the truth, art is about exaggeration and fantasy.'

He is influenced by graffiti artists, and also believes that birds have everything an artist requires for inspiration. He loves large cities and the solar system, stormy skies, trees and butterflies, and really likes ancient oriental and Asian art for its simplicity and attention to detail. He grew up in the east side of a city called Kingston-upon-Hull in Yorkshire.

'When I was growing up it was the 80s and I remember lots of glue sniffing punks and political anger. By the time I became a teenager, electro and hip hop had been born. Most nights were spent in the local park in a big gang of lads and lasses smoking pot. An alternative would be to go do a piece. We got into graffiti like others got into football or drugs. Most people thought we were weird. By the time I was old enough to get into clubs it was the tail-end of acid house and the beginnings of hardcore (now drum and bass). Most of my twenties were spent raving. I moved out of Hull to go to art college and see the world via art.'

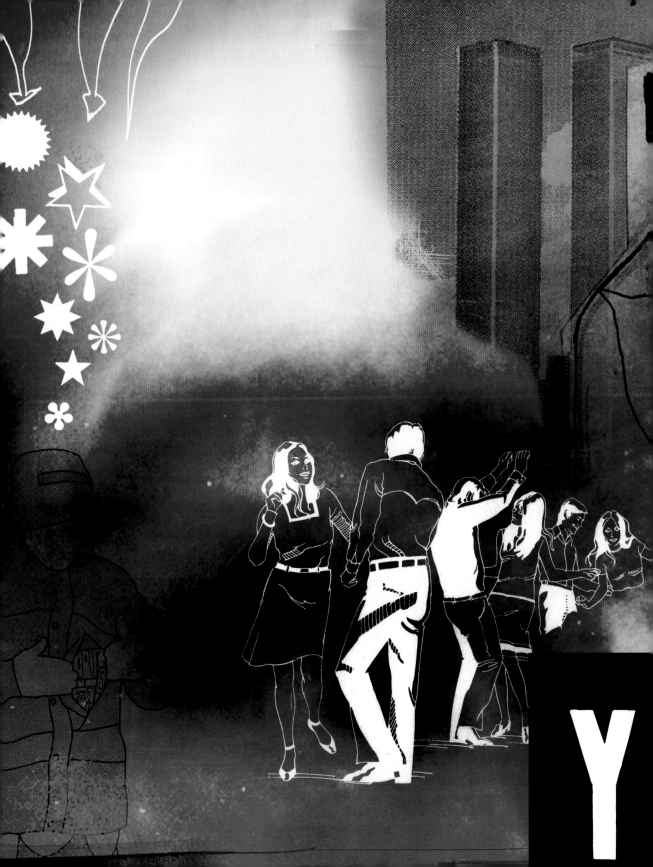

YOUNGUNZ

www.youngunz.fr

YounGunz are the future. An entertainment crew and record label, they embody everything I love about urban culture: energy, talent, attitude, style, and coming outta Paris they do it with a twist. Selector!

RIOT KID

'Just a bunch of guys who decided to ruin your nights'

YOUTH/SUB-CULTURES

Like I said at the beginning of this book, my life has revolved around the street, and this is especially true when it comes to youth and sub-cultures. For me it was an integral part of the escape from horrible middle-class suburbia which surrounded me when I was growing up. First with becoming a Casual and then with rave culture and all that came with it. These are the two defining sub-culture moments in my life: the trainer and the e, and then witnessing the London club scene by going regularly to the Mud and Brain Club. Youth culture and street fashion are intrinsically linked, with the fashion usually a badge or indicator of the sub-culture.

'Street culture is culture. Everything I learned, about football, music, clothes, drugs, girls, I learned through peers. (I certainly didn't get it from school.) It's quite sad that street culture has become so global with the net, and that it doesn't get the same chance to stay in the underground before it's relentlessly commodified and sold back to kids. Take football hooligans: back in the 80s the media went ten years caricaturing them as scarf-wearing skinheads with Doc Martens, when they had floppy fringes, hush puppies, Fred Perry shirts, deerstalkers etc. That could never happen now. Once something is on the street it has such a limited shelf-life in the culture before it is exploited by the media.'

Irvine Welsh

Two cities have played a massive part, London and New York and we're gonna start in London in the Shoreditch-Bethnal Green-Hoxton triangle. Which today is seen as where new style is coming from. But if you went back to the 1940s there was a street look happening where the youth would go to the movies and watch gangster flicks and then start dressing like the stars on the silver screen. Girls were dressing like molls and guys like gangsters, and they were even talking in an Americanized way. This early movement was documented in the early

media and as it was in the 1940s, this was a teen thing way before the whole concept of 'teenagers' was born out of the 50s. By the late 1950s, the rude boy look from Jamaica was happening in Kingston (>p126). This moved across the pond, carried over with the immigration of Jamaicans to the UK. This could explain the rise of the hard Mod look which was seriously important because it was not only very stylish but led to the early skinhead movement, which itself had a lot Jamaican influence to it. (It had nothing to do with the later skinhead movement, which was just about violence and racism.) The hard Mods/skinheads were a really stylish sub-culture, almost totally influenced by Jamaica through the haircut, the suits, the whole style of tailoring, the dancing.

Flipping back to the streets of New York in the late 60s and early 70s, it wasn't about who you were but more about who you thought you were: your own brand, your own billboard. People who give a shit about individuality are not going to wear any manufactured look as they're going to wear something that says something about them. Just check the iconic NY characters from the 70s onwards: Warhol, Iggy Pop, New York Dolls, Ramones, Blondie, Keith Haring, Basquiat: these are people who are still relevant, still influencing what happens today. The Downtown scene in 1981 was perhaps the definitive moment in NY and every hipster is still harking back to then. The outfits that rocked then are still very much part of how to look cool today. There have been new ones – the whole grunge thing, plus hip hop, both of which we'll get to later – but the skinny jeans and T-shirt will always be NY.

'I think what grew out of NY was thrift shopping 'cos it's not cool to buy expensive shit. It talks about your credit card rather than how cool you are. Thrift store shopping is something that is cool. I've been doing it since I was twelve-years-old. Just the fact that old clothes are cooler than new ones, is very New York.'

Mary-Jo Diehl

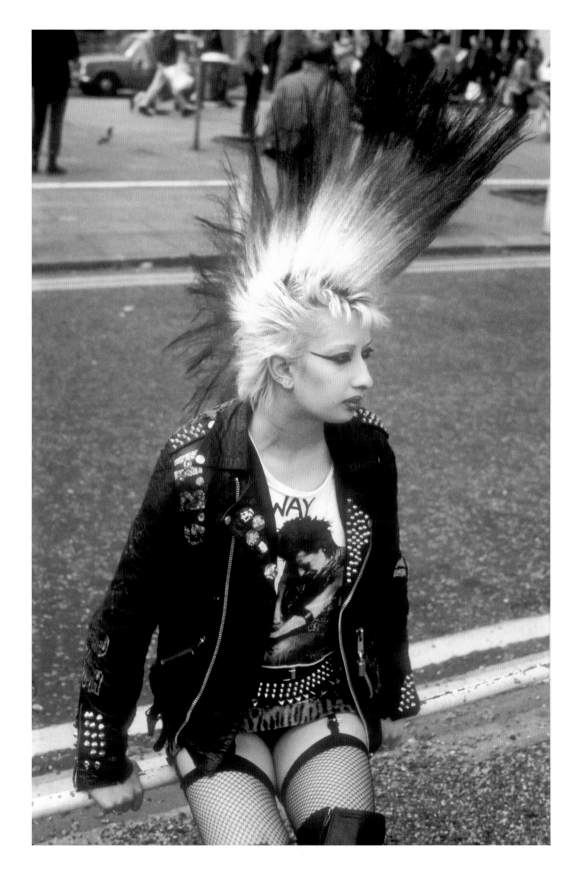

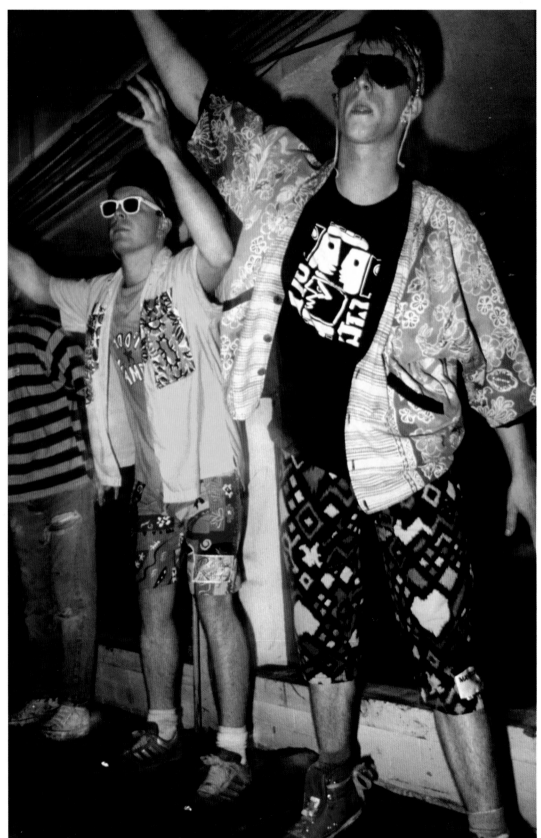

Acid House Ravers, UK 1989. Photograph by David Swindells/PYMCA

Back to the World's End part of London's Kings Road. In October 1971 Malcolm McLaren and Patrick Casey opened a shop called Let It Rock at 430 Kings Road, selling tailor made jackets (called drapes), skin-tight trousers, brothel-creepers, rock and roll vinyl, and magazines. The clothes were designed by McLaren's girlfriend Vivienne Westwood (who was then a school teacher) and the shop was partly responsible for a revival of teddy boy culture. It was one of the only neo-Teddy Boy clothing shops. In 1972 the place was renamed Too Fast To Live Too Young To Die and began selling clothes aimed at 1960s Rocker culture (the Mod's nemesis). But the greasy violent customers gave McLaren and Westwood too much trouble and stole too much stock, so in 1974, the shop was closed down and renamed Sex. But the Sex shop certainly didn't create punk. Punk came from America. McLaren had visited New York and met the New York Dolls and he did some serious research into the look and the street style. He then returned to England, where the Bay City Rollers were the hottest thing. He knew that what he had seen in NY would be the direct opposite to the bland glam-pop that ruled the UK, so he formed a band to create cash from chaos. The Sex Pistols. If anyone created punk rock in England, it was the combination of the personalities of John Beverley (Sid Vicious), John Lydon (Johnny Rotten) and their gang of friends.

'It was the two Johns' group of friends who were key, but were also invisible. People like Bertie Marshal, then known as Berlin, a girl called Debbie and a whole bunch of smackhead whores who were really behind British punk rock. They were going down the Coalhearn, they were going to Louise's, they were all a bunch of thieves with sticky fingers and that was what gave punk rock an edge because it was a dangerous time.'

Mr Hartnett

Then reggae comes back into the mix as the 2-Tone/SKA movement of the late 70s in the UK becomes a fully-fledged youth movement, with bands such as The Specials, the Beat and Madness leading the way. Madness even had their original Bez (>p172) in Chaz Smash. Their first single was 'The Prince', in homage to Prince Buster (>p126). One circle is complete.

By this time (the mid 80s) back in New York, hip hop (>p100) had become the only real street-level sub-culture/street fashion. The fashion was comprised of Lee Rider Jeans, Adidas Superstars and Puma Clyde rocking the ultra fat laces, and sportswear. I knew a couple of guys called Oz and Gee who ran a streetwear shop in the 253 Culture Shack in London's Ladbroke Grove who almost commuted to New York to buy their clothes and sneakers to sell in their shop, bringing back sports bags full of the freshest goods. And it was from this love of sportswear that the casual movement came.

'Being born in Liverpool meant being at the forefront of what we now know as casual culture. The year 1977 saw a dramatic change in fashions, besides a burgeoning punk scene, Liverpool had its own take on the fashions of the time. Flared jeans were replaced with narrow, straight jeans, shirt collars became a lot smaller, but most importantly of all, training shoes became the predominant footwear to be seen in. Never before had an athletic sportswear shoe become staple everyday leisure wear. This was to be the start and although we didn't know it at the time, "casual culture" would change the high street forever.'

Dave Hewitson

The casuals (I was one) always had bad press, but that is part of the whole point of being a sub-culture and it was just as the movement was losing momentum when Danny Rampling made the trip to Ibiza (>p122). The second summer of love (1988–9) happened and went and changed everything, all over again. It opened the way for the skate and grunge fashions that rippled out after rave had created the need for something else. I'm forever stuck in a cross between casual, rave and skater fashions.

→Turn to p244

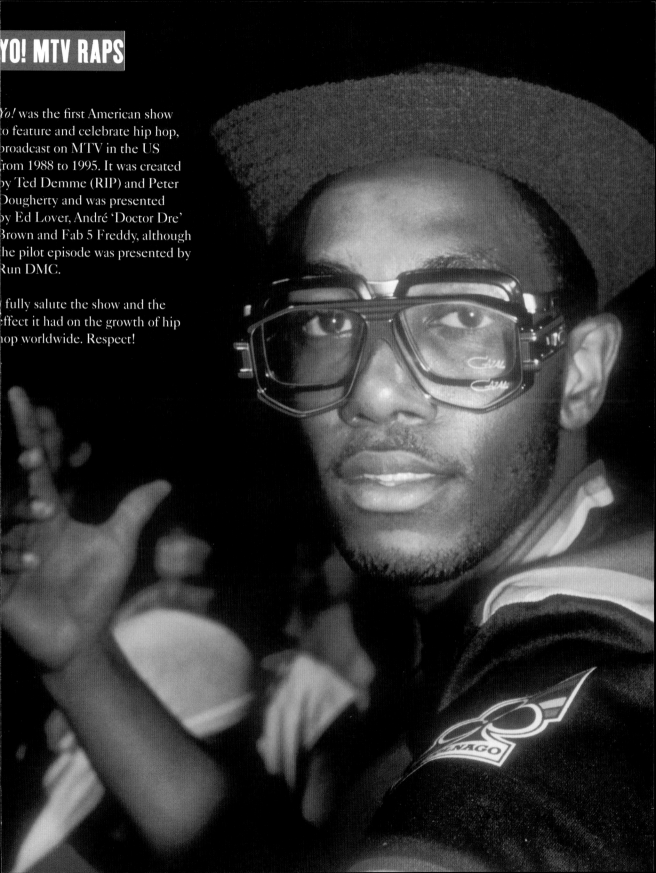

YO! MTV RAPS

Yo! was the first American show to feature and celebrate hip hop, broadcast on MTV in the US from 1988 to 1995. It was created by Ted Demme (RIP) and Peter Dougherty and was presented by Ed Lover, André 'Doctor Dre' Brown and Fab 5 Freddy, although the pilot episode was presented by Run DMC.

I fully salute the show and the effect it had on the growth of hip hop worldwide. Respect!

Z

BENJAMIN ZEPHANIAH

www.benjaminzephaniah.com

Now, let's move sideways (turn left?) and check someone who's been very influential on and off the page, the street poet and writer Benjamin Zephaniah. Benjamin grew up in the Handsworth area of Birmingham, which is best described as the Jamaican capital of Europe, and in 1971 left school at the age of thirteen unable to read or write – which is a testament to his serious talent as he has written and published fifteen books of poems; four novels; three children's books; and two plays. So far. Oh, and he's also released six albums and four singles, making him one of the most prolific voices of our generation. I hope I get up enough to write half of what Benjamin's done. I pulled up and checked his lyric.

<u>What inspires you?' I ask him one day as we cruised the landscape.</u>
'I'm not sure if inspire is the right word. What really fires me up is injustice and people's suffering. If I see something that is unjust I want to do something about it. Once upon a time I'd smash the fucking window or go crazy but now I've got a talent for poetry, I've always loved poetry. But at the end of the day I think if I was completely happy in myself – if I had all the material things I wanted and all that shit – would I still want to do what I do? I'd think yeah, of course. I wouldn't be happy until my sisters and brothers are happy, and happy means free; free from being persecuted for their race or gender or way of life. In one word, what inspires me is oppression.'

<u>Okay, how would you define street culture?</u>
'If someone was to ask me what street culture was I'd show them what mainstream culture is, right – whatever's in the shops or on the catwalks – and I'd say that all this [is] just watered-down street culture. Street culture is culture before the multinationals have got hold of it and made it into a commodity. Street culture is art and attitudes to life that are free of government, are free of companies, that come from everyday people – what they do in their living rooms, what they do on the street, what they do with their guitars that has nothing to do with big music labels or brands. A lot of it does get appropriated.'

<u>Art and creativity has nothing to do with making money, and selling out to a brand is still selling out?</u>
'When I turned down the MBE, a lot of press wrote about it, some congratulating me, but the interesting thing was that if anyone really knew what I was about they would know that I would never accept something like this. Had this been the mid 80s none of the press would have batted an eyelid as there were so many artists who would have felt the same and turned it down. Now they are all happy to jump on the corporate bandwagon or go to the palace or whatever. The reason I stand out when I did this is because there are so few other artists who are willing to say "No, I don't want that sponsorship". It's really sad that the artists feel lucky to be asked by Coke or whoever... You know my poem Talking Turkey? Well, I've been offered thousands and thousands of pounds by a meat brand to use that poem to sell their product! I say to them, "Have you not read the poem, do you not understand it?"'

Time

At the time of the offence I was at home

The day in question no street did I roam

The alleged offence was nothing of my doing

Can innocence be something that needs proving?

I was minding my own business and quite straight

When the wicked one arrested me with hate

In a cell they gave me water and said 'Cheers'

They gave me Judge and Judge gave me two years.

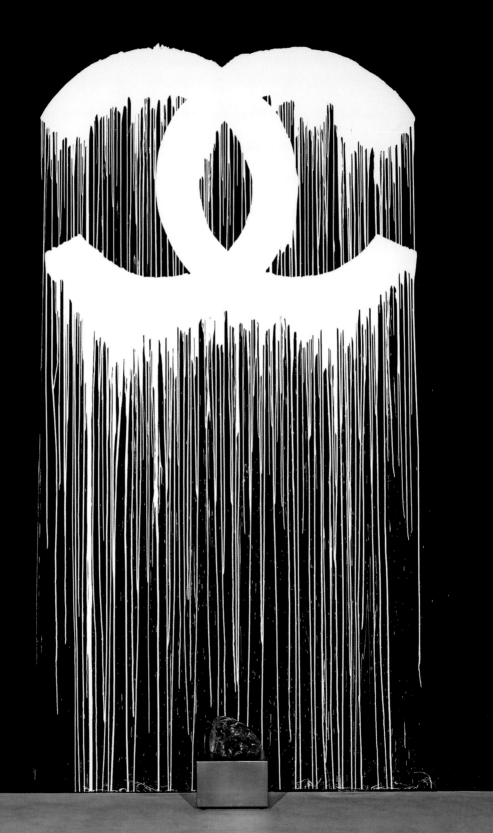

ZEVS

www.gzzglz.com

Sometimes someone comes along and flips everything you've ever thought about something into something else. Zevs has done this with his re-interpretation of street art and graffiti and his approach to brands. He was arrested in Hong Kong in 2009 after his 'liquidation' of a Chanel logo on the front of a Giorgio Armani storefront, and received a $700,000 fine and a suspended jail sentence.

'In the beginning of the 90s, I tagged under various names in Paris. After narrowly escaping being hit by the regional train Zeus, I took the name "Zevs" as my street name.'

Visual Kidnapping, UV graffiti, the liquidation of brands: all these add up to a completely new visual look and aesthetic to intrigue the viewer or passer-by. Zevs' ideas work because he takes something you know about and fucks with it.

'With my work, I like to respond to and extend that which already exists in a given environment. Glyptoteket [Danish art museum] has been an amazing source of inspiration, and has served me as a good point of departure.'

He has been making 'proper graffiti' since the beginning of the 00s. The idea came to him at a time when tags were being removed throughout Paris.

'Face to face with walls blackened by pollution and weathered by time, I make graffiti by cleaning these surfaces in a creative way using a high-pressure jet. When I'm done, I have created a bolt of lightning and a cloud in the dirt. In this way, I circumvent the law and avoid any accusation of vandalism. By reappropriating the traditional social codes, I turn the situation to my advantage and bring the administration responsible for the cleanliness of the city in an embarrassing situation. I "graffiti clean your city!"'

At the age of twelve, he used to meet up at 4 am with a classmate to paint 'punishments' on the walls in the streets next to our school. These punishments were accumulations of the same tag repeated again and again, in the style of writing lines for punishment in school. He was soon caught by the police and considered a criminal.

'Now, I often return to "crime scenes" to erase my tags in order to avoid criminal charges from the owners of buildings, walls and trucks. I'm looking for a way of making work that is at the same time symbolic and an expression of reality. This I try to do in such a way that the question of authorization is left out.' → Turn to p248

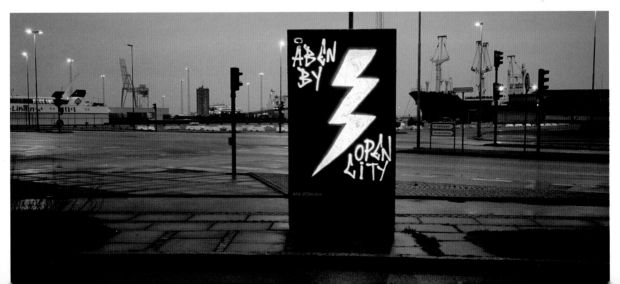

ZBK, AKA ZBOIK, is an artist from Poland, who creates the most amazing street walls/murals around the world and has a unique style. He started out creating classic graffiti and when he began to study fine art he became more interested in

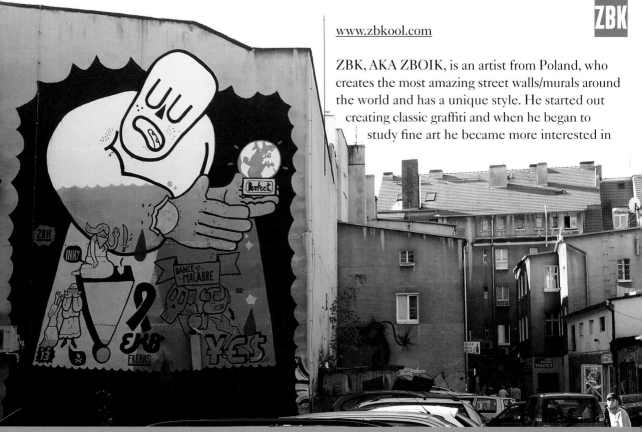

Street culture, is everything that i see in urban area, from painting

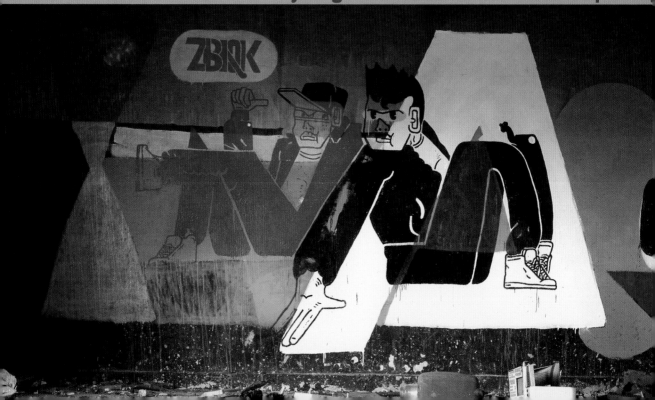

character design. He has been living and working for two years in the city of Wroclaw since graduating.

'I've been working in a mix of painting, design, and whatever comes to my wicked mind. Which was important for kids born in a different political system. It was a gateway to the big western world, what was and still is very inspiring, and gave us motivation to create. My hometown used to be a German city, and we feel we are here, writing the story from beginning. My influences are mostly mass culture, everyday life, old masters and the 80s. It's a really important decade for me if it comes to art, music, fashion.'

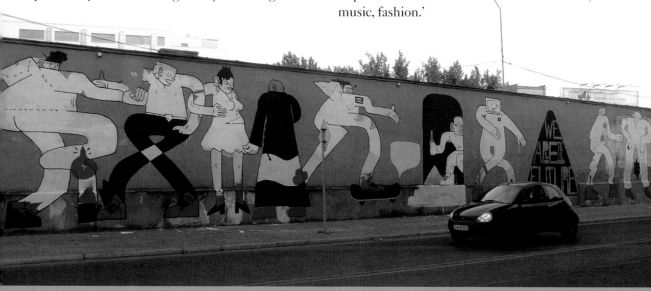

ncers, music, pesky commercials, trash, dirt. You love it and hate it!

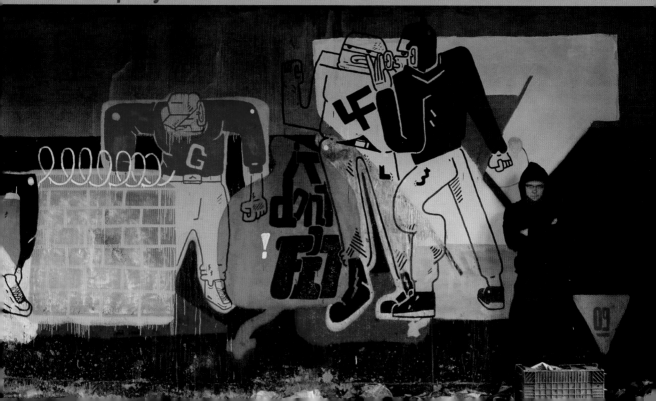

BONUS FEATURES

ESSENTIAL READING

Slaves of New York by Tama Janowitz
Things Fall Apart by Chinua Achebe
Trainspotting by Irvine Welsh
My Traitor's Heart by Rian Malan
Stars of the New Curfew by Ben Okri
Fear and Loathing in Las Vegas
 by Hunter S. Thompson
London Fields by Martin Amis
Vulture/The Nigger Factory by Gil Scot-Heron
Bass Culture by Lloyd Bradley
Wall & Piece by Banksy
Ragtime by E.L.Doctorow
Less Than Zero by Bret Easton Ellis
Hollywood by Charles Bukowski
Bright Lights Big City by Jay Mcinerney
The Andy Warhol Diaries by Andy Warhol
Subway Art by Martha Cooper & Henry Chalfant

ESSENTIAL LISTENING

Substances by DJ Cam
It Takes a Nation of Millions to Hold Us Back
 by Public Enemy
Raising Hell by Run DMC
Paul's Boutique by The Beastie Boys
Pills, Thrills & Bellyaches by The Happy Mondays
Ready to Die by the Notorious B.I.G.
Time Boom X De Devil Dead by Lee 'Scratch' Perry
What Does your Soul Look Like? (EP)
 By DJ Shadow
The Infamous by Mobb Deep
That's Why We Get High by 100proof
No More Stories Are Told Today I'm Sorry They
 Washed Away No More Stories The World Is Grey
 I'm Tired Let's Wash Away
 by Mew
Live & Direct by Aswad

ESSENTIAL WATCHING

Everything & Anything by Nick Broomfield
Everything & Anything by Werner Herzog
The Upsetter (Ethan Higbee and Adam Bhala
 Lough, 2008)
Lake of Fire (Tony Kaye 2006)
Maestro (Josell Ramos, 2003)
Dog Town and the Z-Boys (Stacey Peralta,
 2001)
Dancer in the Dark (Lars von Trier, 2000)
American History X (Tony Kay, 1998)
Time Will Tell (Declan Lowney, 1992)
A short Film about chilling (Angus Cameron,
 1990)
Stranded in Canton (William J Eggleston, 1989)
80 Blocks from Tiffany's (Gary Weis, 1979)
Rockers (Ted Bafaloukos, 1978)

ESSENTIAL ONLINE SHIT

www.woostercollective.com
www.frank151.com
www.12ozprophet.com
http://supertouchart.com
http://arrestedmotion.com
www.theartstreetjournal.com
www.artofthestate.co.uk
www.stealfromwork.org/
http://nahright.com
http://unknown-coolcrew.blogspot.com
http://hypebeast.com
http://thewackblog.com
www.honeyee.com
http://blog.coolcats.fr
www.lamjc.com
www.colette.fr
www.notcot.org
www.oh-wow.com
www.thedailyswarm.com
http://kitsunenoir.com
www.urbantravelblog.com
http://gridskipper.com
http://opentravel.com

THANKS

In loving memory of Joy Slater & Mat Webster REST IN PEACE. Biggest peace & love to Wilma, Kaiya, Casius, Beardie & Zeus; Alex and Thandwe Mamacos (Big up the CPT!); Jayne, Andy, Jono the Bear that fell out of the tree, Big D.; Mickey, Tara, Elodie, Lindsey; Jonathan, Sophie and Oscar; Marianne Gunn O'Connor (it's true about your Midas touch), Jenny Heller & Lizzy Gray; Jamie Camplin (you started all this!); Liz 'GA' King, Johnny, David, Liz-Anne; Bella Granny Franca, Ellen, Linda & Andrea (Big up ROMA!); Conrad & Michelle; Toby Lloyd & Family; My Brother from another mother Nir 'Pilpeled' Peled; Pete & Wil Case; Charlotte Ellis & Blythe; My OG Homeboy Irv, Hannah & Oscar; Irvine Welsh; Jimmy Dodd; Pete & Gisele; John & Heather Roderick (Big Up INDIA!); Marina, Archie, Matt, Dan, Liza; Laser 3.14; Lenny Lennox; Paul Hartnett; Paul Sellars; John Pace; Jonny Dubin ('Fully!'); Jon Swinstead at PYMCA.

Sorry to everyone who didn't make it, but I ran outta space otherwise you'd be in there… Sorry to Rick Rubin, DJ Kool Herc, The Streets, The Beastie Boys, whose management ignored my requests, as I really did want you get you in there as I dig what you do and have nothing but love in my heart and massive respect in my brain, but I just couldn't get through…Big Nish to all the haters out there – unlucky! Better luck next time…

CHAPTER OPENING CREDITS

CHAPTER TITLE PAGES

A – 100proof

B – Photo © Darrell Berry (www. Darrellberry.com)
Darrell was born in Tasmania, Australia, but has spent the last 20 years living in Japan and England. He discovered club culture at legendary Tokyo venues Gold and Maniac Love, in the early 1990s. More recently, Darrell has been documenting the busy East London club/ alternative performance scene. His work has been featured internationally in publications including *A Magazine, Dazed and Confused, L'uomo Vogue* and *i-D.*

C – Photo © Mikko Ryhänen/CTRL, © Becki Fuller, © Jordan Seiler, © 100proof

D- Art © Brad Downey/Photo © Tod Seelie
Brad is one of the finest artists working today
'Whats-Up or The Burden of the Children', 2006. Brooklyn, New York, USA
Duration: 2.5 months. Metal, paint.
Special thanks to Mike Wrobel. WHOOPS!!! Looks like the city miscalculated the strength of that street pole!

E- Photo © Josh Cole (left) © King Adz (right)

F – Photo © Felipe 'Flip' Yung (left) © 100proof (right)

G – Illustration © BROKEN FINGAZ (big up Israel!)

H – Photo/Art © Home Ec (www. home-ec.org)
'We started out creating graphics for a fledgeling clothing company which proved to be the catalyst for our collaboration. Since following orders often produced work that we were not satisfied with, we decided to head out on our own in order to have creative control and ultimately, enjoy design again. Now the work we produce is derived from our good spirit and creative freedom.'

I – Art © Paul Insect

J – Photo © Josh Cole (www.joshcole.co.uk)
Josh is a street culture photographer based in London.

K – Art © Know Hope
L – Photo © David LaChapelle (left) © 100proof (right)

M – Art/Photo © M-City (www.m-city.org) AKA Mariusz Waras
Big up Poland! Mariusz Waras: Graphic designer, outdoor painter, traveller, amateur architect. Graduate from the Faculty of Graphic Arts of the Academy of Fine Arts in Gdansk. Author of a couple hundreds of murals within his individual project series m-city. The main theme of his art is the urban landscape. His works can be seen in Warsaw, Gdansk, Berlin, Paris, Budapest, Sao Paulo, Rio de Janeiro, Bolzano, London, Prague and other sites, as well as in galleries.

N – Photo/Art © Alex Diamond (www.alexdiamond.de)
Alex is one of the future stars of European art. The persona of Alex Diamond was born in 2004 through the monothematic show 'Alex Diamond's Strange Sofa'. Before that he was known as something else and his idea of removing the connection from art to artist means that he is free to create a different story, or concept, each time he produces a body of work. This will keep it fresh-as-fuck, something that is vitally important in art. Alex is influenced by what is happening around him, and creates his art through painting, photography, collages, and installations.

O – Photo © Jonathan Olley (www.jonathanolley.com)
Jonathan is one of my oldest friends in the world and is a world class photographer. His work is the most original out there and he does what no one else does. Period, as they say in America. His wicked work has been widely exhibited and collected, most notably by the Imperial War Museum-London, the Institute of Contemporary Arts, Museo Carrillo Gil, Mexico City and Tate Britain. His awards include two first place prizes at the World Press Photo, a Bronze and Silver award at the Association of Photographers and the Observer/Hodge Award for photojournalism.

P – Art © Pilpeled

Q – Photo/Art © Quik

R – Art © RIPO (www.ripovisuals.com)
'My work is about typographic and other. The public space is a common place to find it. Dichotomies, sarcasm, humor, politics, sex, drugs, drunken ramblings, and serious commentary are all commonly abused themes.'S – Photo © Swoon, © Tilleke Schwarz, © Vincent Skolglund, © Dave White (left) © 100proof (right)

T – Photo/Art © LASER 3.14 (www.laser314.com)
Laser's work is off-the-hook-good. I would describe it as: Urban poetry presented in a street-style moment, complete with a graffiti-style tag that reads Laser 3.14, and he is a thoroughly nice bloke based in Amsterdam.

U – Photos © TrustoCorp
The work of TrustoCorp has been mysteriously appearing on the streets of the larger cities in the USA.

V – Art © Julian Vallee, (www.jvallee.com)
Julian is a lekker Canadian artist/designer. 'I am a graphic designer based in Montréal, Canada. I am working on a range of projects including art direction, motion graphic, print design, art installation and video + design for the music industry. I try to get in touch with every aspect of the environment. I like to use manual art well endorsed by the various technological tools available in order to make the bridge between manual and virtual art.'

W – Photo/Art © Garth Walker (left) © King Adz (right)

X – Photo © Guy Pitchon (left) © 100proof (right)

Y – Photo © Paul Hartnett (left) © 100proof (right)

Z – Art © ZXero Kool (www.zxerokool.com) Photo by Steve Lawler
ZXero Kool is the alter-ego of Jonathan Leong, who hails from Singapore. 'Everything is good except the weather, which can get close to that of a stone grill. Which explains why I prefer to be awake mostly at night. Creatively speaking there was a lot of initial fear that a career in the design line would not bake enough bread to fund my toy/sneaker collecting habit.'

PHOTO/ART CREDITS

FOREVER